KANŌ EITOKU

Japanese Arts Library

General Editor
John Rosenfield

With the cooperation and under the editorial supervision of:

The Agency for Cultural Affairs of the Japanese Government
Tokyo National Museum
Kyoto National Museum
Nara National Museum

KODANSHA INTERNATIONAL LTD. AND SHIBUNDO
Tokyo, New York, and San Francisco

Kanō Eitoku

Tsuneo Takeda

translated and adapted by

H. Mack Horton and Catherine Kaputa

Distributed in the United States by Kodansha International/USA Ltd., through Harper & Row Publishers, Inc., 10 East 53rd Street, New York, New York 10022; in Europe by Boxerbooks Inc., Limmatstrasse 111, 8031 Zurich; and in Japan by Kodansha International Ltd., 2–12–21 Otowa, Bunkyo-ku, Tokyo 112.

Kanō Eitoku was originally published in Japanese by the Shibundo publishing company, Tokyo, 1974, under the title *Kanō Eitoku,* as volume 94 in the series *Nihon no bijutsu.* The English edition was prepared at Kodansha International, Tokyo, by Saburo Nobuki, Takako Suzuki, and Michael Brase.

Published by Kodansha International Ltd., 2–12–21 Otowa, Bunkyo-ku, Tokyo 112 and Kodansha International/USA Ltd., 10 East 53rd Street, New York, New York 10022 and and 44 Montgomery Street, San Francisco, California 94104. Copyright © 1977 by Kodansha International Ltd. and Shibundo. All rights reserved. Printed in Japan.

First edition, 1977.

LCC 76–44155
ISBN 0–87011–295–3
JBC 1371–785628–2361

CONTENTS

Japanese Art Periods

Prehistoric		−537
Asuka		538–644
Nara		645–781
Hakuhō	645–710	
Tempyō	711–81	
Heian		782–1184
Jōgan	782–897	
Fujiwara	898–1184	
Kamakura		1185–1332
Nambokuchō		1333–91
*Muromachi		1392–1572
*Momoyama		1573–99
*Edo		1600–1867

Note: This table has been provided by the Agency for Cultural Affairs of the Japanese Government. Periods marked with an asterisk are described in the Glossary.

ILLUSTRATIONS

74. *Flowers and Trees of the Four Seasons (Shikikaboku-zu)*, by Kanō Mitsunobu. Detail. (See also pl. 67.)
75. *Flowers and Birds (Kachō-zu)*, by Kanō Mitsunobu. Detail.
76. *Waterfall (Bakufu-zu)*, by Kanō Mitsunobu.
77. *Flowers and Birds of the Four Seasons (Shikikachō-zu)*, with "Shūshin" seal.
78. *Pines (Matsu-zu)*. Detail. *Fusuma* panels, Myōhō-in.
79. Pine branches (*matsugae-zu*). Detail from *Pine and Waterfowl (Matsu ni suikin zu)* by Kanō Mitsunobu, Onjō-ji.
80. Pine branches (*matsugae-zu*). Detail from *Autumn Grasses* (pls. 87–88), attributed to Kanō Mitsunobu.
81. Pine branches (*matsugae-zu*). Detail from *Snowy Pine* (pls. 90, 92) by Kanō Mitsunobu.
82. Pine branches (*matsugae-zu*). Detail from *Hermits* (pl. 96) by Kanō Mitsunobu.
83. Pine branches (*matsugae-zu*). Detail from *Flowers and Birds of the Four Seasons* (pl. 77).
84. Pine branches (*matsugae-zu*). Detail from *Pines (Matsu-zu)* by Kanō Mitsunobu, wall paintings, Myōhō-in.
85. Pines branches (*matsugae-zu*). Detail from *Beach Pines* (pls. 70–72), attributed to Kanō Mitsunobu.
86. *Flowering Plants (Kaki-zu)*; attributed to Kanō Mitsunobu. Ceiling paintings.
87. *Flowers and Trees (Kaboku-zu)*; attributed to Kanō Mitsunobu. Detail. (See also pls. 86, 88, 89.)
88. *Autumn Grasses (Akikusa-zu)*; attributed to Kanō Mitsunobu. (See also pl. 87.)
89. *Flowers and Trees (Kaboku-zu)*; attributed to Kanō Mitsunobu. Detail. (See also pls. 86, 87, 88.)
90. *Snowy Pine (Sesshō-zu)*, by Kanō Mitsunobu. (See also pl. 92).
91. *Young Bamboo (Wakatake-zu)*, by Kanō Mitsunobu.
92. *Snowy Pine (Sesshō-zu)*, by Kanō Mitsunobu. Detail. (See also pl. 90.)
93–95. *Hermits (Gunsen-zu)*, by Kanō Mitsunobu. Details. *Chōdaigamae* paintings.
96. *Hermits (Sennin-zu)*, by Kanō Mitsunobu. Wall painting.
97. "Wang Tzu-ch'iao" (*Ō Shikyō zu*); attributed to Kanō Eitoku. Detail from *Hermits (Gunsen-zu)*, *fusuma* panels. (See also pl. 100.)
98. "Lu Chi" (*Rikuseki-zu*); attributed to Kanō Eitoku. Detail from *The Twenty-four Paragons of Filial Piety*, Nanzen-ji. (See also pl. 99.)
99. "Lao Lai-tzu" (*Rō Raishi zu*); attributed to Kanō Eitoku. Detail from *The Twenty-four Paragons of Filial Piety*, Nanzen-ji. (See also pl. 98.)
100. *Hermits (Gunsen-zu)*; attributed to Kanō Eitoku. Detail. *Fusuma* panels. (See also pl. 97.)
101. "Shūshin" seal from *Scenes in and around Kyoto* (pls. 15–16).
102. "Shūshin" seal from *Landscape of the Four Seasons* (pl. 118).
103. "Shūshin" seal from *The Twenty-four Paragons of Filial Piety* (pl. 119).
104. "Shūshin" seal from *Flowers and Birds of the Four Seasons* (pl. 77).
105. "Shūshin" seal from *Hsü-yu and Ch'ao-fu* (pls. 26–27).
106. "Shūshin" seal from *Pai-i and Shu-ch'i* (pl. 28).
107. "Shūshin" seal from *Pair of Doves in a Pine Tree* (pl. 116).
108. "Shūshin" seal from *Pomegranate* (pl. 117).
109. "Shūshin" seal from *Bird of Prey* (pl. 120).

9

A Note to the Reader

Japanese names are given in the customary Japanese order, surname preceding given name. The names of temples and subordinate buildings can be discerned by their suffixes: *-ji*, *-tera*, *-dera* referring to temples (Tōshōdai-ji; Ishiyama-dera); *-in* usually to a subtemple attached to a temple (Shōryō-in at Hōryū-ji); *-dō* to a building with a special function (Miei-dō); *-bō* and *-an* to larger and smaller monastic residences, respectively (Gokuraku-bō; Ryūgin-an).

artistic excellence in his or her field. A basic distinction can be made between schools on the basis of whether successorship was passed on in a hereditary manner, as in the Kanō school, or in a nonhereditary fashion, as in the Rimpa school. In the painting schools organized on the family principle, the headship usually passed from father to son or near relative. Instances abound, however, in which there was no suitable descendant and leadership was bestowed on a master's most talented or favored student. This person was generally adopted into the family and allowed to assume its name. Although some family-centered schools endured for centuries—like the Tosa school, which chiefly served the imperial family and aristocracy, and the Kanō family, whose patrons were generally from the samurai class—most declined in three or four generations.

In the painting schools based on hereditary succession like the Kanō school, there developed a main family *(sōke)* whose leadership was theoretically passed on to the eldest son, generation after generation. Additional sons formed branch families of the school, giving rise in later generations to an elaborate genealogy of families and painters all ostensibly under the direction of the main family. (See page 163 for a chart of the Kanō school.) This pyramidal organization became the governing system not only for painters but for a wide variety of artists and artisans—such as performers of Nō, Kyōgen, and Kabuki, musicians and dancers, calligraphers and poets, sculptors, lacquer and metal workers.

Since most artistic fields take a long time to master, the family system was a thorough and effective means of training from an extremely young age. It also afforded an efficient framework for the completion of massive commissions in temples, residences, and other structures. However, the family system was by nature conservative; it was a vehicle for the preservation of traditional modes and school principles. Overly innovative students and nonconformists were regarded as detrimental to the school system and often expelled. Thus, creativity was frequently stifled and the importation of new talent and styles discouraged. Lacking gifted descendants or inspired leadership, schools often fell into mediocrity.

While family-centered schools of artists and artisans tended to be insular and behind the times, with progressive leadership they could respond to the challenge of new tastes and styles in painting. The Takuma school, for instance, which had been a family-centered school of painters executing traditional Buddhist images since the Heian period (782–1184), turned in the Muromachi period (1392–1572) to the new medium of monochrome ink painting that had become fashionable under Zen influence. Likewise, the Kanō school, under the leadership of men of superior ability like Motonobu and Eitoku, exhibited a freshness and vitality that ensured prosperity for the school. Moreover, while each painting school was associated with a particular style of painting as well as a corpus of thematic subjects that characterized its main production, in reality few schools were absolute. Kanō school painters, whose métier was a Chinese-derived style of ink painting, often with the addition of color, also pro-

13

duced paintings in the native (yamato-e) style based on traditional Japanese themes (as in pls. 15–16).* Even in their characteristic style, Kanō school paintings are not all from one mold. Kanō artists were influenced by a wide range of Chinese and Japanese artists whose paintings they studied, and throughout its history eclectic borrowings can be seen in Kanō school painting.

The transmission of records and documents was an important manifestation of the hereditary school system. Since the "secret" methods and techniques as well as private teachings and philosophy of a particular artistic school were often contained in these documents, they were jealously guarded and reverently passed down from generation to generation. Integral among a school's records were a genealogy and history of the school from its inception, delineating the various leaders of the main line, descendants, and branch families. Often the early history of a school was fabricated at a later date in order to legitimize its standing by tracing its origins to a famous painter in antiquity. The Tosa school, for example, claimed descent from the late Heian period (782–1184) and established an impressive counterfeit genealogy of heads of the school down to Tosa Yukihiro in the fifteenth century, who was, in fact, the first artist with the Tosa name to work as a court painter.

The various records and documents of a school served not only to legitimize a school in Japanese art circles, but also to provide a body of philosophy, family history, and technical information for the training of young members of the family and disciples. Copybooks preserved the styles and compositions of paintings of elder school masters, and books on technique and iconography provided concrete means of instruction. It is important to remember that the great masters of a school were highly revered as the agents of historical evolution and apogee. These painting manuals along with the apprenticeship method of training insured a stylistic unity within the school from one generation to the next, modified, of course, by the innovations of individual master artists or the introduction of new styles. Thus, the historical evolution of a painting school involved an extremely complex relation of personalities and styles, not merely the transmission of general practices and techniques perpetuated through workshop training. It should also be mentioned that study in certain hereditary schools contained religious undertones, and interspersed with the teaching of an art was no doubt spiritual and philosophical training.

This study of Kanō Eitoku by Takeda Tsuneo is the first critical work on the Kanō school to appear in English. Mr. Takeda begins with a historical perspective on the origins of the school in the Muromachi period, tracing it into the sixteenth century and the Momoyama period (1573–99), which saw the transition from a century of warfare to a period of increasing stability, material prosperity, and artistic grandeur. The military generals Oda Nobunaga and Toyotomi Hideyoshi commissioned vast

14 * For such terms as yamato-e, see also Glossary.

decorative projects for the castles and palaces that were their centers of government and visual symbols of their wealth and power. Kanō Eitoku's paintings in these structures, as well as in the mansions of the nobility and in the huge temple complexes, attained a dazzling magnificence that epitomized the spirit of the age and provided a standard for other artists to emulate. These castles and palace buildings and their splendid interior decorations enjoyed a fabled reputation shortly after they were built; accounts by members of the aristocracy and government officials as well as those of foreign diplomats, missionaries, and merchants offer vivid testimonials to their original beauty.

Early documents reviewed by Mr. Takeda recount that Eitoku was a child prodigy, and it was with this grandson that the elderly Motonobu placed his expectations for the future of the school. Motonobu's judgment proved correct, for not only did Eitoku become the most highly esteemed artist of his day, but he also expanded the school's organization into a prosperous academy that monopolized most of the important commissions to decorate official buildings, temples, and residences of the aristocracy and feudal lords.

Eitoku's own painting style evolved from the Chinese style of ink painting that had become popular in the Muromachi period, particularly the styles of his ancestors Kanō Masanobu and Kanō Motonobu. It was Masanobu in the first generation and Motonobu in the second generation who codified the ink painting style that came to be the basis for the Kanō school style. During the Muromachi period, Chinese ink painting had been closely associated with the Zen Buddhist community in Japan, for the first paintings in this medium were brought over in the latter half of the thirteenth century by Chinese and Japanese Zen monks. The earliest practitioners of ink painting in Japan, moreover, were Zen adepts, but in time ink painting became increasingly independent of subtle Zen philosophy and taste. The Kanō family, moreover, were Nichiren Buddhists, and the style of ink painting developed by Masanobu, Motonobu, and Eitoku is decidedly secular in approach. Their work has a clarity of presentation and a direct visual appeal that was favored by many of their patrons, who were without the intellectual sophistication that appreciation of Zen painting demanded. Likewise, color is used more lavishly than in Zen painting, and there is an emphasis on decorative shapes and stylized forms.

In his early works Eitoku's painting style was under the influence of Muromachi ink-painting standards and family tradition. In the Jukō-in (pls. 2–4, 11–14, 18–19), a painting commission of his youthful twenties, the subdued tone and rather stiff angular brushwork of his grandfather Motonobu's style is present. Mr. Takeda shows how, as Eitoku grew older, he abandoned the technical and expressive restraint of his early style and made dramatic use of line, color, and decorative effect. The objects he painted assumed larger and larger proportions, his brushwork was vigorous and startlingly bold, and he favored sensuous colors and glittering squares of gold leaf covering unpainted background areas (pls. 9, 20, 22, 24).

15

His broadly conceived compositions, made to be comprehended in their entirety across the expanse of large rooms, have been labeled Eitoku's *taiga* or monumental style. *Taiga* refers to the large-scale, almost theatrical depiction of compositional elements and motifs in relation to the size of the format. Additionally, it refers to a painting's grandeur of execution: the long, sweeping brushstrokes used to delineate forms, and the uncomplicated or rough modeling of pictorial elements, achieved with wide or coarse-bristled brushes adopted by Eitoku for their nuances of line and texture (pls. 9, 20, 22, 24). The *saiga* or detailed mode, on the other hand, is precise and lucid. The pictorial elements are carefully drawn and delineated, brushstrokes tight and controlled. This style is best suited to a small format such as a fan or album painting, but it was sometimes adopted for a large format (pls. 15–16).

The *taiga* is the style that Eitoku originated and made famous; it is this style with which his name is virtually synonymous today. According to the account in the *Honchō gashi* (History of Japanese Painting), an early history of Japanese painting written by a Kanō family descendant about one century after Eitoku's death, Eitoku developed the monumental style because his atelier was flooded with commissions to decorate the interiors of vast residence halls and temples. In order to meet the demand, Eitoku was forced to abandon painting in the detailed style that had characterized most of his early works, and to develop a more quickly realized, broadly conceived style of painting. Whether Eitoku created the *taiga* style as a means of personal expression or merely as an expediency is difficult to judge. Nevertheless, there are fewer surviving works associated with Eitoku in the *saiga* manner, and Eitoku's *taiga* style quickly became the paradigm of the Momoyama era.

One must remember that the Momoyama period, like so many ages in Japanese history, was an age of contradictions. While Eitoku's flamboyant compositions were in fashion, also in vogue was the quiet and secluded *(wabi)* tea of Sen no Rikyū that inspired the creation of small austere tea rooms and humble-seeming utensils. The birth of Eitoku's expressive monumental style, then, should be considered one of the hallmarks of the age, to be viewed in conjunction with the appreciation of *wabi* tea, the appeal of genre paintings of festivals and the everyday life of commonfolk, and the fascination with paintings and objects influenced by Western styles and subjects.

In examining the career and works of Eitoku and the development of his monumental style, Mr. Takeda faces the many attribution problems that arise from the school system of painting. Indeed, by the early twentieth century a large percentage of the holdings of important Kyoto temples had been attributed to Eitoku on no sound stylistic or documentary basis. Eitoku's signature or seals had been applied to many paintings at a later date, and often certificates of authenticity had been furnished without warrant. In some temples the association with Eitoku was simply through oral tradition. Thus, a large number of "monumental-style" paintings were indiscriminately attributed to Eitoku, an authentication all too eagerly accepted by temple authorities since it enhanced the historical value of their holdings.

This book may be seen as an effort to bring to the English-reading public the results of modern scholarship. Utilizing the stylistic framework carefully developed by Tsuchida Kyōson, Doi Tsugiyoshi, and other twentieth-century art historians, as well as important early documents such as the *Honchō gashi* and *Tansei jakuboku shū,* Mr. Takeda attempts to put Eitoku scholarship on a secure foundation and to distinguish as far as possible Eitoku's works from those of his disciples and descendants. In the final two chapters, Mr. Takeda examines the lives and works of Eitoku's father, Shōei, his brother Sōshū, and his son Mitsunobu, whose overlapping careers show the influence of Eitoku's genius.

In examining the Kanō school's history, scholars demarcate periods of apogee and decline that reflect upon the talent of the respective leaders and members of the school. In the Muromachi period, for example, Kanō Motonobu was one of many *kanga* (Chinese-style) painters striving for recognition in the capital. It was his talent and determination as a painter that established a sure footing for the emerging Kanō school of artists. Likewise, the Kanō school's second great apogee, in the Momoyama period, can be credited to the innovations of Kanō Eitoku. The intervening period, when Kanō Shōei was the head of the school, was a time of less radiant fortunes. The time span from the late Muromachi through the Momoyama periods was a highly competitive, transitional age; this environment served as a stimulus to the creative genius of Eitoku while less versatile men like his father Shōei faltered. Even Motonobu clearly recognized the differing potentials of the two men, and, according to early documents, came to regard his grandson Eitoku rather than his son Shōei as his artistic successor.

After Eitoku's death, the Kanō school again experienced a period of artistic decline. Mitsunobu did not possess the great innovative vitality, artistic talent, or qualities of leadership that his father Eitoku did. According to tradition, when he used the name Ukyō in his youth, Mitsunobu was called *heta Ukyō* ("unskillful Ukyō"). Moreover, it is recounted in the *Honchō gashi* that Mitsunobu was not adequately prepared to assume the headship of the Kanō school upon Eitoku's premature death at the age of forty-eight: he had to receive instruction in Kanō-family painting methods and teachings from other members of the school. In comparison to the work of Eitoku, Mitsunobu's paintings exhibit a superficial opulence—they are a refined version of his father's buoyant, color-and-gold compositions. However, many works merit artistic recognition, such as his *fusuma* paintings in the Kangaku-in, Onjō-ji, in the Myōhō-in, and in the Hōnen-in, as well as several sets of folding screens depicting flowers and birds of the four seasons.

In the generation following Mitsunobu's, Kanō school painters flourished both in Kyoto and in the new capital at Edo (modern Tokyo). Kōi, though not a member of the Kanō family, exhibited promise as a student of Mitsunobu's. Later he was adopted into the family, given the Kanō name, and allowed to manage a separate branch of the Kanō school in Kyoto. Additionally, Mitsunobu's nephew Tan'yū

17

achieved recognition as a shogunal artist in Edo and effected a revival of the school in the seventeenth century. Many other Kanō artists followed Tan'yū to Edo, and by the second half of the seventeenth century there were four main branches *(oku eshi)* and fifteen minor branches *(omote eshi)* of the Kanō family in service to the Tokugawa shogunate. Moreover, by this time there were hundreds of other Kanō painters, distant relatives and disciples, who were not in service to the Tokugawa regime. These minor Kanō artists are generally called *machi Kanō* or "townsmen Kanō," since they provided paintings for city dwellers and provincial daimyo all over Japan.

Traditionally recognized by art historians as the three greatest Kanō painters are Motonobu (active mid-fifteenth century), Eitoku (active second half of sixteenth century), and Tan'yū (active mid-seventeenth century). These three men and their periods of activity represent the three high points in the Kanō school's history of painting activity. According to art-historical orthodoxy formulated in the first half of the twentieth century, the remaining Kanō artists were unprogressive, uninspired, or derivative, with only a few works singled out as meriting attention. By contrast, the Rimpa school, an art movement based on native Japanese styles and themes, has been given a position of superiority in seventeenth-century Japanese art, in spite of the fact that in the seventeenth century the Kanō school had many more painters, produced a larger volume of paintings, and had a stronger impact on contemporary society than the Rimpa school. This judgment of modern taste is comparable to the latter-day elevation of Impressionism over the French Academy. Nor have many modern scholars given the Kanō school credit as a source of inspiration and training for the many artists who passed through the portals of the school during their apprenticeship, later to achieve recognition outside the school. However, due to the work of contemporary Japanese scholars like Mr. Takeda, Kanō painting has become a viable field of inquiry.

———•••———

A great debt of gratitude is owned to John Rosenfield of Harvard University, who gave untiringly of his knowledge throughout the translation process. Mr. Hiroshi Ōnishi of the University of Tokyo kindly went over the manuscript checking the readings of certain names and passages, and clarified several points on the development of painting groups discussed in the Introduction. Finally, we would like to cite Michael Brase of Kodansha International for his diligent editing of the manuscript. The translators, of course, are responsible for all errors in the final text.

Catherine Kaputa

KANŌ EITOKU

1

ORIGINS OF THE KANŌ SCHOOL

The founder of the Kanō tradition, Kanō Masanobu (1434–1530), worked amid a variety of newly established schools of painting. In the native Japanese styles, for instance, which had fallen into disuse owing to the massive wave of Chinese influence in the thirteenth and fourteenth centuries, a movement to restore *yamato-e* traditions was started by artists of the Tosa family. Chinese-style painting, however, was far more fashionable, and several groups had begun to form. One of them stemmed from the powerful work of Sesshū Tōyō (1420–1506), whose career marked perhaps the full maturation of Japanese ink painting *(suibokuga)* in the Chinese manner. Another group was headed by members of the Oguri family, who attempted to preserve the lyrical, idealistic mode of landscape painting developed in the mid-fifteenth century by the master Tenshō Shūbun. A third group, called the Ami school, was led by the artists Nōami, Geiami, and Sōami, who worked as virtual curators and critics for the heads *(shōgun)* of the military regime. None of these groups, apparently, was able to set up an effective organization that persisted for very long.

While Kanō Masanobu had undertaken painting commissions solely as an individual artist, his son Motonobu established a system for training young artists and also for carrying out large painting projects in collaboration with many assistants. During the Temmon era (1532–55), for example, Motonobu received a coveted commission for a series of paintings at the Ishiyama Hongan-ji temple, Osaka. In order to meet the demands of this project, which was too large for him to complete alone, Motonobu employed a number of assistants. Unfortunately, none of these paintings have survived, but they must have been typical of the growing vogue for *shōhekiga*—that is, paintings on such formats as sliding screens *(fusuma)*, doors *(sugido)*, paper pasted directly on the wall *(kabe haritsuke)*, ceilings, and *tsuitate* (nonfolding standing screens).

Motonobu's methods, designed for relatively fast, high-quality production, were employed in another of the prime examples of his group workmanship, the paintings commissioned for the abbot's quarters *(hōjō)* of the Reiun-in (pl. 1), a subtemple of the Myōshin-ji in Kyoto. In this commission Motonobu brought to a high level the adaptation of Muromachi monochrome ink painting to its new function as mural decoration. Paintings were designed to span many panels of a single wall or to extend

over several sides of a room in one dramatic composition. It became common to place foreground elements or close-up views at either end of a composition, with a broadly conceived, panoramic view in the center. This format gave the compositions a sense of depth that helped to create an illusion of space and distance in room interiors.

Motonobu's role as the seminal figure in the history of the Kanō school is described in the *Honchō gashi* (History of Japanese Painting),* written in 1693 by Kanō Einō, who stated that with Motonobu the Kanō school became "the leader of all in the craft of painting." Motonobu was not only a gifted painter, but he was also a successful organizer in training artists and completing commissions, and attracted a large number of followers. While painting histories and biographies reveal that Masanobu had few followers, they indicate that Motonobu had a large group under his direction. This sixteenth-century method of group workmanship continued throughout the history of the Kanō school.

Motonobu's accomplishment in organizing the Kanō school into a powerful painting academy is even more impressive when one considers the chaotic political and social conditions of the time. Motonobu's lifetime is coeval with what the Japanese call the *sengoku jidai* ("age of the country at war"), an era of almost constant military and civil strife beginning with the Ōnin war (1467–77) and lasting for nearly a century. The fortunes and livelihood of many wealthy families became jeopardized as the country was ravaged by pitched battles and marauding soldiers; the economic order became more and more precarious. The *sengoku* age naturally had repercussions on the prosperity of the Kanō school. Contemporary documents state that the school was in such dire straits during this period that Motonobu and his disciples had to take refuge in the countryside and make a living by selling fan paintings.

Motonobu, like others of foresight and ability who were undaunted by agitated conditions, was only temporarily set back by the vicissitudes of the age. He first laid down a secure framework for the operation of his atelier. Historical records verify that he actively recruited patrons, something that Masanobu had not attempted. He began, of course, with high-ranking members of the shogunal regime and other military families; he approached the imperial family and the aristocracy; he elicited support from influential Buddhist temples of the Zen, Pure Land, and Nichiren sects. Motonobu even approached merchants who were gaining status as *nouveaux riches* in Kyoto and the port city of Sakai, near Osaka. His success in procuring commissions was not a result of his active program of solicitation alone; it can also be explained by his innovations as an artist—his invention of new compositional forms and means of expression.

Motonobu's employment of a large number of assistants was necessitated by the quantity and scope of the painting commissions that flooded his atelier. In order to preserve stylistic unity within each project, Motonobu developed a distinctive Kanō-school style to be followed by painters subordinate to him. The most striking mani-

* The *Honchō gashi* is also discussed in the Glossary.

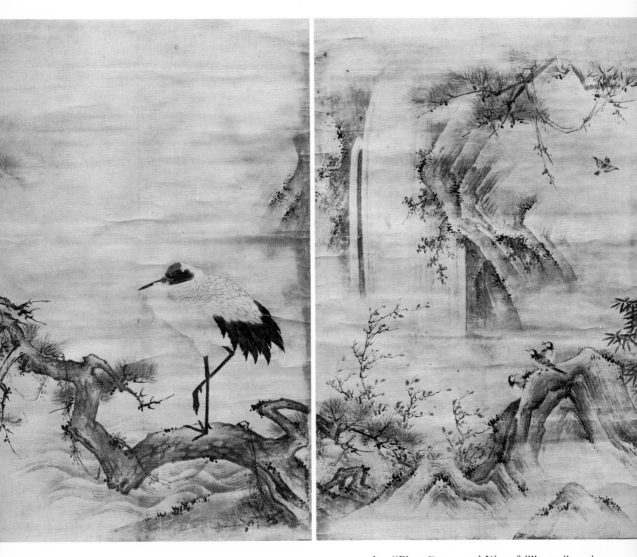

1. "Pine, Crane, and Waterfall"; attributed to Kanō Motonobu. Detail from *Landscape with Flowers and Birds*, a set of twelve hanging scrolls (originally *fusuma* panels). Ink on paper. H. 177.5 cm. Reiun-in, Myōshin-ji, Kyoto.

festation of this was his adoption of a classification of paintings into three styles of brushwork: *shintai,* the formal or angular; *gyōtai,* the "running" or semicursive; and *sōtai,* the "grass" or cursive—based on the flow of the ink and the character of the line formed. The origins of this terminology can be traced to China and the sister art of calligraphy. Later it was borrowed to describe expressive modes of brushwork in painting. There is a progression in the three modes from the clearly defined and detailed character of the *shintai* style, to the brevity and ease of execution of the *sōtai* manner, with the *gyōtai* or "running" style occupying a position in between.

While Motonobu can be accused of repressing the individuality of his disciples by limiting them to prescriptionlike painting formulas, he did enable the Kanō school to meet the demand for screen and wall paintings needed in *shoin* buildings.* Moreover, the fact that the Kanō school was capable of satisfying the expanding market enhanced its prestige in painting circles. The paintings done for the Reiun-in are a case in point (pl. 1). They exhibit each of the three brush styles; they were painted collaboratively by Motonobu and his assistants; they are superb in quality; and they possess a unified style that can well be described as Motonobu's.

Motonobu laid the stylistic foundation for the later Kanō school and established its high social prestige, but its greatest prosperity was achieved under Motonobu's grandson, Kanō Eitoku, during the major part of the brief Momoyama period (1573–99). An intriguing aspect of this period is that in such a short span of time—a quarter of a century—lived so many remarkable men. In the military sphere three formidable generals rose to dominate the government: Oda Nobunaga (1534–82), Toyotomi Hideyoshi (1536–98), and Tokugawa Ieyasu (1542–1616). Sen no Rikyū and Furuta Oribe revolutionized tea ceremony taste. Among painters, Eitoku and his circle were the trend setters. Painters who had originally been disciples of his grandfather Motonobu adopted the style of Eitoku, and some, like Gen'ya (active mid-sixteenth century) specialized in executing monumental paintings in imitation of Eitoku. Even Eitoku's father, Shōei (1519–92), worked steadily in support of the Kanō school after he passed on the headship of the main branch of the school to his son. By the Tenshō era (1573–92) there were a large number of Kanō relatives who apprenticed themselves under Eitoku, including his son Mitsunobu (1561–1608).

Perhaps one of Eitoku's most remarkable traits was his ability to amass a large number of talented artists under his direction or that of his close associates. What resulted was an executive structure, dominated by Eitoku, with a complex hierarchical stratification subordinate to it. Furthermore, Kanō school records indicate that many painters who founded individual schools, such as Hasegawa Tōhaku (1539–1610), Kaihō Yūshō (1533–1615), and Unkoku Tōgan (1547–1618), initially studied in a Kanō atelier. Thus, it seems that Kanō school influence permeated the entire fabric of Momoyama art.

24 * See Glossary for such terms as *shoin.*

2

KANŌ EITOKU

Kanō Eitoku was born in 1543, on the thirteenth day of the first month. He was the eldest son of Shōei, whose lineage formed the main branch of the Kanō family. As a youth, Eitoku went by the name of Genshirō; later he adopted the name Kuninobu and used the *gō,* or artist's name, Eitoku. His early training as a painter was received, not from his father, but at the hands of his grandfather Motonobu, who died when Eitoku was sixteen—facts recorded by the *Honchō gashi.* Furthermore, another early document, the seventeenth-century *Tansei jakuboku shū,* a compilation of the biographies of Japanese painters, written by Kanō Ikkei (1599–1662), states that Eitoku, even as a child, promised to be a better artist than his father Shōei. As a result, it was with Eitoku that Motonobu's expectations for the future of the Kanō school rested.

The oldest written account of Eitoku may be the record of the fact that in 1552 Motonobu went with his grandson to call upon the shogun Ashikaga Yoshiteru, who had returned to Kyoto after having taken refuge in the Ōmi district. This visit was recorded in the diary of the nobleman Yamashina Tokitsugu *(Tokitsugu-kyō ki),* but the grandson's name is not given. Of course, it is possible that the grandson was a son of Kanō Yūsetsu (1514–62) or Kanō Hideyori (d. 1557), Motonobu's first and second sons. However, Eitoku's reputation as a child prodigy has been preserved in many family records, and the fact that he became the direct heir to the Kanō school succession further supports the possibility that, even at the age of nine, he would be the grandson singled out by the aged Motonobu for this important state audience.

JUKŌ-IN

Although Eitoku was later to develop into a revolutionary artist, he was still bound by the constraints of Muromachi painting standards and family tradition when he undertook his first major commission, at the Jukō-in. A subtemple of the vast Daitoku-ji monastery compound located on the northwestern outskirts of Kyoto, the Jukō-in was built in 1566 as a family chapel for the recently deceased Miyoshi Nagayoshi (alternately, Miyoshi Chōkei; 1522–64). The Miyoshi were one of the leading samurai families of the Momoyama period, and the intense struggle for political power among

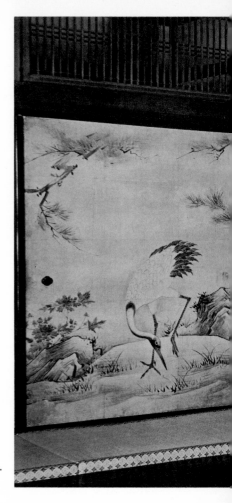

2. Partial view of the main room in the *hōjō*, Jukō-in. Daitoku-ji, Kyoto.

such families served as a stimulus to the arts: they vied with each other for supremacy in the artistic and religious arena as well as the political.

When Eitoku began the Jukō-in paintings he was only twenty-three years old, and he worked on them over a three-year period with his father, Shōei—a further example of collaborative Kanō family enterprise. Many early records state that the thirty-two *fusuma* paintings in the Jukō-in were done by Eitoku alone. But today most scholars are agreed in assigning only the series *Landscape with Flowers and Birds* and *The Four Elegant Pastimes* to his brush (pls. 2–4, 11–14, 18–19). These are found, it is important to note, in the two largest rooms, including the sixteen-panel central room, while the work of Eitoku's father, Shōei, is in rooms of less impressive dimensions.

EITOKU'S RISING REPUTATION

While still in his twenties Eitoku became an artistic celebrity. Sponsorship came from all quarters of the ruling elite—leading military chieftains *(daimyō)* and members of the imperial court. For example, Eitoku was patronized by the court noble Konoe Sakihisa (1536–1612), a member of the Konoe family that for centuries had provided

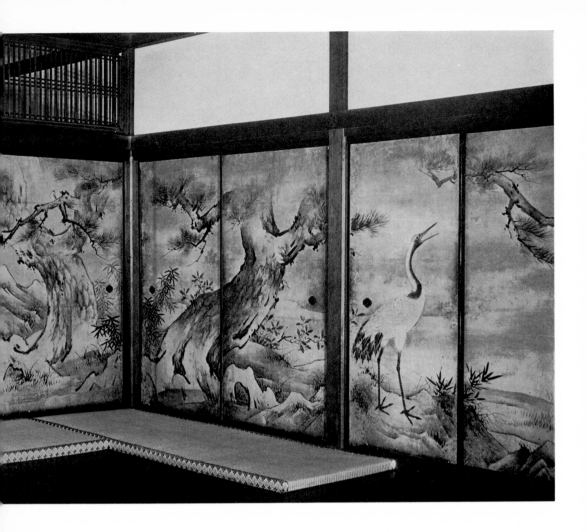

officials for the imperial regime. In 1567, the year after he began the Jukō-in commission, Eitoku and three assistants executed *fusuma* paintings for the public rooms in the Konoe mansion. An account of Eitoku's activity here is related in Yamashina Tokitsugu's diary. Tokitsugu notes, for instance, in an entry in 1567, that he chatted with Eitoku and the other painters. Later in the same year, and then again in the second month of the following year, he recorded that Eitoku was still working on the paintings. None of these paintings, however, are extant. Eitoku also made preparatory drawings for the designs on the *kuzubakama* (a kind of culottes for men, made of arrowroot fiber) used by the Konoe family.

Surely the most illustrious of Eitoku's early sponsors was Oda Nobunaga (1534–82), a samurai of obscure origins who became supreme military commander and the *de facto* ruler of Japan by the mid-1560s. It is recorded in two contemporary sources that in 1574 Nobunaga gave two pairs of screens to Uesugi Kenshin, one on the theme of *The Tale of Genji,* the other depicting scenes in and around Kyoto.* According to other sources, the screens were presented in 1573, but the later date is more likely.

* Such themes are discussed in the Glossary.

3. "Birds in a Plum Tree," by Kanō Eitoku. Detail
from *Landscape with Flowers and Birds*, a set of sixteen
fusuma panels. Ink and gold on paper. H. 175.5 cm.
Jukō-in, Daitoku-ji, Kyoto.

Two small birds are perched on the trunk of a gnarled
old plum, the one on the left gesturing excitedly, it seems,
to its mate concerning some newsworthy event. The full-
bodied trunk juts out over the water's edge in a con-
torted profile, while its angular branches, teeming with
blossoms, rise and bend in many directions. One branch,
to the left of the detail represented here, dips into the
water, creating ripples. The dynamic, powerful brush-
work and resplendent colors underscore Eitoku's self-
confidence as an artist. Moreover, a sense of near and
far as well as three dimensionality in space is achieved
through the intersections of the various branches and
the clearly perceived volume of the rotund trunk. While
the kinetic movement of the young plum branches may
seem unduly theatrical, the intense expression of this
section is resolved by the surrounding scene (pl. 4). (See
also pls. 2, 11–13, 18.)

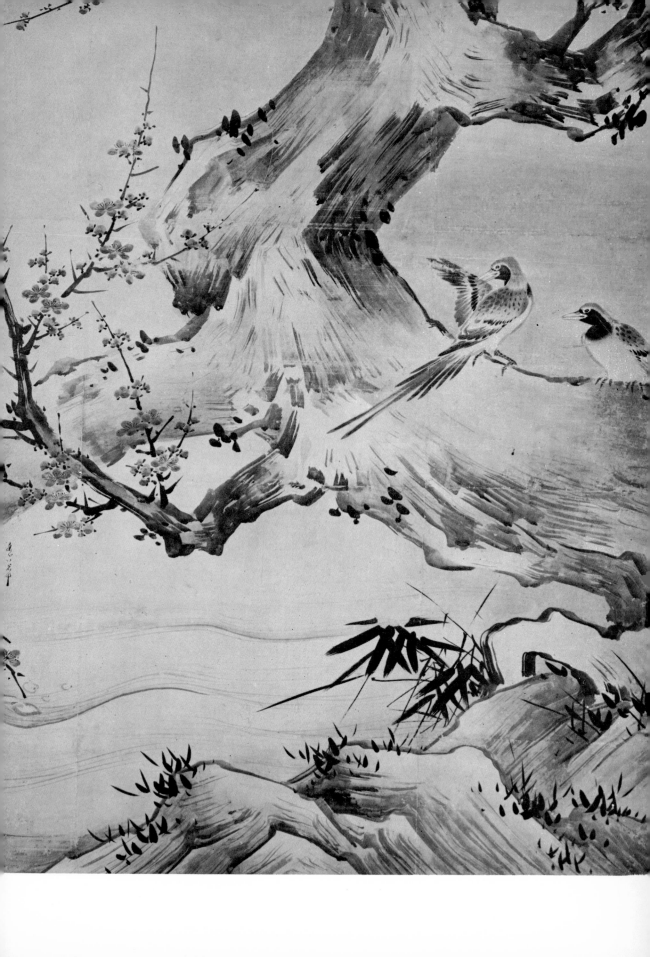

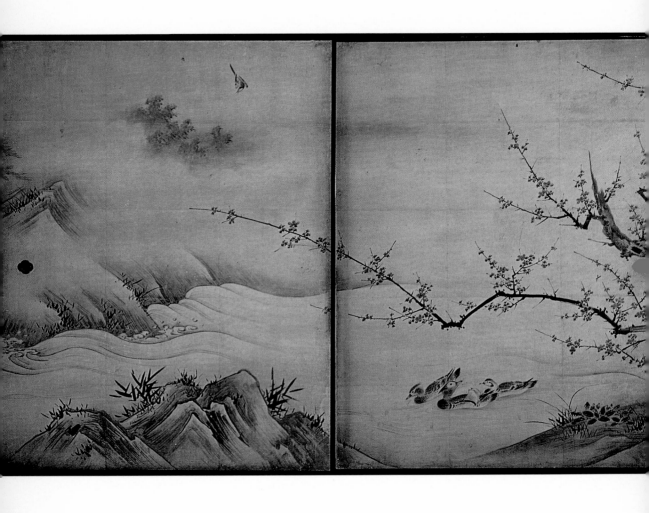

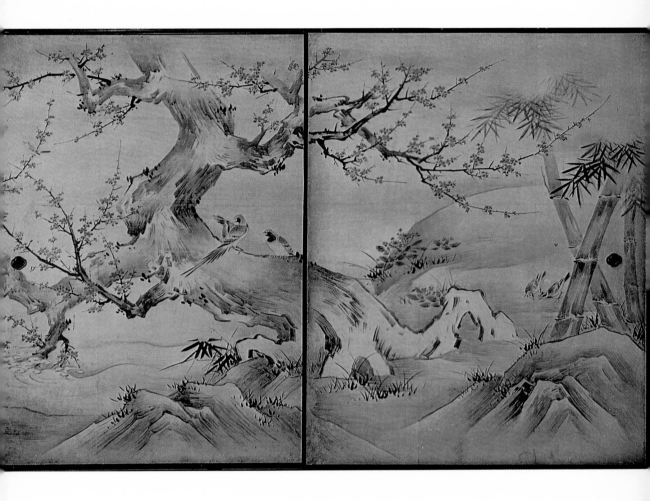

4. "Plum Blossoms and Birds," by Kanō Eitoku. Detail from *Landscape with Flowers and Birds*, a set of sixteen *fusuma* panels. Ink and gold on paper. H. 175.5 cm. Jukō-in, Daitoku-ji, Kyoto.

These four *fusuma* panels from the east wall of the *Landscape with Flowers and Birds* screens have as their central subject an immense plum tree. The efflorescence of Eitoku's youth is expressed in his sensitive interpretation of the great tree, in the tension established between the age-weary posture of the gnarled trunk and the light, gesturing limbs in full blossom. As opposed to the minute and stiff brushwork of *The Four Elegant Pastimes*, this work was done in a careless, coarse manner which imparts a feeling of vivacity and spirited movement. Care has been lavished on the depiction of wildlife in the scene, like the pair of birds perched on the tree trunk and the geese sporting in the pond, and they afford a fitting completion to the design of the painting. This work is especially important as an indicator of the beginnings of Eitoku's monumental style. (See also pls. 2–3, 11–13, 18.)

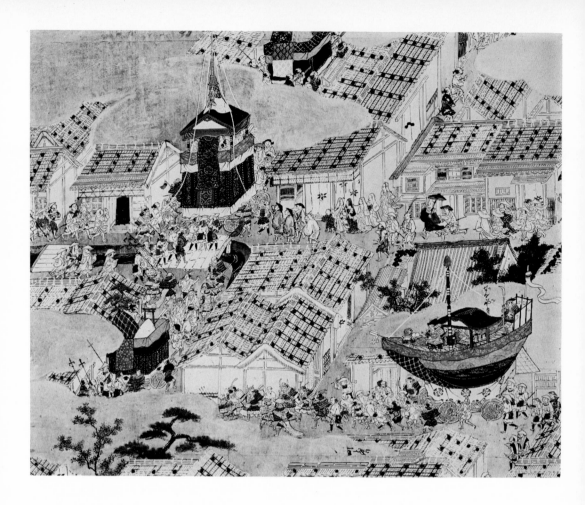

The screens *Scenes in and around Kyoto* (pls. 5–7, 15–16) are particularly relevant to this study, for they have remained in the Uesugi family collection throughout the years, while the *Genji* screens have disappeared. Despite the general agreement that these are the works given to Uesugi Kenshin in 1574, there has been much discussion over when they were actually painted. Some scholars have observed that the screens record the appearance of residences of military men of the early years of the Eiroku era (1558–70). If one follows the account set forth in the *Uesugi nempu* (Chronicles of the Uesugi Family), the screens were executed by Eitoku when he was about twenty years old (c. 1562–63), then acquired by Oda Nobunaga when he visited Kyoto in 1568, and later given to Uesugi Kenshin. Contrariwise, the *Hokuetsu kasho* (Family Records of the Daimyo of Esshū) states that the screens *Scenes in and around Kyoto* were the direct result of a meeting between Eitoku and Oda Nobunaga. In this explanation, Eitoku would have painted them not long before 1574, the year of their presentation, when he was thirty-one, using a model based on the topography of the city as it existed at an earlier date.

AZUCHI CASTLE

The introduction of firearms in the 1540s by the Portuguese proved to be a watershed in Japanese history. Not only did the use of explosive weaponry irrevocably alter the

5. *Scenes in and around Kyoto,* by Kanō Eitoku. Detail from the left screen. Pair of six-fold screens. Ink and color with gold-leaf ground. H. 160.5 cm., w. 323.5 cm. (each screen). Private collection, Japan. (See also pls. 6–7, 15–16.)

traditional methods of warfare, it also necessitated the development of a new type of defensive architecture able to withstand mortar attack. Castles were now built on massive stone bases with an elaborate system of fortifications, and to decorate the dimly lit interiors of these structures, gold-background paintings were favored.

One of the earliest and most innovative of these defensive structures was the seven-story Azuchi Castle, built by Oda Nobunaga on a rise of hills overlooking the eastern coast of Lake Biwa. Azuchi Castle contained Nobunaga's residence and the offices of military and civil administration. It was erected in 1576 and Eitoku was put in charge of decorating the vast inner rooms, a project that consumed his energies until 1579. That Eitoku concentrated solely on this project during these years is learned from his younger brother Sōshū's last will and testament, which states that Eitoku entrusted him with the work on other Kyoto mansions during the three-year interval. It also seems likely that a number of Kanō school artists were assigned painting projects at Azuchi Castle under Eitoku's supervision.

The extraordinary enthusiasm that Eitoku devoted to this commission was due to the trust and favor bestowed on him by Nobunaga. Moreover, it is clear that Eitoku's scheme of paintings for the castle rooms met with Nobunaga's satisfaction, for it is recounted that Nobunaga proudly led a group of visitors through the gorgeous inner rooms after their completion.

The decoration of the rooms in the castle donjon *(tenshukaku)* is described in the *Shinchō-kō ki* (The Biography of Nobunaga), written by one of Nobunaga's officers, Ōta Gyūichi (1527–1610?). The ninth chapter chronicles the screen paintings of the second through seventh levels and attributes to Eitoku in particular the painting of plum trees in monochrome ink in a large, twelve-mat room on the second floor. All of the screen and wall paintings at Azuchi Castle were executed in polychrome with gold backgrounds.

In the decoration of Azuchi Castle a new epoch in artistic conception appeared in Japan, an age of all-encompassing decorative schema for architectural interiors. Practically no interior surface of this castle was left unadorned: *fusuma,* pillars, ceilings, and transoms *(ramma)* were decorated with paintings or carvings. The reception rooms *(zashiki)* on the second floor were painted in black lacquer to harmonize with the colorful screen paintings and their sparkling gold backgrounds; on the sixth floor the outside pillars were painted cinnabar red while the inside ones were done in gold; and on the seventh floor both the inside and outside of the reception room were done in gold, with the pillars in black.

At New Year's time, 1578, when many of the paintings were yet incomplete, Nobunaga played host to an assembly of vassal military leaders, displaying for their enjoyment the *Famous Places of the Three Lands* done by Eitoku in deep, vibrant colors for the imperial reception chambers *(onari no ma)* of Azuchi Castle. On New Year's Day of the next year Nobunaga's guests once more celebrated the day by admiring Eitoku's gold screens in the inner castle. The subjects of the screens ranged from

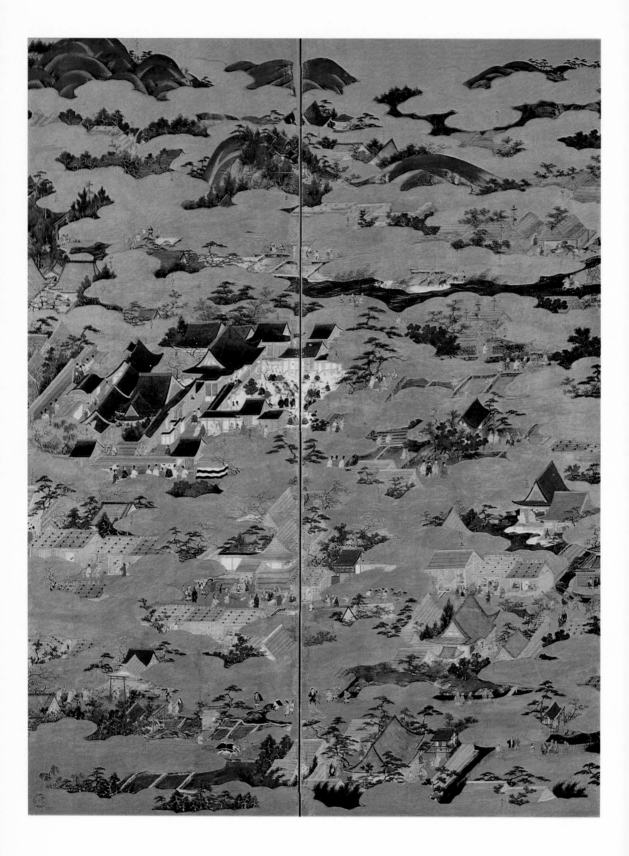

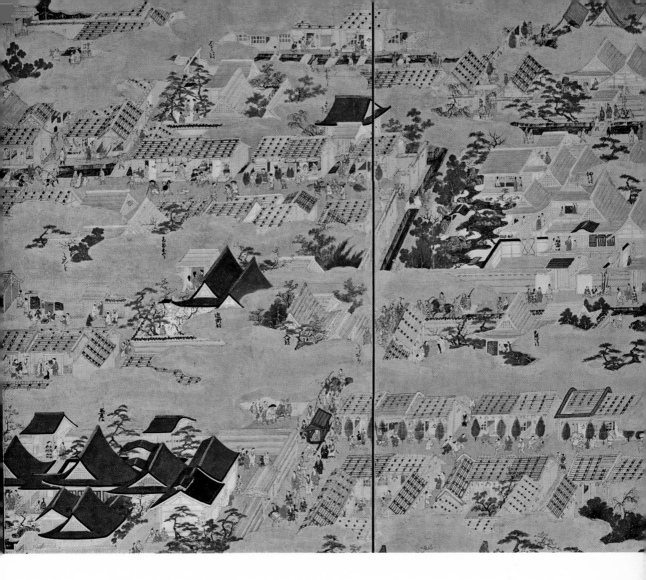

6. *Scenes in and around Kyoto*, by Kanō Eitoku. Detail. Pair of six-fold screens. Ink and colors on gold-leaf ground. H. 160.5 cm., w. 323.5 cm. (each screen). Private collection, Japan.

Illustrated here are the two leftmost panels of the left screen (pl. 15) of this pair of six-fold screens, which depict the imperial palace as the center of Kyoto proper (*rakuchū*) and Mount Hiei as a backdrop for the suburbs (*rakugai*). The season is spring, with the resplendent red and white plum blossoms of the capital in full bloom and bright green verdure spotting the countryside. Before the Buejin gate of the Shiba family mansion there are people disporting themselves at the cockfighting match (*tori awase*) held in the third month. In the south court of the Shishinden palace, officials are gathering for the ceremonial banquet given in the middle of the first month. (See also pls. 5, 7, 15–16.)

7. *Scenes in and around Kyoto*, by Kanō Eitoku. Detail.

One corner of the northern section of the capital is portrayed in this detail from the right screen (pl. 16). In the lower left corner is the Kubōtei, the mansion of the Ashikaga shogun. In the upper right corner, depicted in a conspicuously large manner, is the mansion of the Hosokawa family, who held a high-ranking position in the military government. Surrounding these can be seen the mansions of the Konoe and Miyoshi families. Since it is late in the year the activities depicted are the *ohitaki* ("fire-lighting") of the eleventh month, and the *sekizoro* festival (customarily, people wore red silk masks and went around town yelling *sekizoro gozareya* ["It's the end of the year"]). The pine and bamboo decorations (*kadomatsu*) traditionally displayed at New Year's time are shown. (See also pls. 5–6, 15–16.)

Chinese landscapes, such as the eight views of the Hsiao and Hsiang rivers, to scenes of flowers and birds or trees and animals in partial landscape settings. Chinese worthies and historical figures were thought to create a milieu appropriate for the private living quarters.

Pleasing a formidable personality like Nobunaga was undoubtedly difficult. However, after the completion of the Azuchi interiors Nobunaga demonstrated his satisfaction by conferring on Eitoku the title of *hōin* (Seal of the Law) and granting him an annual stipend of three hundred *koku* (a total of approximately 5,400 liters) of rice. Further, in midyear 1581 Nobunaga rewarded everyone from Eitoku and his son Mitsunobu to the carpenters from Nara with *kosode* (short-sleeved kimono). Although the much-admired Azuchi-Castle paintings, completed in 1579, boosted Eitoku's reputation, they were destroyed only a handful of years later, in 1582, when the castle was demolished following the tragic demise of Nobunaga.

EITOKU AND HIDEYOSHI

The process of national unification begun by Oda Nobunaga was completed by his successor, Toyotomi Hideyoshi (1536–98). Hideyoshi's rise to power was extraordinary. He began his career in the lowly position of temple servant, then became sandal-bearer for Oda Nobunaga, a position that served as a springboard for Hideyoshi's own military career. Like Nobunaga's, Hideyoshi's dominance extended beyond the battlefield. His jaunty taste set the trend in painting, interior design, pottery, and fashions, and the castles and palaces he built stimulated the arts as a whole. He drew into his circle of intimates the leading taste-makers of the day; in the fine arts his favorite painter was Kanō Eitoku, and in the tea cult his mentor was Sen no Rikyū (1522–91).

There is proof that Hideyoshi's relationship with Eitoku was established long before Hideyoshi succeeded Nobunaga as the virtual military dictator of Japan in 1582. Evidence of an early liaison can be deduced from the lacquer stirrups and saddle with reed design made in the first month of 1577, on which is affixed the signature of Hideyoshi, then a subordinate of Nobunaga. The preparatory drawing is known to be by Eitoku (pl. 8). There is also the legend that, in 1582, after Hideyoshi suspended the water attack on Takamatsu Castle in Bizen Province, and hurriedly devised a settlement with the Mōri clan, the screens that he presented as a peace offering to this powerful daimyo family in western Honshu were the *Chinese Lions* done by Eitoku, now in the Imperial Household Collection (pl. 9).

During the construction of the Osaka Castle, the Jurakudai, and other vast palaces built by Hideyoshi, Eitoku oversaw the production of the brightly colored paintings with gold-leaf backgrounds. These lavishly decorated residences served as models for the palaces of lesser daimyo who were eager to emulate Hideyoshi's flamboyant tastes. Thus, the demand for Kanō school paintings must have been immense. It is known,

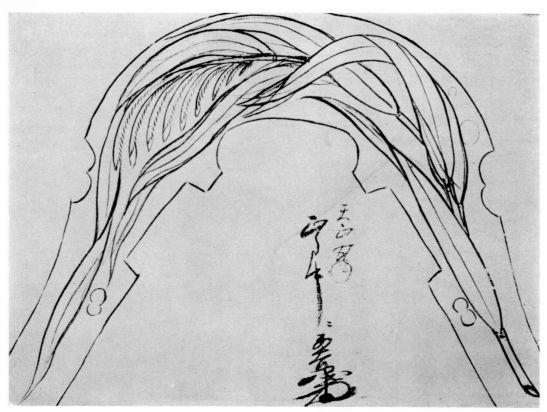

8. Preliminary drawing for a lacquer saddle with reed design; attributed to Kanō Eitoku. Tokyo National Museum.

for example, from a letter of 1583 that Eitoku, fearing a flood of forthcoming new commissions, urged Tosa Mitsuyoshi (1539–1613) to come to the capital to paint.

Hideyoshi began the construction of Osaka Castle in the autumn of 1583, and its major section, the donjon *(tenshukaku),* was completed in the fourth month of the succeeding year. In scale alone it far surpassed Azuchi Castle. The outer walls of Osaka Castle enclosed some 111 hectares, and the base measured over 1.5 kilometers in each direction. According to the *Honchō gashi,* the huge screens of the rooms comprising the donjon were entrusted to Eitoku and his atelier. All of these paintings have been destroyed.

The same fate was met by the screen and wall paintings executed by Eitoku for Hideyoshi's mansion called the Jurakudai (Palace of Assembled Pleasures). It was built in Kyoto on land within the old boundaries of the imperial palace. The plan of the Jurakudai was exceptional. In addition to the manifold living chambers, its grounds contained a tea house, a performing stage, a boathouse, music rooms, and other luxuries. Although work on this structure had just been begun in 1587, Hideyoshi urged his workmen to have his palace completed by the fourth month of 1588 in preparation for a five-day state visit by the emperor Goyōzei (r. 1586–1611). Hideyoshi went to great pains to have the inner rooms regally decorated in honor of this visit, especially the screens of the great hall *(ōhiroma),* which were accomplished by Eitoku and his assistants.

37

9. *Chinese Lions*, by Kanō Eitoku. Six-fold screen. Ink and colors with gold-leaf ground. H. 225 cm., w. 459 cm. Imperial Household Collection.

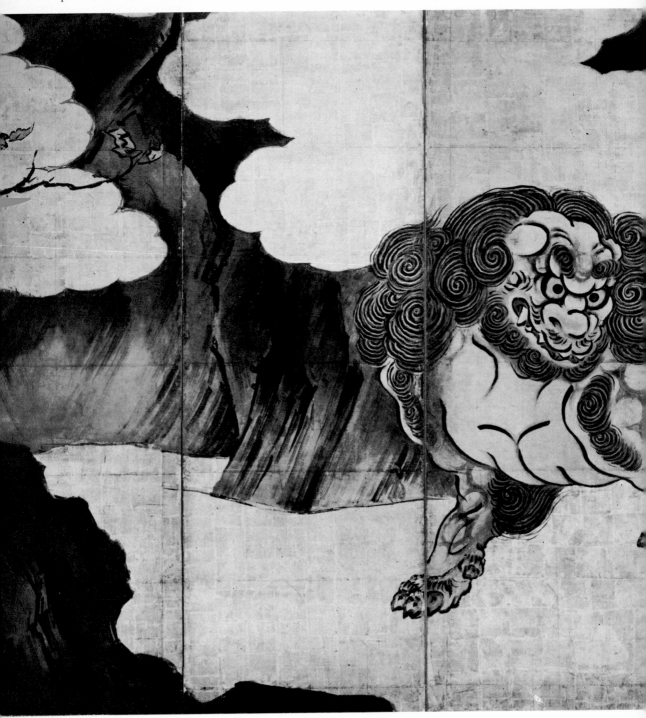

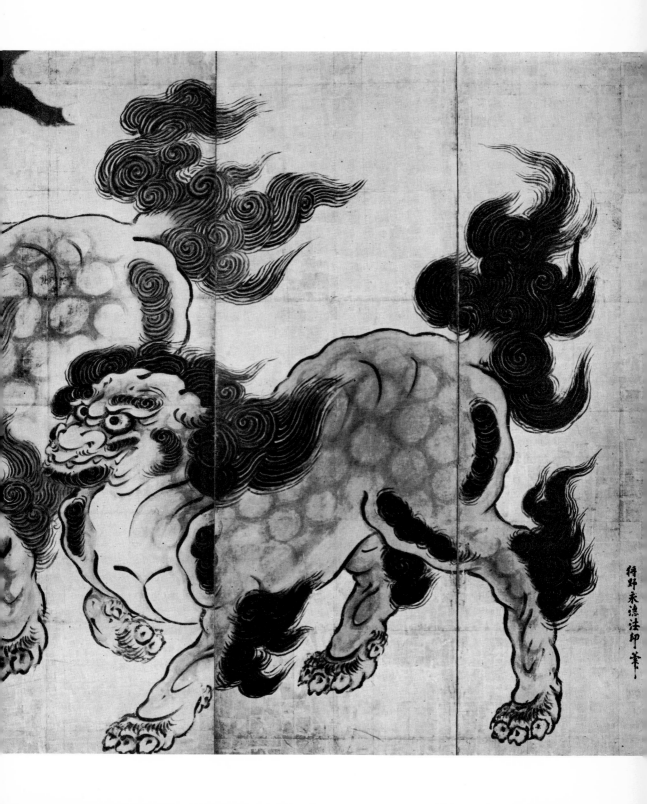

狩野永德法印筆

10. *Pine*; attributed to Kanō Eitoku. Detail.
Four *fusuma* panels in the great entrance hall
(*ōgenkan*). Ink and colors with gold-leaf ground.
H. 172.5 cm., w. 111.5 cm. (each panel). Myōhō-
in, Kyoto.

Eitoku's next major commission was for the Sentō palace of the retired emperor
Ōgimachi (r. 1560–86). Its construction took place in 1584–86, and a 1586 entry in
Yoshida Kanemi's diary *(Kanemi-kyō ki)* states that the paintings were by Eitoku.[1]*
This structure is referred to, some years later, in a letter dated 1611 from Hino Teru-
suke to Konchiin Sūden, which discussed the retired emperor's palace as having been
built under the direction of Hideyoshi's magistrate Maeda Gen'i (1539–1602) and
containing marvelous gold-background paintings by Eitoku.

To repair the ceiling painting of a dragon in the *hattō* (main hall) of the Tōfuku-ji
in Kyoto, it was again Eitoku who was summoned by Hideyoshi for the project. The
Tōfuku-ji's dragon ceiling had been conceived about two centuries earlier by the
famous artist Minchō (1352–1431), but it had subsequently been damaged by fire.
Eitoku began working in 1588, but soon fell ill and was forced to discontinue the
project. Following the *Honchō gashi's* account, Eitoku had finished the clouds and
had just begun work on the dragon when he collapsed. He entrusted the plans for the
remaining work to Kanō Sanraku (1559–1635), his adopted son. No doubt Eitoku's
health was adversely affected by the massive painting commissions that had been
consigned to him in rapid succession over the last few years. The scale of the Tōfuku-ji

40 * All numbered notes are to be found on page 162.

project, for one, had been immense. The dragon's head measured over two meters in length and the body over nineteen meters.

By the beginning of the next year, 1589, Eitoku had sufficiently regained his health to begin work on the Tenzui-ji, a subtemple in the Daitoku-ji compound, built by Hideyoshi in memory of his deceased mother, Ōmandokoro. The paintings made for this chapel were of immense scale and more elegant than those normally found in a Zen temple. The *Hōzan shishō*, an Edo-period compilation of selected documents of the Daitoku-ji temple, is detailed with regard to the scheme of decoration in this chapel. Following this source, Eitoku can be credited with the paintings of pines in the central room, bamboo in the *rei no ma*, cherry blossoms in the patron's room, chrysanthemums in the *ihatsu no ma*, and the monochrome ink screens of landscape in the main *shoin*, as well as *The Three Laughers of Tiger Valley* in the east room and the Mount Fuji scene in the north room. The fact that the paintings of flowering trees and plants in the above rooms were all in colored pigments with a gold ground is recounted in the temple's records. Since the screen and wall decoration in each room at the Tenzui-ji was generally devoted to a single subject, it became common to refer to an individual room by its thematic decor; for example, the central room is frequently called simply the pine room. One can see a parallel to this in two rooms on the fourth floor of Azuchi Castle that came to be known as the pine room and the bamboo

41

room; their decoration was probably similar in style and subject to the rooms in the Tenzui-ji.

It seems that Eitoku's health had clearly taken a turn for the better, for in 1589 he took command of the work on the imperial palace *(dairi)*, which extended through 1590. In a diary entry made in the sixth month of 1590, from the *Oyudono no ue no nikki* (Diary of the Imperial Servants), it is reported that the court noble Kajūji Haretoyo showed the emperor how the *fusuma* paintings by Eitoku were being executed in the imperial palace. However, the sovereignty of Eitoku and the Kanō school as the sole painters for the imperial palace project was in danger. Later that year, during the eighth month of 1590, Maeda Gen'i had solicited the Hasegawa school to paint the screens in the auxiliary living quarters *(tainoya)* of the imperial palace. This occurrence ired the proud Eitoku, who would not accept this turn of events without a struggle. According to Haretoyo's own diary *(Haretoyo nikki)*, Eitoku, in the company of his son Mitsunobu and brother Sōshū, went to complain about the Hasegawa commission. Haretoyo, through the intercession of the court noble Kujō Kanetaka (1553–1636), achieved the withdrawal of the Hasegawa contract. Elated with their success, Eitoku and Mitsunobu celebrated their victory with drinks and toasts in Haretoyo's palace.

Eitoku died in the ninth month, fourteenth day, of 1590. According to Haretoyo's diary, Mitsunobu completed Eitoku's unfinished work in the imperial palace. However, without the authoritative leadership and ambition of Eitoku, the eminent position of the Kanō school was endangered. Mitsunobu, who succeeded his father as the head of the Kanō school, had neither his skill nor executive abilities. According to the *Honchō gashi,* Mitsunobu directed his energies toward mastering the school's methods of painting, aided in his studies by the many disciples of Eitoku. The number of Kanō commissions diminished, and some of their former patrons, so loyal to the Kanō atelier under Eitoku, sought other artists for their painting projects. For example, the Toyotomi family requested the school of Hasegawa Tōhaku to do the painting in the Shōun-ji, a memorial temple erected upon the early death of Hideyoshi's eldest son, Sutemaru, in 1592. Such an occurrence could not have happened under Eitoku's reign.

Despite the fact that Eitoku died at the premature age of forty-eight, he had an immensely prolific career. It is curious to note that Eitoku's father, Shōei (1519–92), was in good health at the time of his son's death. When Shōei himself was forty-eight, he was working on the screen paintings at the Jukō-in with Eitoku. Eitoku's chief competitors, Hasegawa Tōhaku (1539–1610) and Kaihō Yūshō (1533–1615), outlived him by a few decades and went on to complete major commissions, while the Kanō school's painting projects suffered setbacks. After the loss of Eitoku it seems that the Kanō school was hampered by the conservatism of Mitsunobu and his circle, with the more innovative work of Sanraku and his followers providing the only stopgap to the school's declining fortunes.

3

THE EITOKU STYLE

Eitoku's painting matched the assertive spirit of his age and appealed to the taste of the military leaders of the Momoyama period. But, like many of the warriors themselves, much of Eitoku's work met an untimely end: only a tiny fraction of his entire production remains. Nothing survives of his major screen commissions in the Azuchi and Osaka castles and the Ōgimachi and Jurakudai palaces, the most opulent structures of his age. Furthermore, and equally as unfortunate, there is little documentation to prove that many of the paintings that have come down to us in his name are actual Eitoku creations. A few paintings can be accepted as authentic, however, and through them it is possible to attain a clear understanding of Eitoku's work.

At the beginning of his career, Eitoku painted in the style of his grandfather Motonobu. His early works retain the precise, or *saiga,* style that characterizes the work of the older man. Nonetheless, the monumental, or *taiga,* style that Eitoku personally developed has its roots in this early work. The later *taiga* style, which served as a model for future generations of Kanō artists, is characterized by compositions and pictorial themes that are monumental in spirit and executed with a vigorous handling of the brush. Motonobu had used color in his compositions, but it had always been conservatively applied in keeping with Chinese models. Eitoku, in his monumental decorative works, expanded his range of colors and juxtaposed them with shining gold backgrounds for a new and impressive effect.

The new style was widely adopted, and unsigned works from this period painted in Eitoku's characteristic style were often attributed to him in later years. This is particularly true of the Edo period, when many paintings in the Momoyama style were given "certificates of authenticity" *(kiwamegaki)* by the painter-critics Kanō Tan'yū, Kanō Yasunobu, and Kanō Einō, or were impressed with Eitoku's "Shūshin" (alternately read "Kuninobu") seal. It was during this period that the screens of countless Kyoto temples came to be considered works of Kanō Eitoku.

In order to determine which of these attributions are valid, a standard group of authentic works for comparative purposes would be necessary. But such a group does not exist. Opinion today is by no means unanimous on even such previously con-

fident attributions as the *Chinese Lions* in the Imperial Household Collection (pl. 9). Also called into question are *Pine and Hawk* (pls. 20, 22) of the Tokyo University of Fine Arts, which bears a certificate attributing it to Eitoku; *Hermits* (pls. 97, 100) in the abbot's quarters of Nanzen-ji; and *Cypress Trees* (pls. 23–24) in the Tokyo National Museum—all of which have been attributed to Eitoku for centuries.

A primary source of information on Kanō Eitoku is the *Honchō gashi* (History of Japanese Painting), one of the major early documents of the history of Japanese painting. According to its author, Kanō Einō (1631–97), Eitoku developed the monumental style in response to the ever increasing number of commissions that flooded his atelier. Einō writes that as the warlord Toyotomi Hideyoshi and his subordinates demanded larger and more elaborate decoration for their mansions, Eitoku found it impossible to continue working in the time-consuming *saiga* style and began to rely upon the more expansive and cursive technique that Einō labeled *taiga*. The *Honchō gashi* further states that Eitoku's later work became immense in scale—series of panels with pine and plum trees extended laterally for over six meters and human figures reached 90 to 130 centimeters in height. Brushstrokes, characterized as rough, wild, and free of superfluity, were executed in part with coarse straw brushes *(warafude)*. Einō concluded that these elements added a new dimension to the traditional Kanō style, and that Eitoku's excellence came from the unorthodox strength of his brushstroke, his individuality of mood, and his skilled use of the *taiga* style.

THE FUSUMA PAINTINGS IN THE JUKŌ-IN

Eitoku's early work may be seen in two series of sliding-panel *(fusuma)* paintings in the abbot's quarters of the Jukō-in, a subtemple in the compound of the great Zen monastery of Daitoku-ji. The paintings are at once conservative and innovative. The eight-panel screen entitled *The Four Elegant Pastimes* (pls. 14, 19) in the patron's room *(danna no ma)* represents the *saiga* style Eitoku inherited from his grandfather. The sixteen-panel *Landscape with Flowers and Birds* (pls. 2–4, 11–13, 18) in the main room *(naka no ma)* incorporates elements of Eitoku's nascent monumental style. The Jukō-in was erected in 1566 and the screen paintings, by Eitoku and his father, Shōei, are believed to have been done at the same time.

The Four Elegant Pastimes depicts the traditional pursuits of cultivated Chinese gentlemen—zithern *(kin)* music, chess *(ki)*, calligraphy *(sho)*, and painting *(ga)*. The painting, carried out in the precise *saiga* style, is quiet, dignified, and refined. Form is delineated through rigid line; figures are portrayed with detail and clarity. But though the elements of the painting are in themselves superbly executed, they do not completely relate organically; the scenes of the zithern and chess board, writing table and standing screen lack cohesion. Moreover, the zeal for precision in the depiction of rocks and trees is overly strong at times. Clearly Eitoku was strongly influenced by the detailed technique of his mentor Motonobu. This painting is closely related to a

work of the same theme attributed to Motonobu in the abbot's quarters of the Reiun-in, but Eitoku's painting is quite stylized in comparison.

All told, *The Four Elegant Pastimes* reflects the competent control of the *saiga* technique Eitoku had developed by his early twenties. But even as Eitoku completed this work he was developing the less detailed, more monumental and personal style that gave freer rein to his creative energy. This is seen in the companion work in the Jukō-in, *Landscape with Flowers and Birds* (pls. 2–4, 11–13, 18).

Comprised of sixteen *fusuma* panels, *Landscape with Flowers and Birds* depicts scenes of the four seasons. The compositional cycle begins at the east wall with spring, evoked by a massive flowering plum tree (pls. 3–4). The limbs of the plum are charged with vitality; their exuberant movement contrasts with the contorted trunk whose ancient roots are firmly anchored in the rock-strewn earth. Eitoku's coarse and rapid brushstrokes and constant variation of ink tone add to the energy and movement of the scene. This style of brushstroke, known as the *sōtai* or "cursive mode," is quite different from the minute and stiff *shintai* brushstroke seen in the figures in *The Four Elegant Pastimes*. The vigor of the composition and the free brushstroke of *Landscape with Flowers and Birds* combine with its monumental dimensions to transcend the artist's earlier, more subdued manner. Gold dust is added only in the open spaces of the work, and the deft brushwork and evocative ink tone match the atmosphere of the room itself.

In the northeast corner of the room, spring changes into early summer. The transition between the two compositions is effected by means of a jagged rock that cleaves a frothing stream into two divergent channels (pl. 12). Atop the rock a wagtail perches, the quiet, immobile form of the bird contrasting with the rushing waters. The bird is emphasized through detailed, precise brushstrokes that counter the broad and free handling of its natural surroundings, the scene incorporating both the precise and the cursive styles within a single composition.

Two massive pine trees in the northwest corner (pl. 2) form the next focal point of the composition. The pine of the north wall resolves the movement begun by the plum of the east wall, and the other pine, on the west wall, begins a new motion leading to the south. Together the two pines form a central axis for the entire composition, each tree accompanied by a graceful crane, the bird on the west wall bending its neck to earth, that to the north (pl. 11) crying at the sky. The latter pose is reminiscent of the celebrated crane by the Southern Sung master Mu Ch'i, also in Daitoku-ji. The motif was long a favorite of the Kanō school and a second similar crane can be seen in the Reiun-in screen series attributed to Motonobu. Whether because of its large scale or because it attempted to reflect earlier crane paintings exactly, the Jukō-in crane lacks the intensity of expression seen in the geese in the last section of the composition (pl. 13). The two geese are incisively captured as they call to their companions aloft in the late autumn sky. These screens, called "Wild Geese in Rushes," are among the most charming of the series.

45

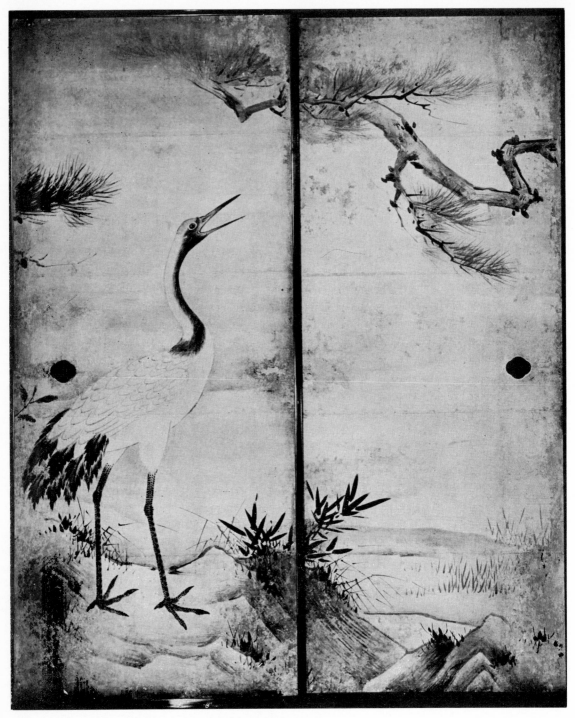

11. "Crane and Pine Tree," by Kanō Eitoku. Detail
from *Landscape with Flowers and Birds*, a set of sixteen
fusuma panels. Ink and gold on paper. H. 175.5 cm. Jukō-
in, Daitoku-ji, Kyoto. (See also pls. 2–4, 12–13, 18.)

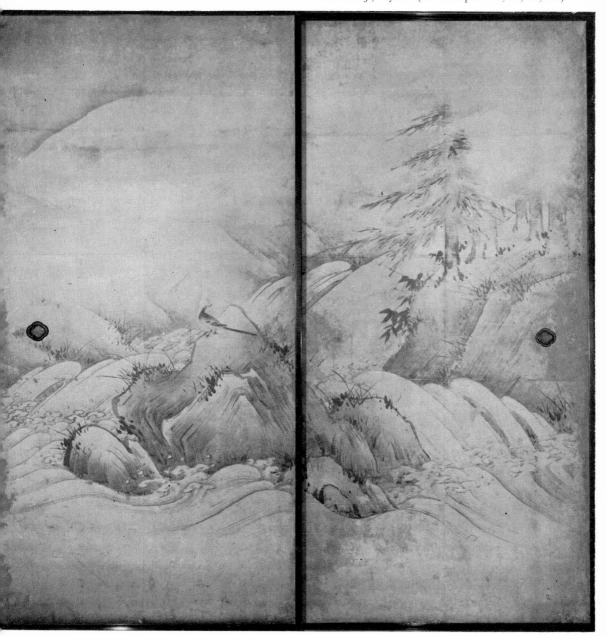

13. "Wild Geese in Rushes," by Kanō Eitoku. Detail
from *Landscape with Flowers and Birds*, a set of sixteen
fusuma panels. Ink and gold on paper. H. 175.5 cm.
Jukō-in, Daitoku-ji, Kyoto. (See also pls. 2–4, 11–12, 18.)

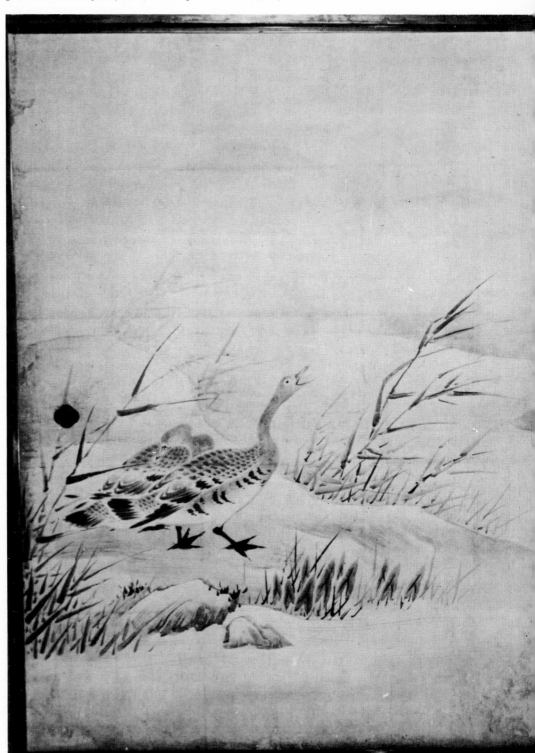

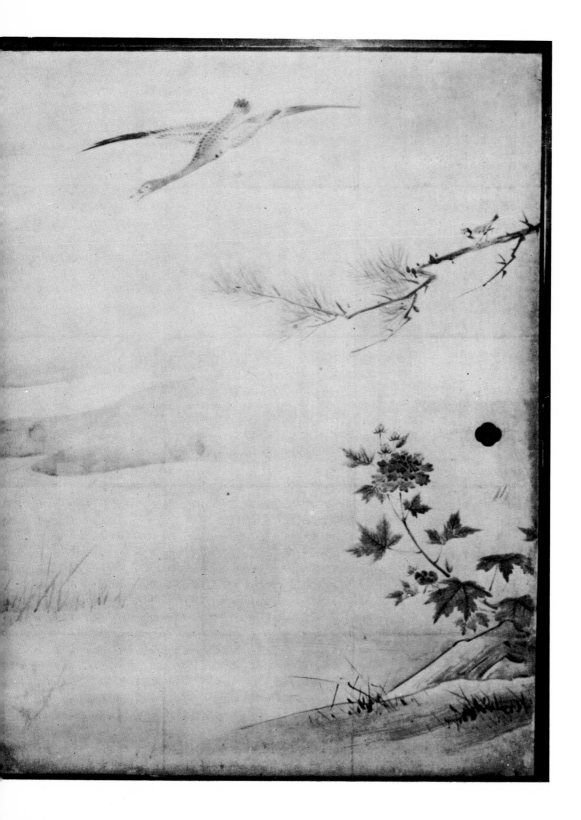

14. *The Four Elegant Pastimes,* by Kanō Eitoku. Detail.
Eight *fusuma* panels. Ink and light colors on paper. H.
175.5 cm. Jukō-in, Daitoku-ji, Kyoto. (See also pl. 19.)

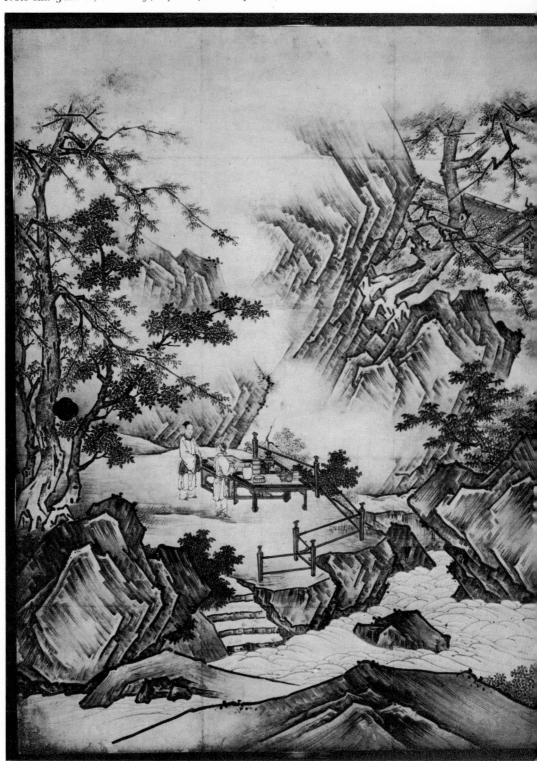

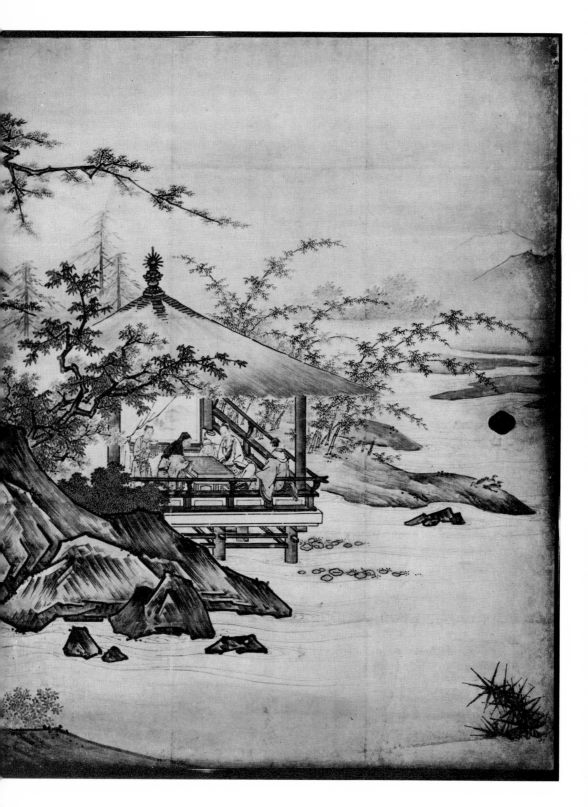

Landscape with Flowers and Birds sets a standard by which one may judge subsequent Kanō school production. Its lively brushstrokes and rhythmical distribution of scenery lend the work a large-scale vigor and intensity that surpass those of *The Four Elegant Pastimes*. The theme of seasonal change and the choice of pines and plums as subjects follow earlier precedents in Kanō painting. The scale is grand, the spring plum segment being over four meters across and the autumn pines section reaching over seven meters.

Moreover, *Landscape with Flowers and Birds* differs in composition from works by Motonobu. The scenes in Motonobu's paintings are generally not as rigorously interconnected as those of Eitoku, which relate to each other in skillfully managed succession. Eitoku further differs from Motonobu in that his foregrounds are enlarged and enhanced and his backgrounds simplified or eliminated. The relationship of top to bottom and of right to left is more important for Eitoku than recession from foreground to background, and this lends the painting a decorative two-dimensional aspect. Placement of animal subjects reflects studied consideration: the small birds in the plum trees, the cranes by the pines, and the ducks in the reeds are all skillfully located to create a taut yet balanced effect.

SCENES IN AND AROUND KYOTO

Although Eitoku is perhaps best known for his monumental style, an examination of his paintings in other manners is necessary if we are to gain a proper notion of his talents. Kanō Einō's *Honchō gashi* states unequivocally that before Eitoku devoted himself to the *taiga* style, he painted in the *saiga* manner, and his *Four Elegant Pastimes* in the Jukō-in has already been discussed. As exemplified in this work, the *saiga* technique could be adapted for use on large folding screens and *fusuma*, although it was most commonly employed on small hanging scrolls, fans, and standing screens. Paintings in the larger formats may be viewed as aggregations of small scenes in the *saiga* manner. Technically, the *saiga* category encompasses certain *yamato-e* techniques, but it also includes detailed paintings in monochrome ink, the style in which Eitoku first worked.

One of Eitoku's most famous works in the *saiga* style is the pair of six-fold screens entitled *Scenes in and around Kyoto* (pls. 5–7, 15–16). Both screens bear the "Shūshin" jar-shaped seal (pl. 101). It has been previously mentioned that these screens boast a distinguished history, having been presented by Oda Nobunaga as an overture of peace to the northern general Uesugi Kenshin in the spring of 1574. They have remained in the possession of the Uesugi family to the present day. This history of the origins and ownership of the screens is nearly certain, despite the fact that the military leaders' mansions depicted in them can be dated to the early Eiroku era (1558–70), about ten to fifteen years previous to the date of Oda Nobunaga's presentation.

52 Replete with meticulous detail, *Scenes in and around Kyoto (Rakuchū-rakugai zu),* in

plates 15–16, depicts the manners and customs of the citizens of Kyoto through the twelve months of the year and demonstrates Eitoku's skill in figure painting. In the foreground may be seen the city of Kyoto proper *(rakuchū)*—the southern wards on the right and the northern wards on the left. The upper sections depict the suburbs *(rakugai)*—the eastern district on the left screen and northern and western districts on the right. Within these boundaries are shown the famous sights of the capital city and the yearly events of the nobility, warriors, clergy, and common people. The traditional activities of the twelve months are all included, among them the cockfighting match held by the palace guards in the third month (pl. 6), "fire lighting" *(ohitaki)* of the eleventh (pl. 7), and the year-end celebration of the twelfth month (pl. 7). Most prominent of all, perhaps, is the Gion Festival of the sixth month (pl. 5), an essential element of any *rakuchū-rakugai* painting and easily identifiable by the huge festival floats that parade along the avenue of the Fourth Ward in the downtown area.

The screens are an invaluable document of actual conditions in the capital at the end of the Muromachi period. Furthermore, the precision with which the activities and famous spots are depicted makes this a fine example of the *saiga* style. Even though Eitoku utilized a large scale format—the composition extends over a pair of six-fold screens—there are no large-scale compositional effects, rather a multiplicity of small units in an allover composition. Nowhere is the precision of the *saiga* style more strongly expressed than in the figures. They are depicted in groups, rather than as individuals, and executed with a lively but concise brushstroke. Carefully and thoughtfully executed are a wide variety of trees—plums and cherries, willow and pines, bamboo groves, and even trees that are dead and leafless. Cloud forms of gold separate one scene from the next and serve as a buffer for the frenetic activity around them. The polychromy with gold clouds is reminiscent of the *yamato-e* tradition of Japanese painting, as opposed to the line work, which derives more from Chinese painting techniques.

Folding Fans

Flowers and Birds (pl. 21) and *The Eight Views of the Hsiao and Hsiang Rivers* (pl. 17), two fan paintings in the Fujita Art Museum, are also good examples of Eitoku's skill in painting freely in a format best suited to the *saiga* style. They are thought to be a pair, originally affixed to either side of a single folding fan, and were once owned by Hideyoshi himself. Though the authorship of the fan paintings is not recorded, the striking style of execution indicates that they are probably by Eitoku. According to the inscription on the container and the picture itself, Hideyoshi gave the fan to the official receptionist *(settaiyaku)* of the Mōri clan, Sase Yozaemon. Hideyoshi was lodging at Hanaoka in Suō Province, within the Mōri domain, en route to Nagoya in Kyushu, where he had set up his headquarters for the invasion of Korea. As this was in 1592, it was presented after Eitoku's death, assuming the information to be correct.

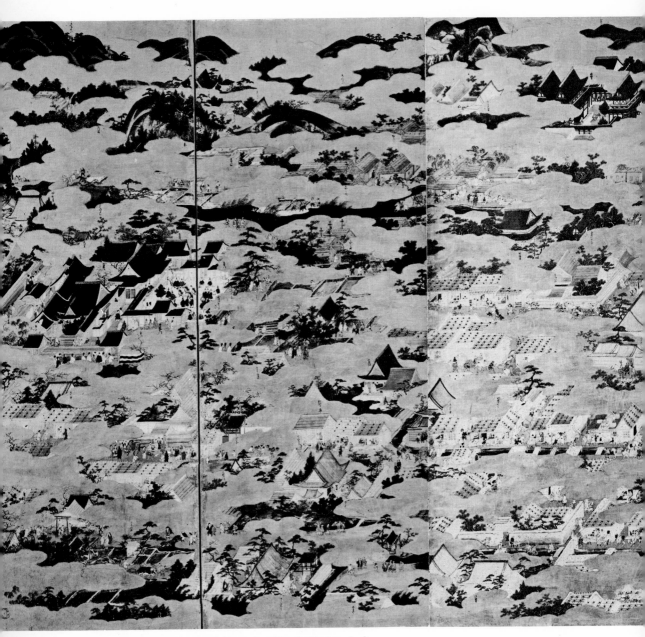

15. *Scenes in and around Kyoto*, by Kanō Eitoku. Left
screen from a pair of six-fold screens. (See pl. 16 for
right screen.) Ink and color with a gold-leaf ground.
H. 160.5 cm., w. 323.5 cm. (each screen). Private collec-
tion, Japan. (See also pls. 5–7.)

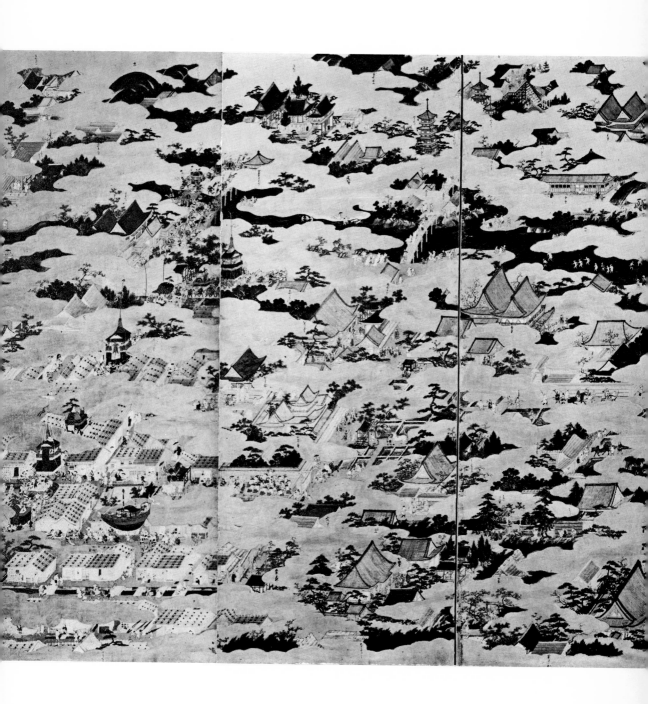

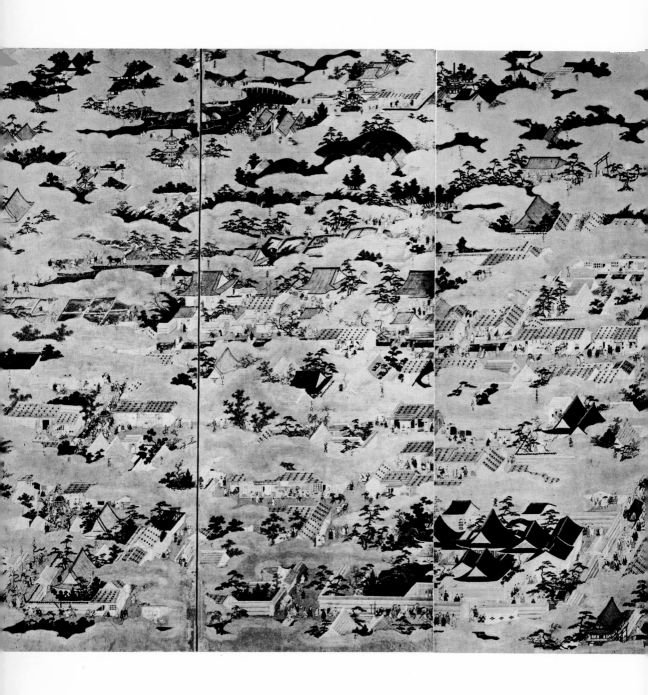

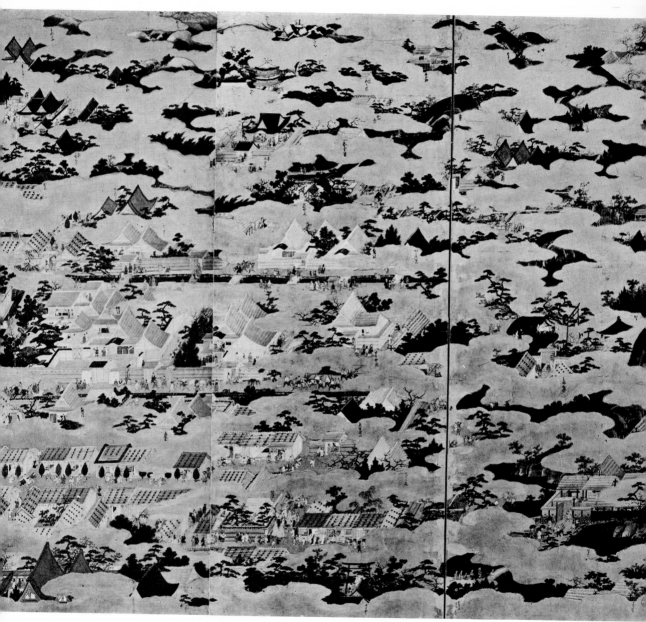

16. *Scenes in and around Kyoto*, by Kanō Eitoku. Right
screen from a pair of six-fold screens. (See pl. 15 for
left screen.) Ink and color with a gold-leaf ground.
H. 160.5 cm., w. 323.5 cm. (each screen). Private collec-
tion, Japan. (See also pls. 5–7.)

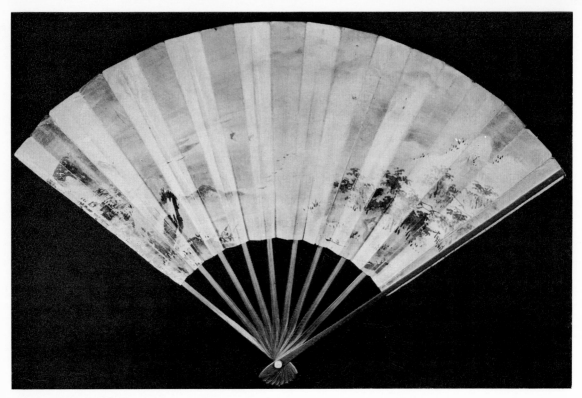

17. *The Eight Views of the Hsiao and Hsiang Rivers*; at-
tributed to Kanō Eitoku. Folding fan painting. Ink and
gold on paper. W. 52 cm. Fujita Art Museum, Osaka.
(See pl. 21 for probable reverse side.)

The landscape composition (pl. 17) depicts the traditional Chinese theme of the
eight views of the Hsiao and Hsiang rivers. Surrounding the central water area are
the eight requisite scenes—evening snowfall and mountain village at the right, re-
turning fishing boats and landing geese in the center, and autumn moon, night rain,
distant temple, and fishing village at the left. The ink tone is tastefully varied and the
gold paint adds charm to the overall effect. The second fan painting, *Flowers and
Birds* (pl. 21), is a depiction of the seasons, with plum blossoms, irises, chrysanthemums,
waterfowl, and snowy mountains in the distance. Elements of the style strongly
resemble *Landscape with Flowers and Birds* in the Jukō-in (pls. 2–4, 11–13, 18).

These serene monochrome ink compositions are painted in the semicursive "run-
ning" style known as *gyōtai,* which is less detailed than the rigid *shintai* but more clear-
ly defined than the cursive *sōtai* manner. The paper was prepared with a lustrous coat-
ing of *gofun,* shell lime mixed with glue, over which a pigment of gold dust *(kindei)*
is lightly brushed. The handling of the plums, irises, and chrysanthemums, of the
mountain villages and distant temples, and of the sailboats and skiffs is not as precise
as the brushwork of *Scenes in and around Kyoto.* The strokes here, however, are done in
the "boneless" *(mokkotsu)* technique, in which the object is depicted by areas of ink
and not by a black outline. This technique imbues the paintings with a distinctive

58 feeling.

CHINESE LIONS

Eitoku's most influential works were painted in the *taiga* style. The screen attributed to him in the Imperial Household Collection titled *Chinese Lions* is a fine example of this mode (pl. 9). Although depicted in it are only three basic constituents—lions, clouds, and rocks—the entire pictorial surface is animated through his coarse, untrammeled line. This robust brushwork, blending the polychromy with the gold background, is far removed from the *saiga* style. Perhaps it is as a result of the unbroken gold background that the same thick, animated brushstroke seen in the monochrome ink *Landscape with Flowers and Birds* has even greater success here. The flaming rhythms of the curly manes and tails and the decorative white spotting of the bodies of the lions give them a sense of mythical unreality, half-playful, half-demonical. The *Chinese Lions* screen recalls the grandeur of the Eitoku compositions in the interiors of the Jurakudai palace and Osaka Castle.

We have now examined the works that can be attributed to Eitoku with near certainty. From these few paintings, however, we cannot gain a complete picture of Eitoku's oeuvre. To do so, we will next examine a number of paintings attributed to him on somewhat weaker but still convincing grounds. These paintings can be divided into three categories: works that were granted a written certificate of authenticity, works that bear a seal with Eitoku's pseudonym "Shūshin," and works that have been traditionally attributed to him. They are done in both monochrome ink and gold-ground polychrome and appear in the familiar formats of Momoyama painting—screens, hanging scrolls, and fan paintings.

PAINTINGS AUTHENTICATED IN WRITING

Collectors of Japanese art are familiar with the short tabs of paper *(kiwamegaki)* that are kept in the storage boxes of paintings and record the judgment of an art critic on the authenticity or authorship of the work; occasionally the *kiwame* will be written on the box or on painting itself *(shichūkiwame)*. Though these certificates of authenticity are often of great age and offer convincing documentation, they cannot be taken in themselves as absolute proof. The majority of the attributions of paintings to Eitoku have been made by artists of the Kanō school; the *Chinese Lions* screen, for example, bears an authentication written directly on the painting itself by Kanō Tan'yū, the well-known painter-critic grandson of Eitoku (pl. 112). A second major work attributed in this way to Eitoku is the *Pine and Hawk* screens (pls. 20, 22), now in the collection of the Tokyo University of Fine Arts; both the right and left screens bear the inscription "Eitoku's own brush—certified by Einō" (pl. 114). Einō (1631–97) was the Kanō painter and scholar who wrote the *Honchō gashi*.

The great pines that extend across the screens of *Pine and Hawk* serves to stabilize and unify the composition of this typical example of Momoyama polychrome painting with gold background. Though the painting is enhanced by the rocks in the flowing

59

18. "Wild Geese in Rushes," by Kanō Eitoku. Detail from *Landscape with Flowers and Birds*, a set of sixteen *fusuma* panels. Ink and gold on paper. H. 175.5 cm. Jukō-in, Daitoku-ji, Kyoto.

Landscape with Flowers and Birds is a series of sixteen panels on the east, north, and west walls of the *naka no ma* or central guest room in the Jukō-in. The scenes span the seasons, from spring at the east to winter at the west. The "Wild Geese in Rushes" panel is a scene in late autumn; it impressionistically captures two geese as they beckon to their companions cavorting in the sky above. Gold dust is added only in the open spaces of the work, and the deft brushwork and evocative tone of the ink harmonize well with the interior space of the room. Just in his twenties, Eitoku has already begun to display the creative power that marks his mature period. (See also pls. 2–4, 11–13.)

19. *The Four Elegant Pastimes*, by Kanō Eitoku. Detail. Eight *fusuma* panels. Ink and light colors on paper. H. 175.5 cm. Jukō-in, Daitoku-ji, Kyoto.

The Four Elegant Pastimes span eight *fusuma* panels on the east and north walls of the patron's room of the Jukō-in. This section reproduces the two rightmost panels. *The Four Elegant Pastimes* takes up a traditional Chinese theme, the pursuits of music (*kin*), chess (*ki*), calligraphy (*sho*), and painting (*ga*). A single landscape spreading over the various panels provides visual unity to the separate vignettes of gentlemanly accomplishment. Although *Landscape with Flowers and Birds* in the next room (pls. 2–4, 11–13, 18) was also done by Eitoku, the mood is completely different. The loose freedom of those scenes is abandoned in this painting, done in the *shintai* style and infinitely more restrained and detailed. (See also pl. 14.)

stream and by the distant mountains veiled in golden clouds, it is the pine trees and the hawks that dominate the simply arranged composition. The bright color and clarity of conception add to the pleasing effect. Although the style of the work is unquestionably that of Eitoku, the work is not necessarily by him, despite Einō's authentication. Comparing this to *The Four Elegant Pastimes* of the Jukō-in (pls. 14, 19) we can discern differences in the strength and extent of the brushstrokes defining the cliffs, even though in both the formal style *(shintai)* is used. Moreover, although the composition of *Pine and Hawk* is monumental in the finest Eitoku manner, the details seem stereotyped derivations of the Eitoku style and cast doubt on the accuracy of the attribution.

Another representative work attributed to Eitoku is the pair of screens entitled *Cranes under a Pine Tree—Wild Geese in Rushes* (pl. 25). Both screens bear the inscription "Genuine work of my grandfather Eitoku of the *hōin* rank—certified by Yasunobu," with Yasunobu's seal impressed under his signature (pl. 113). Yasunobu (1613–85) was the younger of Tan'yū's two brothers. He became the eighth head of the main branch of the Kanō family when Sadanobu (Eitoku's grandson) died leaving no heir. His certificate signifies that the painting was at that time regarded as a genuine Eitoku work.

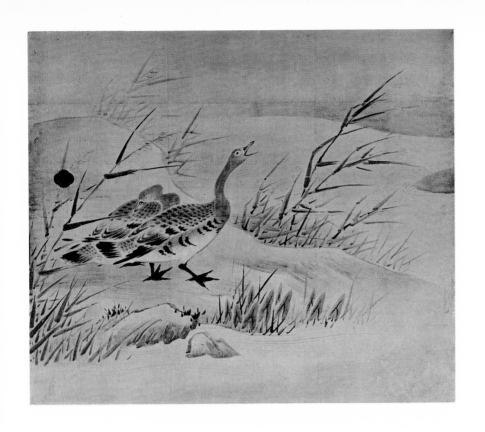

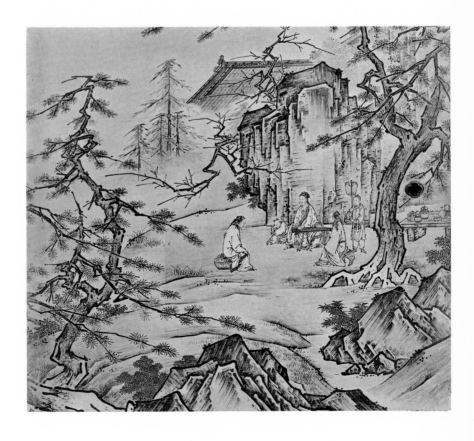

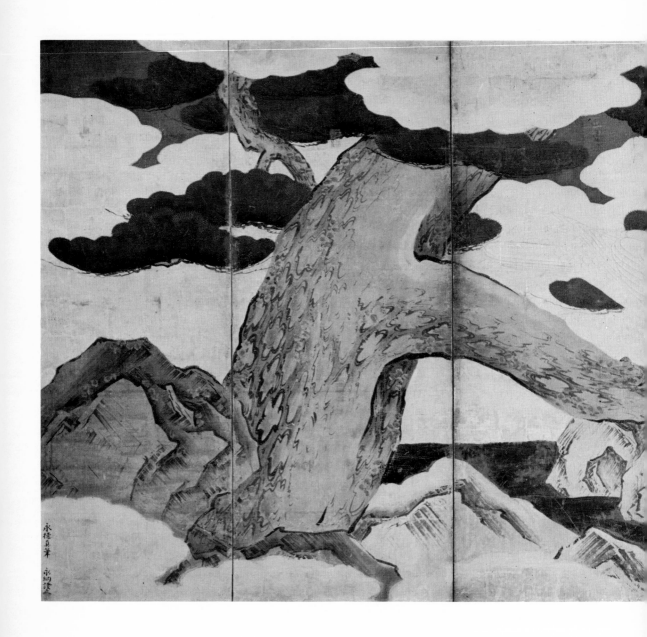

20. *Pine and Hawk*; attributed to Kanō Eitoku. Left
screen of a pair of six-fold screens. Ink and colors with
gold-leaf ground. H. 160.5 cm., w. 360 cm. (each screen).
Tokyo University of Fine Arts. (See also pl. 22.)

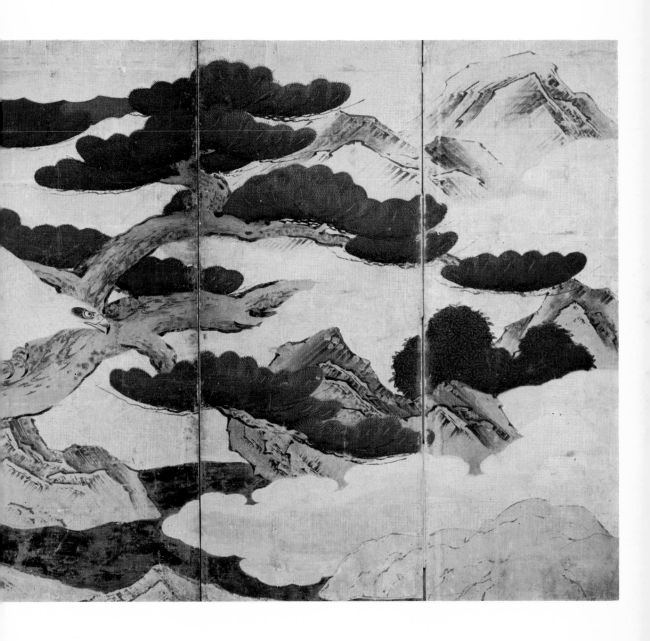

21. *Flowers and Birds*; attributed to Kanō Eitoku. Folding fan painting. Ink and gold on paper. W. 52 cm. Fujita Art Museum, Osaka.

The four seasons are used as a thematic device for the arrangement, across the fan, of plum blossoms, irises, chrysanthemums, waterfowl, and snowy mountains. The composition is simple and painted sketchily in the "running" manner (*gyōtai*). According to the inscription on the right corner of the fan and that on the box, this fan painting was presented in 1592 to the official receptionist (*settaiyaku*) of the Mōri clan, Sase Yozaemon, by Hideyoshi, who was on his way to his Nagoya headquarters for the invasion of Korea. (See pl. 17 for probable reverse side of this fan.)

22. *Pine and Hawk*; attributed to Kanō Eitoku. Detail. Pair of six-fold screens. Ink and colors with gold-leaf ground. H. 160.5 cm., w. 360 cm. (each screen). Tokyo University of Fine Arts.

As a symbol the hawk was associated with the warrior class, and hawking expeditions were held throughout the year. Perched alert on a pine branch and glaring at its surroundings, this predatory bird was a favorite pictorial theme of military families, who saw it as an emblem of military potency. While the theme of this work is heroic in intention, one is struck by the unpleasant, rather complicated gold background, which obfuscates the portrayal of the exquisite hawk. This screen bears an inscription of authenticity as a work of Eitoku's, yet it lacks the wild extravagence of his monumental compositions and concentrates on harmonizing the diverse elements of the design. (See also pl. 20.)

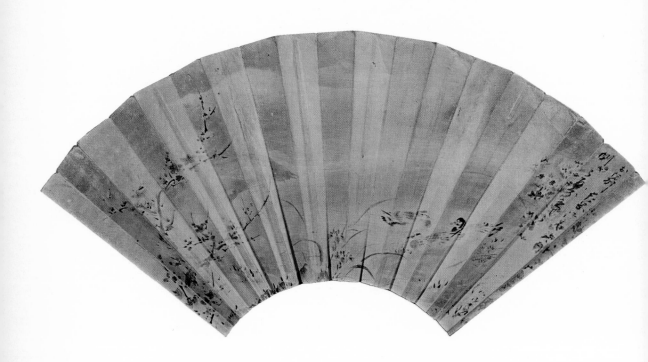

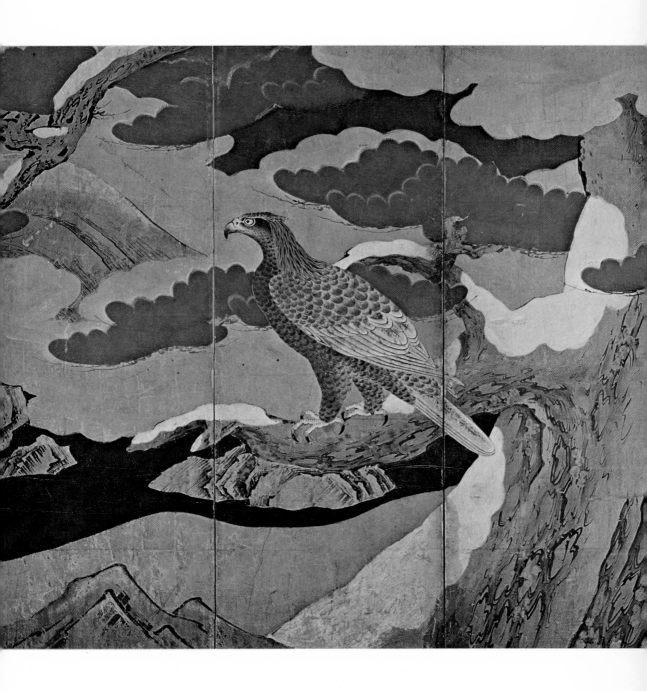

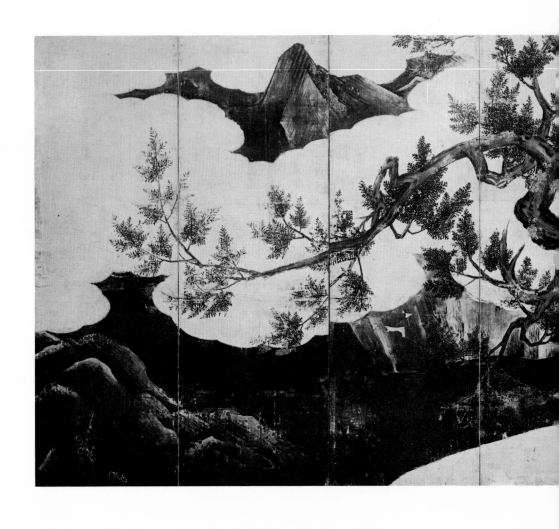

23. *Cypress Trees*; attributed to Kanō Eitoku. Eight-
fold screen. Ink and colors with gold-leaf ground. H.
169.7 cm., w. 460.5 cm. Tokyo National Museum. (See
also pl. 24.)

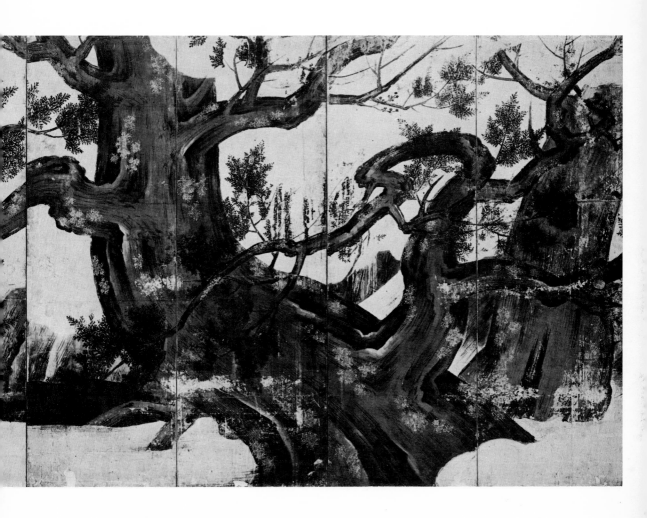

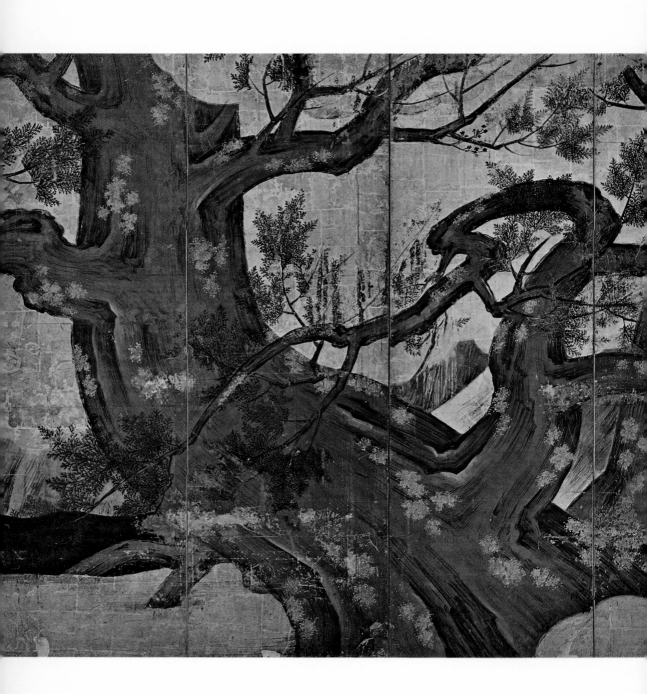

24. *Cypress Trees*; attributed to Kanō Eitoku. Detail. Eight-fold screen. Ink and colors with gold-leaf ground. H. 169.7 cm., w. 460.5 cm. Tokyo National Museum. The huge branches of a mighty cypress stretch to the left and right, and act as a sturdy support for the large-scale composition. The violent twisting of the gnarled old trunk contrasts sharply with the crisp forms of the young verdant cypress leaves. Although Eitoku restricted his palette to mainly greens and browns, he utilized a strong navy blue tone for the stagnant water in the glen to provide a striking counterpoint. While the style of this work is more convincing as an authentic Eitoku painting than *Pine and Hawk* (pls. 20, 22), there are aspects of the style of the tree and brushwork that call for caution in attribution. Four of the panels of this screen bear evidence of having had handholds, and it is thought that *Cypress Trees* was originally a *fusuma* painting in the palace of Prince Hachijō-no-miya Toshi-hito. (See also pl. 23.)

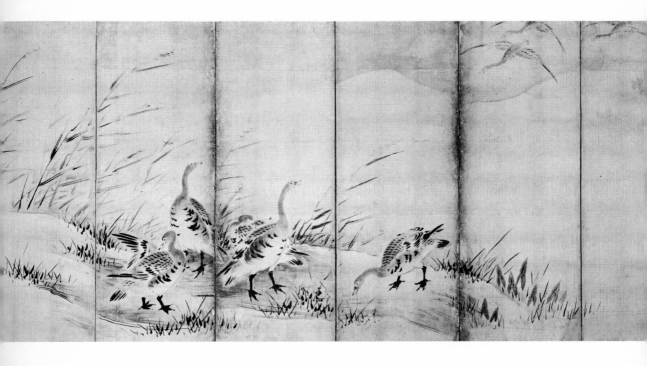

25. *Cranes under a Pine Tree—Wild Geese in Rushes*; attributed to Kanō Eitoku. Pair of six-fold screens. Ink on paper. H. 160.5 cm., w. 359 cm. (each screen). Private collection, Japan.

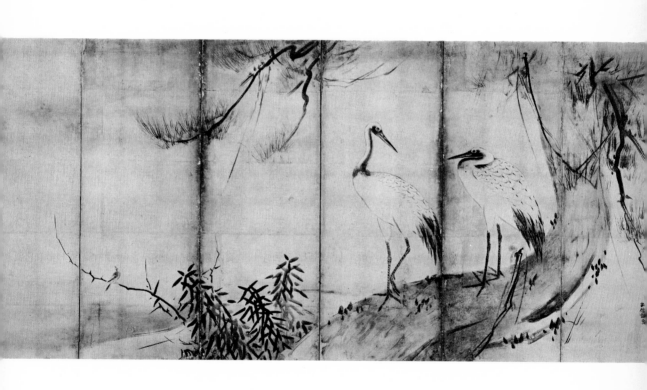

The right screen depicts two cranes beneath the branches of a gnarled pine; the blank background sets off these foreground subjects, which are painted in rough and quick strokes. These brushstrokes reflect the *taiga* manner, as does the simple yet magnificent composition. Indeed, it is specifically noted in the *Honchō gashi* that "the brushwork is all in a coarse, cursive style." The left screen is not as monumental in composition as the right. Rather, it has a more intimate tone, with geese amid the rushes awaiting those flying down from the snow-laden mountains. The "Wild Geese in Rushes" screen closely resembles in technique the Jukō-in paintings of the same subject and is more evocative of the essential Eitoku style than is the "Cranes under a Pine Tree" half of this screen pair.

One must continually keep in mind that *Chinese Lions, Pine and Hawk,* and *Cranes under a Pine Tree—Wild Geese in Rushes* were attributed to Eitoku by other Kanō artists of the early Edo period primarily on the basis of the many elements of the Eitoku style inherent in them, there being little actual documentation available. One must further recall that it is difficult to make direct comparative investigations of these paintings since they encompass both monochrome ink and gold-ground polychrome media as well as bird, flower, animal, human, and landscape subject matter. Comparison, then, of works of different subjects that may or may not actually be by Eitoku is anything but definitive. In general, the most reliable technique for making attributions to Eitoku is the comparison not of entire subjects but of small details, such as the texturing of cliffs *(shumpō)* and the rendering of trees *(juhō)*. Even this, though, is fraught with uncertainty.

Paintings Bearing the "Shūshin" Seal

As with certificates of authenticity, seals can provide clues to the provenance of paintings, but can be misleading as well. *Scenes in and around Kyoto* is impressed with the "Shūshin" jar-in-a-circle seal, often used by Eitoku. However, other works exist that bear various close copies of this jar-shaped seal but whose styles vary greatly in composition, subject, and technique. The various "Shūshin" seals are reproduced in the appendix "Seals and Certificates." Often these seals were added by later generations and cannot be trusted completely.

The "Shūshin" seal is impressed on the pair of hanging scrolls (pls. 26–27) depicting the Chinese sages Hsü-yu and Ch'ao-fu (Kyoyū and Sōho in Japanese), now in the Tokyo National Museum. Legend has it that when Hsü-yu was offered the rule of the Chinese empire by the Hsia-dynasty emperor Tao, he was so disgusted by the offer that he washed his contaminated ears in the waters of the Ying River. The sage Ch'ao-fu, when he realized what had happened, turned his ox away from the tainted water. These two scrolls, while small, are done with deft and vibrant brushwork in the "running" style *(gyōtai)*. It is this movement-filled brushwork that stylistically links the *Hsü-yu* and *Ch'ao-fu* scrolls to *Landscape with Flowers and Birds* in the Jukō-in (pls.

2–4, 11–13, 18). The scrolls strike a balance between monumentality and precision, incorporating the monumental style for the depiction of nature while retaining aspects of the detailed method for the physiognomy and the garments of the figures. Though the jar-shaped "Shūshin" seals impressed on both works appear to be of later date, stylistically the scrolls can be placed in Eitoku's oeuvre. It is known that Eitoku painted the same theme in the eight-mat room on the fourth floor of Azuchi Castle, and had these works survived, undoubtedly they would have provided instructive comparative material.

Another work depicting a Chinese historical theme is *Pai-i and Shu-ch'i* (pl. 28). Deploring the rise of the Chou dynasty, the brothers Pai-i and Shu-ch'i (Hakui and Shukusei in Japanese) sequestered themselves on Shou-yang Mountain, where they died of starvation. The sensitive ink line used to demarcate their facial expressions suggests the idealism and moral courage underlying the character of these two men. Compared with the *Hsü-yu* and *Ch'ao-fu* paintings, this work reveals certain differences in figure depiction: Pai-i and Shu-ch'i's drapery is simpler and falls in gentler, more rhythmical folds, and their faces are less wizened and angular. In spite of these discrepancies and the fact that the "Shūshin" seal was almost certainly applied at a later date, the brush handling is close to Eitoku's own. From the patched areas of the painting it can be ascertained that this painting previously formed part of a larger *fusuma* composition. Thus, the original composition was less cramped vertically and horizontally; the present seals were probably added when this remodeling was carried out.

TRADITIONALLY ATTRIBUTED PAINTINGS

Perhaps the largest number of works attributed to Eitoku bear neither certificates of authenticity nor seals. *Landscape with Flowers and Birds* and *The Four Elegant Pastimes* in the Jukō-in discussed previously fall into this category. A third representative work of this type is the eight-fold *Cypress Trees* screen (pls. 23–24), now in the Tokyo National Museum. Perfectly embodying Eitoku's monumental style, the single cypress tree overwhelms the viewer with its larger-than-life dimensions. The massive trunk and contorted branches are less supple than those of the large plum tree in the Jukō-in *Landscape with Flowers and Birds* (pl. 4). The gnarled, moss-grown bark of the ancient cypress conveys a feeling of hardiness that contrasts with the delicate green foliage radiating from the tips of the branches. The brilliant colors in conjunction with the monumental composition serve to create an overwhelming visual impression.

Evidence of the presence of *fusuma* handholds indicates the work was remodeled from a four-panel *fusuma* painting; in its original state the painting extended further to the left and right. The screen bears a distinguished history: it was painted in 1590 for the mansion of Prince Hachijō-no-miya Toshihito, a son of the emperor Goyōzei who was adopted by Hideyoshi. Toshihito is famous as the person in charge of the

73

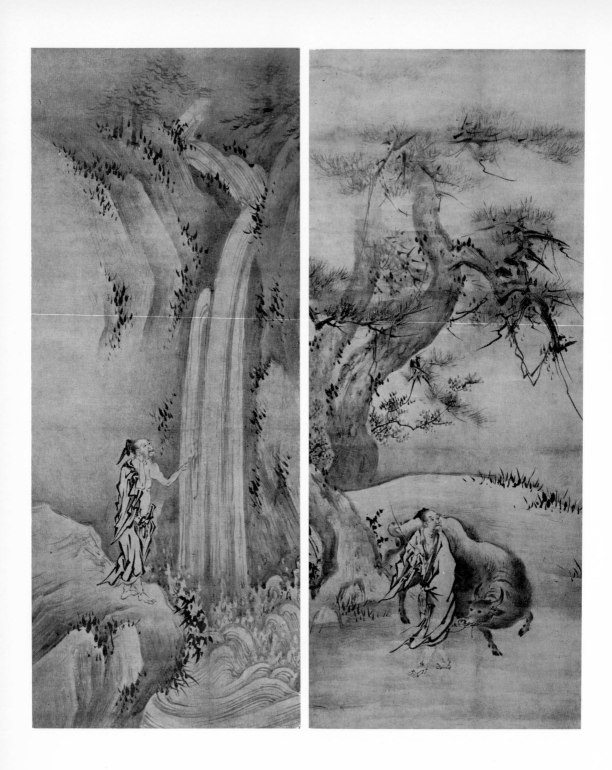

26–27. *Hsü-yu—Ch'ao-fu*; attributed to Kanō Eitoku.
Pair of hanging scrolls. Ink on paper. H. 125.5 cm.,
w. 52.5 cm. (each scroll). Tokyo National Museum.

28. *Pai-i and Shu-ch'i*; attributed to Kanō Eitoku. Hanging scroll. Ink on paper. H. 115 cm., w. 53 cm. Private collection, Japan.

75

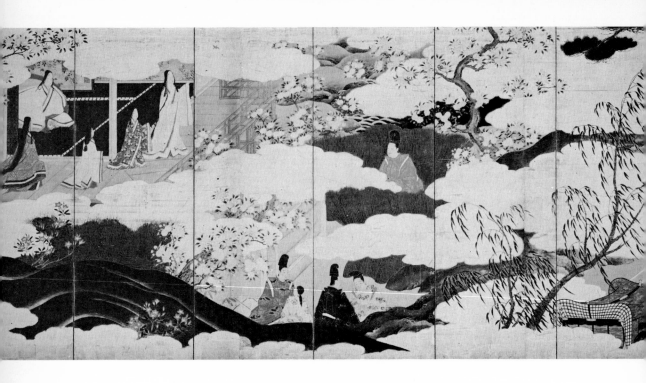

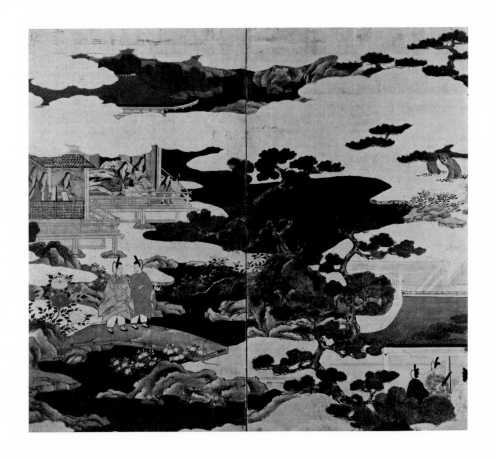

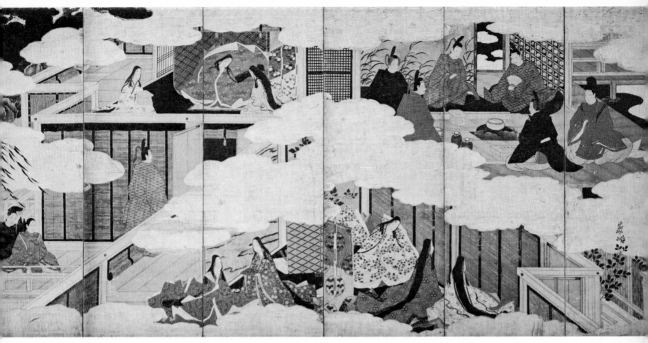

29. *The Tale of Genji*; attributed to Kanō Eitoku. Pair of six-fold screens. Ink and colors with gold leaf. H. 167.5 cm., w. 362 cm. (each screen). Imperial Household Collection.

Katsura detached palace project of 1620–24. The Hachijō-no-miya family later came to be known as the Katsura-no-miya family after this famous building project. Eitoku's role in the decoration of the Hachijō-no-miya mansion is by no means certain, for it seems that it was completed just about the time of his death. We know, for example, that the day after Eitoku died, Hideyoshi inspected the mansion and criticized it for its size and strong fortifications. Although opinion is divided as to whether the *Cypress Trees* painting is by Eitoku himself, it is an incontestable example of Eitoku's monumental style.

The *Tale of Genji* screens now in the Imperial Household Collection (pl. 29) were also once owned by the Katsura-no-miya family. Though they lack authentication and seals, they are attributed to Eitoku. The illustration of episodes from *The Tale of Genji* was traditionally associated with the Tosa school, which painted in the *yamato-e* style; later, a wide variety of artists took up this theme and often adopted a *yamato-e* style for its execution.

The left screen of the pair depicts the "Young Murasaki" *(Waka Murasaki)* chapter of the book. The right screen portrays three chapters: at the upper left is "The Gossamer Fly" *(Kagerō)*; at the upper right is "First Bird Song of the New Year" *(Hatsune)*; and at the bottom center is "The Bell Cricket" *(Suzumushi)*. The detailed garments of the figures stylistically recall the precise, classically refined manner of *yamato-e*.

30. *The Tale of Genji*, bearing the "Shūshin" seal. Surviving half of a pair of two-fold screens. Ink and colors with gold leaf. H. 170 cm., w. 185 cm. Private collection, Japan.

31. *Hermits*; attributed to Kanō Eitoku. Pair of six-fold screens. Ink on paper. H. 156.6 cm., w. 363.3 cm. (each screen). Private collection, Japan.

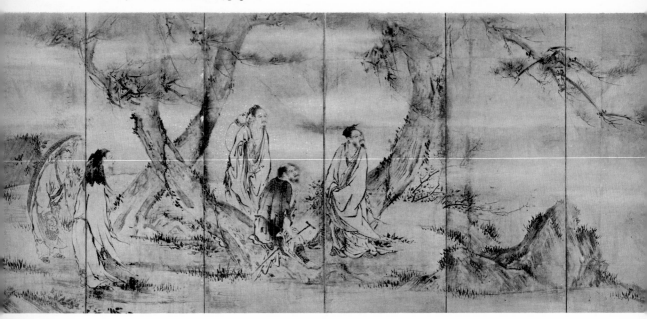

The painting in general, however, is a monumental composition, the figures being of large dimensions, though not quite of the 90-to-130-centimeter scale recorded in the *Honchō gashi*. Furthermore, Eitoku does not use the "attenuated eyes and hooked nose" *(hikime kagihana)* employed in traditional *yamato-e* faces, but rather a more realistic facial depiction derived from Chinese techniques. His treatment of the rocks and hill in the lower left corner of the left screen also reflects Chinese, not *yamato-e,* sources. The painter concentrated on making the figures and scenery individually expressive, rather than on re-creating a traditionally understated *Tale of Genji* mood.

Documents record the presentation of *Tale of Genji* screens to Uesugi Kenshin by Oda Nobunaga, Eitoku's patron, but whether these are the very same screens is not clear. The uncertainty is compounded by the existence of a *Tale of Genji* screen belonging to the Toda family (pl. 30). Only one of the original pair of screens survives, and its subject, traditionally thought to be a depiction of the "Wind in the Pines" *(Matsukaze)* chapter of *The Tale of Genji,* has recently been questioned due to inconsistencies in the iconography. However, according to an extant inventory slip, the lost screen bore the inscription "Eitoku's brush—certified by Kanō Einō." Furthermore, the "Shūshin" seal is impressed on the surviving screen. In mood and treatment of detail, the Toda *Tale of Genji* screen is quite different from that of the Imperial Household Collection, and there is no consensus as to whether one or both were created by Eitoku. Both

attributions date from the Edo period, a time of active attribution to Eitoku, with judgment based as often on imprecise stylistic grounds as on concrete documentation.

A third painting of related history is *Autumn Grasses* (pl. 115). It is thought to have been remodeled from *fusuma* panels belonging to the Hachijō-no-miya family in the late Tenshō era (1573–92). The paintings were perhaps attributed to Eitoku in part because of this history, which parallels that of the *Tale of Genji* screens in the Imperial Household Collection. There are also stylistic correlations in the depiction of rocks and trees in these works.

Remaining in this category of unsigned and unsealed paintings traditionally attributed to Eitoku are three important monochrome ink works. The first is a pair of screens entitled *Hermits* (pl. 31). The traces of handholds tell us they were once *fusuma* paintings. In the right screen, a sage with attendant sits on a spit of land across a stream from a sage who is fishing; all three are staring into the water. On the left screen, four sages and an attendant gaze into the distance. Two of the sages appear to be T'ieh-kuai and Lu Tung-pin (Tekkai and Rodōhin in Japanese), who are not historically associated; the other figures are unknown.

The composition, coming under the category of painting subjects known as landscape with figures *(sansuijimbutsu)*, is of modest size, and the distribution of the figures is well balanced and stable. To describe the cliffs and tree, the painter has used a

"running" style of brushwork similar to that found in the *Hsü-yu* and *Ch'ao-fu* scrolls (pls. 26–27). Another point of similarity between these two works can be seen in the facial expressions of the figures, which seem to have been based on the same proto-type. Although the ink tone is more brittle and the garments more complicated than in the *Hsü-yu* and *Ch'ao-fu* scrolls, in general the style of *Hermits* supports the traditional attribution to Eitoku. Definitive attribution, however, must await further research.

Similar to *Hermits* in figure depiction are the screens entitled *The Twenty-four Paragons of Filial Piety* in the Hōnen-in, Kyoto (pl. 119). Although the brush handling in these screens is at times flaccid in comparison with *Hermits,* there exists an affinity between the two paintings. Adding support to the Eitoku attribution are the "Shūshin" seals (pl. 103) seen at the bottom left and right of the Kuo Chu and Lao Lai-t'zu sec-tions of one of the screen pair. The other screen, which depicts Meng Tsung (Mōsō in Japanese), bears traces of an identical seal that was partially obliterated during repairs; its present stamp is of a later date. In 1935 the Japanese scholar Tsuchida Kyōson ascribed *The Twenty-four Paragons of Filial Piety* to Eitoku, but laying aside the question of whether the "Shūshin" seals are valid or not, the most that can be said at this point is that the paintings are definitely in the Eitoku style.

The deftly painted striations that model the trees and rocks in the single six-fold screen *Bird of Prey* (pl. 120), the final work in this monochrome ink subdivision, also correspond with other Eitoku works. Although *Bird of Prey* differs in subject and composition from the screens based on Chinese historical themes examined earlier, there are similarities in brushwork. It was at the beginning of the Edo period that the expansive composition and use of vacant space became generally recognized as touch-stones of the Eitoku style.

Linking the monochrome ink paintings discussed above are their coarse brushwork and arid pictorial mood, but a number of dissimilarities and contradictions exist that have yet to be unraveled. The *Hsü-yu* and *Ch'ao-fu* scrolls and the *Landscape with Flowers and Birds* of the Jukō-in should be considered the standard works of Eitoku's oeuvre in monochrome ink with slight color. *Cranes under a Pine Tree—Wild Geese in Rushes* can be tentatively viewed as a work deriving from the Eitoku style and to which one can compare less typical paintings. It is necessary to underscore again the uncertainty of many current attributions and the need for further research into Eitoku's production.

4

EITOKU'S CIRCLE: SHŌEI AND SŌSHŪ

Until his death in 1590 Eitoku was the driving force behind the Kanō school. As shown earlier, the few extant paintings attributed to him by way of certificates of authenticity, seals, and tradition constitute only a fraction of his lifetime production, but, nevertheless, they provide a clear impression of his style. It is quite possible that even among this small number of Eitoku paintings are included works by other artists painting in his style. Consequently, to understand Eitoku's painting most fully, we should be aware not only of his extant oeuvre but also of that of his immediate circle. Particularly representative are the works of two contemporaries, Eitoku's father, Shōei, and younger brother, Sōshū.

KANŌ SHŌEI

Eitoku's father, Shōei (1519–92), was the fourth-generation head of the Kanō school and direct heir to the Motonobu style. Although he outlived his son by two years and can thus be counted among Eitoku's contemporaries, he had developed a mature style based on the Motonobu manner well before his son developed his own monumental style. He is thus seen historically as a conservator rather than an innovator, credited with maintaining Kanō school standards rather than with creating a new painting style.

Before he took the tonsure and adopted the Buddhist name of Shōei, by which he is commonly known, he used the name Naonobu (alternatively read Tadanobu). This name appears frequently on fan paintings and on several screens and hanging scrolls. The earliest record of him, however, in the *Shōnyo shōnin nikki* (Diary of the Priest Shōnyo), refers to him as Genshichi, and recounts that Genshichi painted fans and a pair of monochrome ink screens together with Motonobu in 1553, near the end of an extended term of painting at the Ishiyama Hongan-ji temple. He is referred to by this name in the *Oyudono no ue no nikki* as well, where it is recorded in an entry of 1566 that "Genshichi painted fans."

Written references to Shōei are fragmentary and certificates of authenticity are rare, making it difficult to trace his stylistic development with certainty. The last two

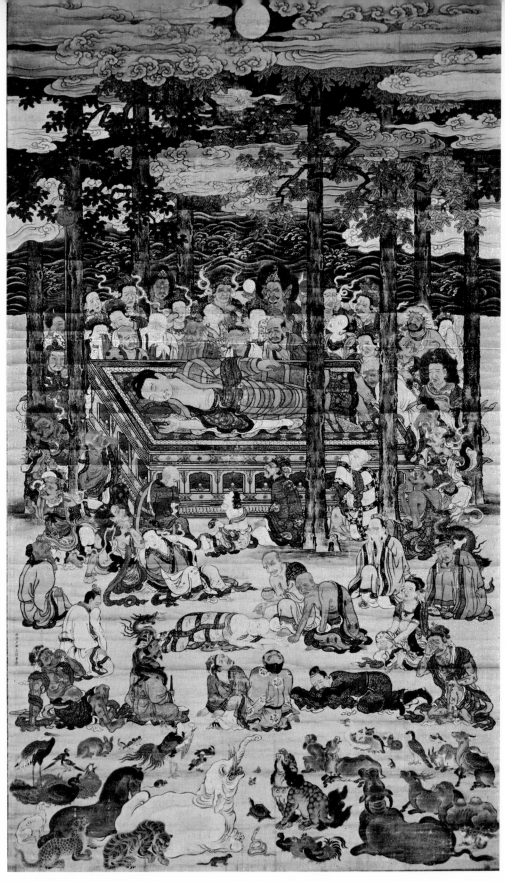

32. *The Death of the Buddha*, by Kanō Shōei. Hanging scroll. Ink
and colors on paper. H. 633 cm., w. 381 cm. Daitoku-ji, Kyoto.

33. Rajōmon *ema* painting, by Kanō Shōei. Copy in the *Itsukushima ema kagami* of the lost original. Woodblock ink print. Itsukushima Shrine, Hiroshima Prefecture.

decades of his life are especially vague, leading some to conjecture that from the inception of the Tenshō era (1573–92) he was eclipsed by his son Eitoku. Nearly all of Shōei's dated paintings were completed during the period 1558–72.

The earliest datable work of Shōei's is *The Death of the Buddha* at Daitoku-ji (pl. 32). The scholar Doi Tsugiyoshi has recently pointed out that according to a list of donors affixed to the storage box, this painting was dedicated in 1563 in association with the completion of a new Buddhist image. The work is impressed with the "Naonobu" seal and bears the signature "Painted by Kanō *kobu* [*mimbu*] Naonobu."[2] *The Death of the Buddha* dates then from Shōei's forty-fifth year, a period not long after Motonobu's death and about the time Eitoku was reaching his prime.

In 1566 Shōei and Eitoku executed the *fusuma* paintings for the abbot's quarters of the Jukō-in, a chapel located in the Daitoku-ji compound. It was thought for centuries that all the paintings in the building were the work of Eitoku, but Doi Tsugiyoshi's recent research has shown that Shōei was responsible for five of the compositions. These are *The Eight Views of the Hsiao and Hsiang Rivers* (pl. 35) in the *rei no ma*; *Monkeys* (pls. 36, 52), *Bamboo and Leopard* (pl. 36), and *Bamboo and Tigers* (pl. 36), all three originally in the *ihatsu no ma*; and *Fish amid Waterplants in a Lotus Pond* (pl. 37) in the Buddhist altar room.

34. *The Twenty-four Paragons of Filial Piety,* by Kanō Shōei. Pair of six-fold screens. Ink on paper. Private collection, Japan.

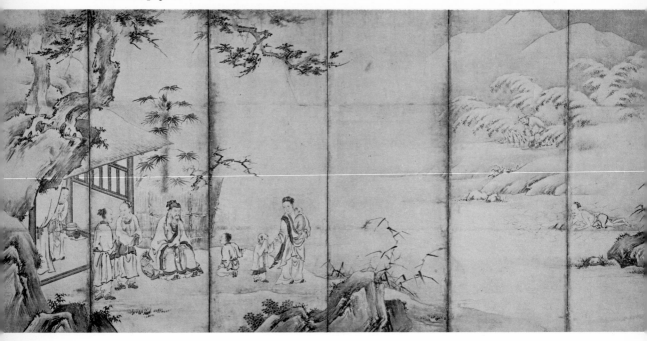

In 1568, two years after the Jukō-in commission, Shōei was called to Bungo Province, Kyushu, by the great daimyo Ōtomo Sōrin (1530–87). Sōrin—warrior, priest, and finally Christian—was a longtime patron of Shōei's. It is recorded in the *Hōzan shishō* that Shōei executed the polychrome flower-and-bird *fusuma* paintings in the *rei no ma* of Daitoku-ji's Zuihō-in, a chapel constructed in 1552 with Sōrin as patron *(ōdanna)*. The last of Shōei's datable work was carried out in connection with this trip to Kyushu at Sōrin's request. During the trip Shōei stopped at Itsukushima Shrine and, early in 1569, created an *ema* painting titled *Rajōmon.* The painting depicted the warrior Minamoto no Yorimitsu subduing the demon of Rajōmon, the famous gate that historically stood at the southern entrance of Kyoto. Although this painting was lost in the Meiji period (1868–1912), there remains a close miniature copy (pl. 33) in the *Itsukushima ema kagami* (Collection of *Ema* Dedicated to Itsukushima Shrine), published in 1831. The inscription of the *ema* reads "Painted by Kanō *mimbu no jō* Fujiwara Naonobu, the third day of the first lunar month, 1569."[3] Tsuji Nobuo has pointed out that the signature *mimbu no jō* (Assistant in the Ministry of Public Affairs), inscribed on the Itsukushima *ema* and the Daitoku-ji *Death of the Buddha,* is also connected with paintings done by Shōei in 1572. The paintings referred to are the screens mentioned in an entry of 1572 in the *Oyudono no ue no nikki*[4] and a portrait of Yoshida Kanesuke (1516–73) mentioned in an entry of the same year in the *Kanemi-kyō ki*

84

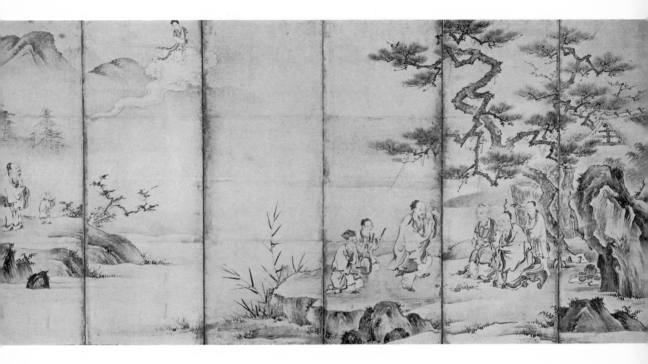

(Diary of Lord Kanemi). Tsuji further points out that Shōei also painted the twenty-four paragons of filial piety for the chief priest of Itsukushima Shrine during this period (pl. 34). These paintings form the datable oeuvre of Shōei, all created in the Eiroku era (1558–70).

Screens and Hanging Scrolls

Shōei's largest single project still in existence is the *fusuma* and wall painting commission he shared with Eitoku at the Jukō-in, and *The Eight Views of the Hsiao and Hsiang Rivers* there is the most representative of Shōei's monochrome ink style. Located in the *rei no ma,* the work spans eight *fusuma* panels; the two leftmost of the four west panels (pl. 35) depict scenes of evening rain, fishing village, and distant temple. Shōei's artistic expertise is evinced by his skillful assimilation of the various scenes into one panoramic composition. He is less successful, however, in his attempt to elaborate on Motonobu's semicursive *(gyōtai)* style, as seen in Motonobu's paintings in the abbot's quarters of the Reiun-in (pl. 1). In comparing *The Eight Views of the Hsiao and Hsiang Rivers* to Eitoku's *Landscape with Flowers and Birds* in the adjoining central room (pls. 2–4, 11–13, 18), Shōei's work seems untroubled and calm, whereas Eitoku's is bursting with exuberance. Even the wind and the rain-swept willow are subdued, revealing Shōei's style rather than Eitoku's.

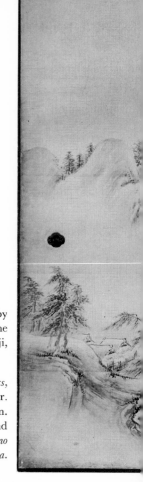

35. *The Eight Views of the Hsiao and Hsiang Rivers*, by Kanō Shōei. Detail from the eight *fusuma* panels in the *rei no ma*. Ink on paper. H. 177 cm. Jukō-in, Daitoku-ji, Kyoto.

36. *Monkeys, Bamboo and Leopard, and Bamboo and Tigers*, by Kanō Shōei. Wall and screen paintings. Ink on paper. *Monkeys* panels in *nishi no ma* (h. 175.5 cm., w. 93.5 cm. each), *Bamboo and Leopard* (h. 179.5 cm., w. 185 cm.) and *Bamboo and Tigers* (h. 179.5 cm., w. 185 cm.) in *shoin no ma* of the *ihatsu no ma*, all originally in the *ihatsu no ma*. Jukō-in, Daitoku-ji, Kyoto. (See also pl. 52.)

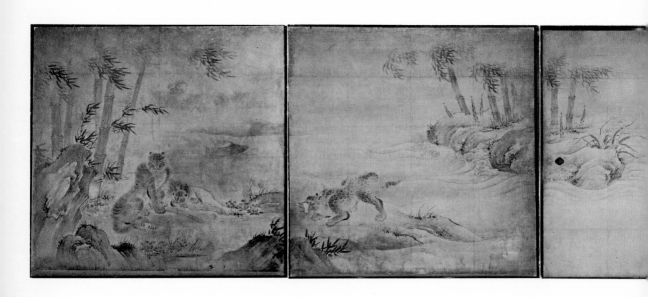

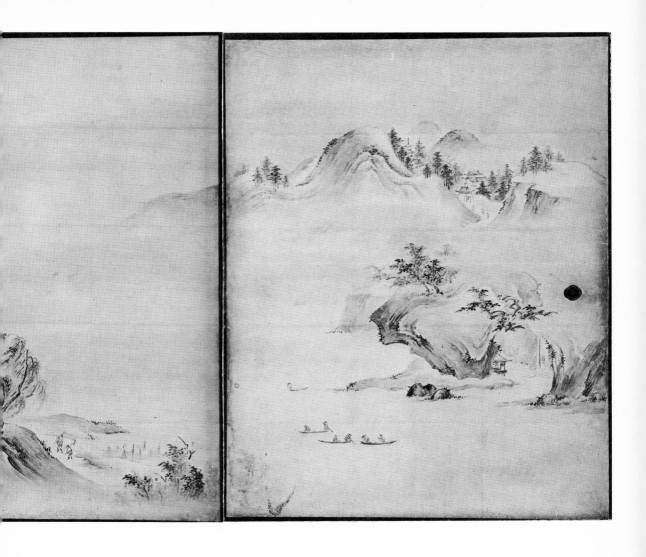

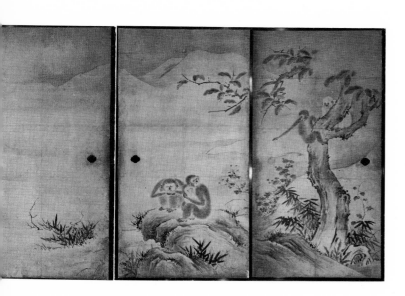

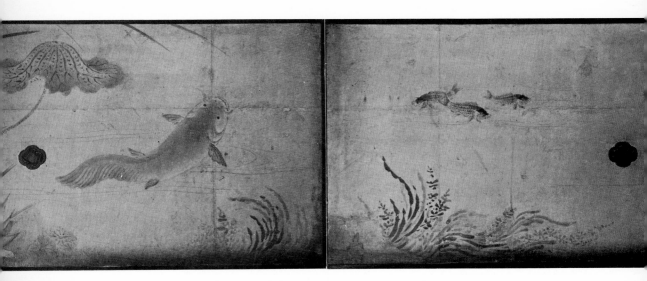

The three Jukō-in works entitled *Monkeys, Bamboo and Leopard,* and *Bamboo and Tigers* (pl. 36) were all originally located in the *ihatsu no ma.* Though the screen painting of monkeys is now in the west room and the other two form wall panels in the *shoin no ma* of the *ihatsu no ma,* they were originally conceived as one series. These works fall under the *sōjū* (land animals) category of paintings, which is usually conceived in a dramatic style. Shōei's depiction, however, is far from bold. The luxuriant ink tones and pliant brushstrokes imbue the three screens with a conservative, restful appearance like that of *The Eight Views of the Hsiao and Hsiang Rivers.* In the monkey panels (pl. 52), Shōei has emulated the famous painting of monkeys by Mu Ch'i, giving them a gentle, human quality in his own manner.

Shōei is most likely also the creator of six of the eight wainscot panels in the Jukō-in's Buddhist altar room, entitled *Fish amid Water Plants in a Lotus Pond* (pl. 37). The seventh and eighth panels, depicting a heron in water, are of a distinctly different style. The six Shōei panels, portraying a carp, a catfish, a flying swallow, and water-plant life, exhibit the lyrical charm of the artist's mature style. Though small in scale, they are accurately detailed and show Shōei's modest manner.

88 Aside from the screen paintings in the Jukō-in, the majority of Shōei's monochrome

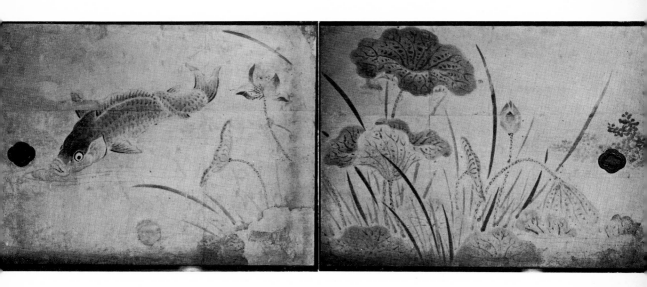

37. *Fish amid Water Plants in a Lotus Pond,* by
Kanō Shōei. Detail. Eight wainscoting *fusuma*
panels in the Buddhist altar room. Ink on
paper. H. 51.8 cm. Jukō-in, Daitoku-ji, Kyoto. 89

38. *Flowers and Birds of the Four Seasons*, by Kanō Shōei.
Pair of six-fold screens. Ink on paper. H. 159.5 cm., w.
352.5 cm. (each screen). Private collection, Japan.

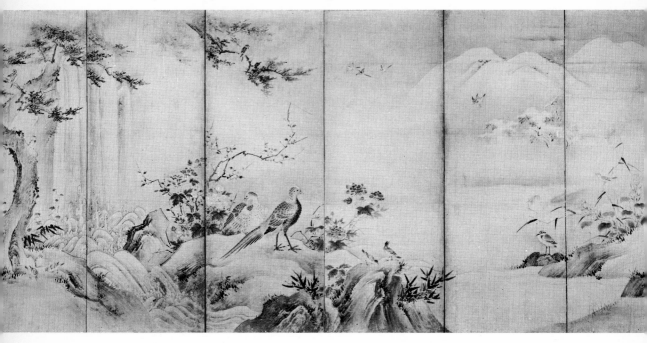

ink works depicts flowers and birds of the four seasons. Three fine examples are the
works belonging to the Nagasaki family (pl. 38), the Saikoku-ji temple (pls. 39, 53),
and the Boston Museum of Fine Arts (pl. 40). Though they do not all bear the jar-
shaped "Naonobu" seal, all are closely related in style and recall the manner of
Motonobu. Consequently, all are believed to be by Shōei or his immediate subordi-
nates, and date from the early Momoyama period.

The changing of the seasons is depicted in the standard right-to-left progression in
the Nagasaki-family pair of six-fold screens (pl. 38). Spring, occupying the first four
panels, is evoked by plum trees, dandelions, and violets dispersed about two pines.
The last two panels of the right screen represent summer, with gardenias blooming
on the bank of a pond. The seasonal cycle continues on the second screen with the
reeds and rose mallows of summer in the foreground and the snow-capped distant
mountains in the background forming a seasonal counterpoint. The composition
reflects Motonobu's style of painting flowers and birds, though its atmosphere is more
reserved. An analysis of the detail in the birds, trees, and rocks suggests the hand of
Shōei; many elements strongly resemble his *Eight Views of the Hsiao and Hsiang Rivers*
in the Jukō-in (pl. 35). Due to this and the acceptable "Naonobu" seal impressed
on both screens, one can attribute this work almost unequivocally to Shōei.

Stylistically akin to the above pair of screens is the *Flowers and Birds of the Four
Seasons* in the Saikoku-ji collection (pls. 39, 53). The composition is calm and simple.

90

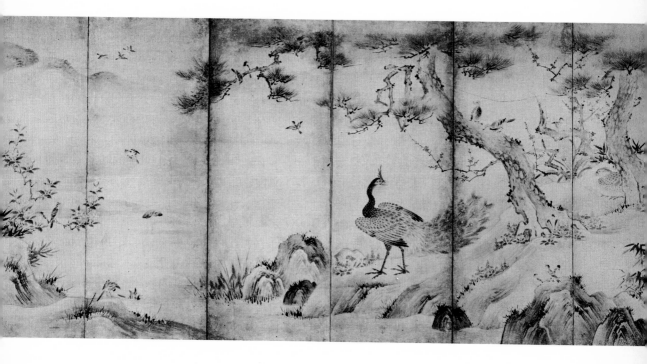

The use of trees as a framing device is again adhered to, in this instance a pair of pine trees on the right screen and a willow on the left screen. Seasonal flora demarcates the yearly cycle: the dandelions and violets of spring, the water plantains and reeds of summer, and the rushes and rose mallow of autumn. Distant snowy mountains complete the progression through the year. Due to its simplicity of means, in both execution and composition, this unsigned painting was for generations attributed to Shōei. However, in light of small divergences from the treatment of the pictorial elements in Shōei's other paintings, it is quite possible that this work was done by an assistant in his atelier.

The *Flowers and Birds of the Four Seasons* screen in the Boston Museum of Fine Arts (pl. 40) differs from the previous two screens in that it is painted in the formal *(shintai)* style. Only the right half remains of what was originally a pair of screens. The themes are spring and summer, with the composition focused on the two pines at the right, whose sweeping branches establish a strong directional movement from right to left. Strutting about under the branches are a flock of chickens, depicted with both humor and reserve. While the composition is in the Motonobu style, the quiet, stable tone of the work reflects Shōei's temperament. The style of the cliffs and trees is characteristic of Shōei, and with the added support of Kanō Tan'yū's inscription "Painted by Shōei" and his seal impression on the painting itself, one can confidently assign this painting to Shōei.

91

39. *Flowers and Birds of the Four Seasons*; attributed to Kanō Shōei. Left screen of a pair of six-fold screens. Ink on paper. Saikoku-ji, Hiroshima Prefecture. (See also pl. 53.)

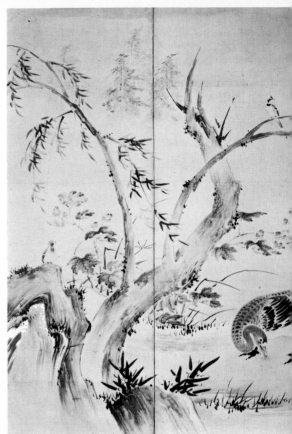

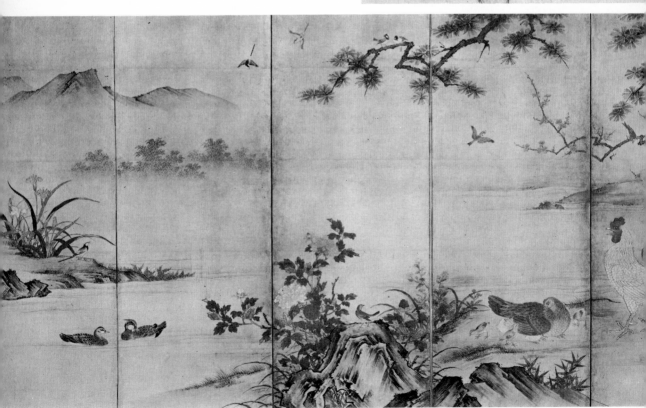

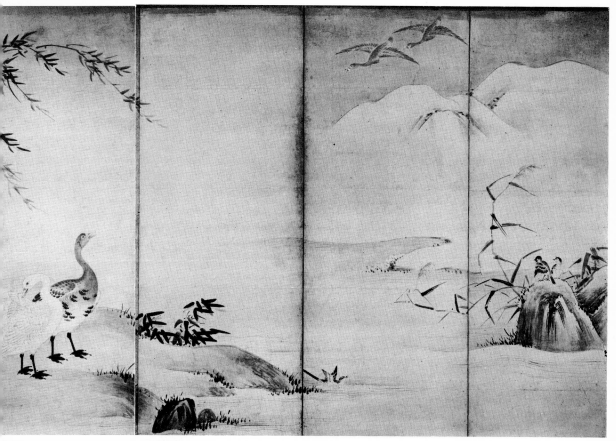

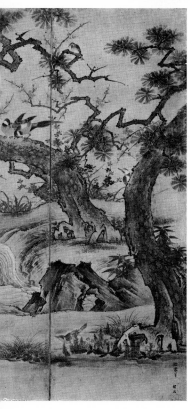

40. *Flowers and Birds of the Four Seasons*, by
Kanō Shōei. Single six-fold screen. Ink on
paper. H. 151.5 cm., w. 372 cm. Boston Mu-
seum of Fine Arts.

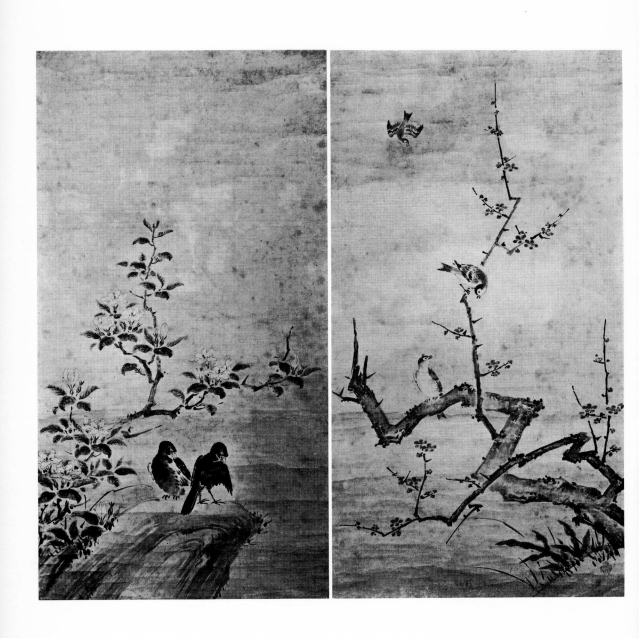

41–42. *Mynah Birds and Gardenias—Small Birds
and Plum Tree*, by Kanō Shōei. Pair of hanging
scrolls. Ink on paper. H. 101 cm., w. 55 cm.
(each scroll). Tokyo National Museum.

94

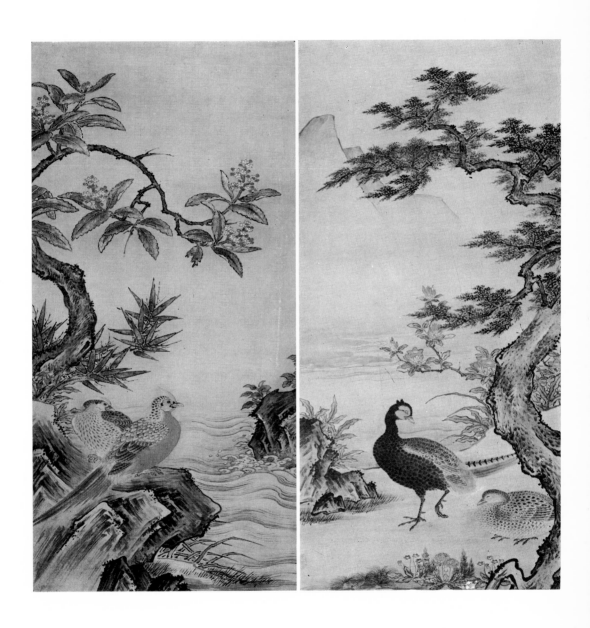

43–44. *Pheasants and Azaleas—Golden Pheasants and Loquat*, by Kanō Shōei. Pair of hanging scrolls. Ink and colors on paper. H. 101 cm., w. 49 cm. (each scroll). Private collection, Japan.

Shōei also produced many flower and bird paintings in the hanging-scroll format. *Mynah Birds and Gardenias* and *Small Birds and Plum Tree* (pls. 41–42), painted in the semicursive *(gyōtai)* monochrome ink style, and *Pheasants and Azaleas* and *Golden Pheasants and Loquat* (pls. 43–44), done in the formal *(shintai)* polychrome mode, are representative works of this type. Although these two pairs of hanging scrolls differ greatly in size from Shōei's screen paintings, they invite comparison in choice and handling of subject matter. His hanging scrolls, in fact, isolate individual scenes from flower and bird screens and represent them autonomously within this smaller format. In these hanging scrolls, as in his screens, Shōei arranges his subject matter in an abstract, conventionalized manner: he emphasizes the foreground elements and abbreviates or excludes background subject matter, and he firmly roots the trees, flowers, and rocks in the lower margins of the paintings.

The serene mood and the fluid brushwork typical of Shōei are seen again in a pair of single-panel screens *(tsuitate)* painted in vivid polychrome colors with a gold-leaf background at the Daitoku-ji temple. On one side of each of the screens is a scene of flowers and birds of the four seasons, with spring and summer on one screen (pl. 50) and fall and winter on the other (pl. 51). The reverse side of each screen depicts Chinese historical figures (pls. 48–49).

The spring and summer painting (pl. 50) is concisely but effectively composed around a flowering plum branch in the upper right and a large red and white peony at the lower left. Two swallows, one perched on the branch above and the other on the rock below, form a counterpoint to the diagonal formed by the branch and flower. The fall and winter scenes on the other screen (pl. 51) are dominated by rose mallow plants growing from the lichen-covered rocks at the lower margin of the painting. Water plantains growing at the river's edge, a cavorting swallow, and a distant snow-covered mountain poking through the gold background complete the scene. Although these screens have been attributed to Eitoku for centuries by temple tradition, when analyzed stylistically they align more closely with Shōei's oeuvre. For example, the fluidity of brushwork and the configuration and texturing of the rocks are hallmarks of Shōei's manner.

Historical Figures

With the reattribution to Shōei of the Daitoku-ji single-panel *(tsuitate)* paintings of flowers and birds of the four seasons came a reexamination of the paintings on the reverse sides, depicting Hsia-ma and T'ieh-kuai (Gama and Tekkai in Japanese) on one panel and Huang Ch'u-p'ing (Kōshohei in Japanese) changing a rock into a sheep on the other (pls. 48–49). Stylistic correlation of detail in these works lends credence to a Shōei attribution. However, these paintings present special stylistic problems when assessing the figure-painting style of Shōei. The individuality of expression is quite removed from typical Kanō-school work, and the poses of the squat, humpbacked men are awkward. Moreover, there is a discernible difference between these figures

96

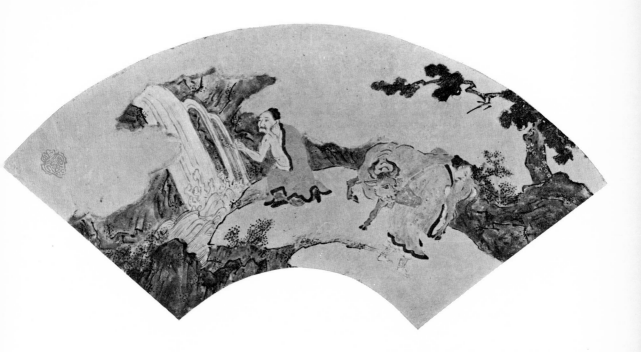

45. *Hsü-yu and Ch'ao-fu*, bearing the "Naonobu" seal. Folding fan painting mounted on a six-fold screen. Ink and colors on paper. W. 50 cm. Honnō-ji, Kyoto.

and those in *The Death of the Buddha* (pl. 32), which adheres to traditional conventions for paintings of this famous Buddhist theme. These three works are valuable documents for the study of Shōei's figure-painting style.

The Death of the Buddha is the earliest dated Shōei painting extant and one of his greatest works. The commission was an important one, and he lavished his utmost care on the huge painting surface. Shōei concentrated particularly on the depiction of the grieving animals and people gathered around the expired Buddha, and while the human figures seem somewhat stylized and brittle, the polychrome animals are rendered with care. The composition as a whole is static, lacking depth or movement. Despite this, it is a most important work, providing, through a Buddhist theme, insights into Shōei's figure-painting style as well as preserving definitive examples of his seal and signature.

Fan Painting

As noted previously, the earliest references to Shōei speak of him as a painter of fans. Sixty of these fans, mounted on a pair of six-fold screens, are now in the collection of the Honnō-ji temple in Kyoto. It appears that they were initially intended to be mounted on screens, for they have no fold marks on them. These polychrome fans depict various Chinese historical figures and all bear the jar-shaped "Naonobu" seal, though not all are of the standard configuration. Shōei, like Motonobu, produced many

97

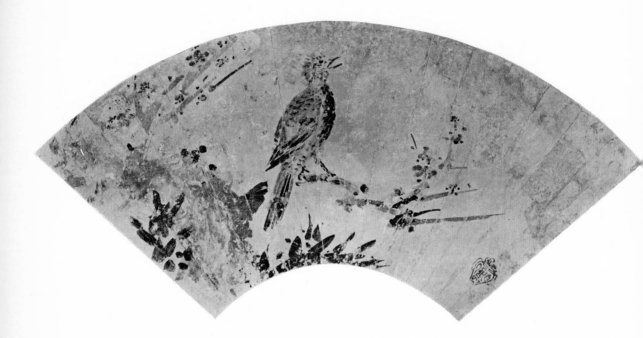

46. *Bulbul on a Plum Branch*, bearing the "Naonobu" seal. Folding fan mounted on a six-fold screen. Ink and gold on paper. W. 48.5 cm. Nanzen-ji, Kyoto.

fan paintings. However, many of those bearing his seal were not produced by the master himself, but by artists in his atelier. For example, *Hsü-yu and Ch'ao-fu* (pl. 45), a representative fan in the group, does not bear the standard Shōei seal, indicating it may be a product of his atelier. Moreover, although the depiction is evocative of previous representations of the same subject, the brushwork is stiff and unrefined.

Of the two hundred and forty fans mounted on eight separate six-fold screens in the collection of the Nanzen-ji temple, Kyoto, nine bear the "Naonobu" seal. Because these Nanzen-ji fans were made for individual use rather than for mounting, they avoid the mass-produced similarity of those on the Honnō-ji screens. They do, however, demonstrate a similar style. These fans are chiefly of Chinese historical subjects, save two each of flowers and birds (pl. 46) and the eight views of the Hsiao and Hsiang rivers on oval-shaped nonfolding fans *(uchiwa)*. *Bulbul on a Plum Branch* (pl. 46), in monochrome ink rather than the usual colors, is a rarity among flower and bird paintings of this era. The composition is quite simple, comprising only the plum tree at the left and a bulbul *(hiyodori)* perched on a branch in the center. The brushstrokes are coarse and brisk, displaying the conservative neatness and careful construction of Shōei.

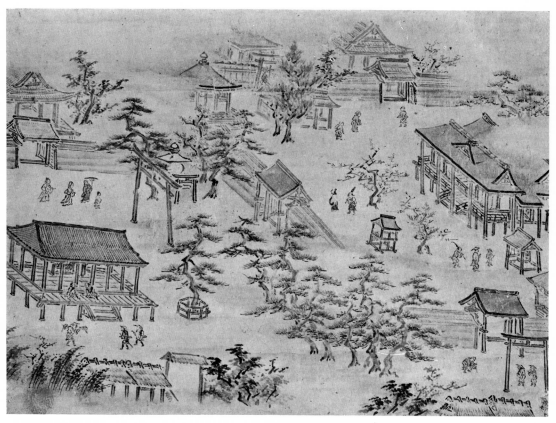

47. *Kitano Shrine*, bearing the "Naonobu" seal. Painting. Ink on paper. Tokiwayama Bunko, Kamakura.

Genre Scenes

Much of the Kanō school production at the beginning of the Momoyama period dealt with genre subjects. Shōei's monochrome ink miniature titled *Kitano Shrine* (pl. 47) is unusual in that pictures of genre scenes at famous places *(meishofūzoku-zu)* were most typically depicted in the detailed polychrome *yamato-e* style. This painting offers glimpses of traditional Japanese customs such as plum viewing as well as technical information about the architecture of the period. The building at the right with the eight-gabled roof is the main shrine *(shinden)*, and the simpler structure to the far left is the sutra reading hall *(kyōdō)*. Because the gate called the Sankōmon is not present, it is clear that the painting predates 1607, the year the gate was constructed. The style of this painting is characteristic of Shōei in both its attention to detail and lack of dynamism.

Shōei also painted genre scenes on fans. His *Scenes in and around Kyoto* (not illustrated) has a close affinity to other Kanō works of that theme. Until his final years, Shōei seems to have remained well in touch with the current production of the Kanō painters working around him, despite a decreased output in his old age.

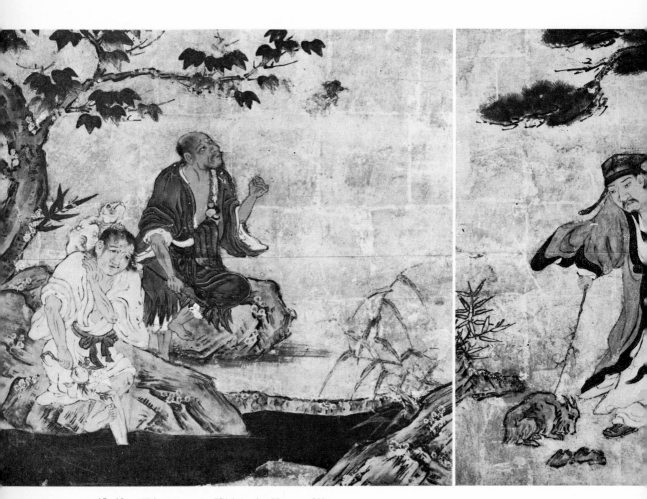

48–49. *Hsia-ma and T'ieh-kuai—Huang Ch'u-p'ing*. Two sides of a pair of *tsuitate* screens. Ink and colors with gold-leaf ground. H. 53 cm., w. 55 cm. (each screen). Daitoku-ji, Kyoto. (See pls. 50–51 for reverse sides.)

100

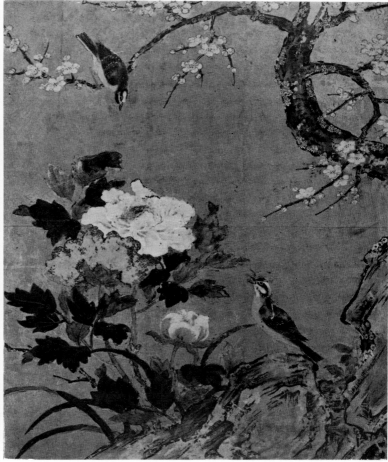

50. *Flowers and Birds of the Four Seasons*. Detail. One side of a pair of *tsuitate* screens. Ink and colors on a gold-leaf ground. H. 53 cm., w. 55 cm. (See also pls. 48–49, 51.)

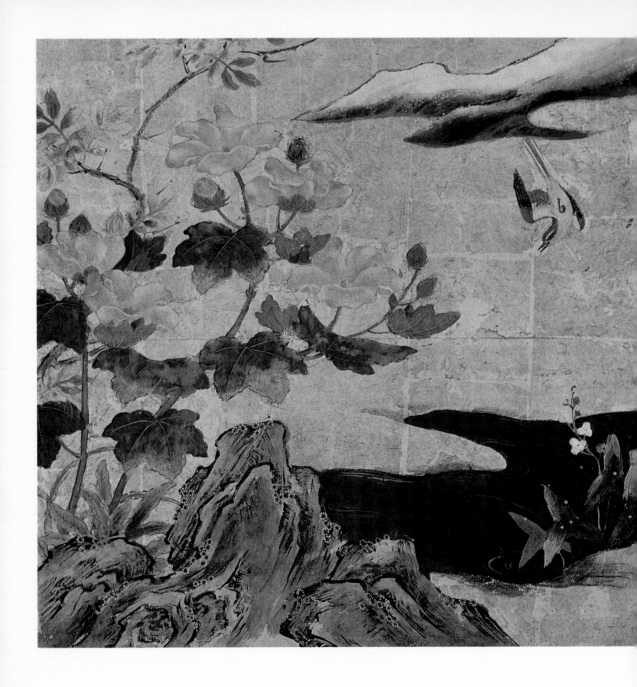

51. *Flowers and Birds of the Four Seasons.* Detail. One side of a pair of *tsuitate* screens. Ink and colors with gold-leaf ground. H. 53 cm., w. 55 cm. Daitoku-ji, Kyoto.

This is the autumn and winter side of a pair of nonfolding standing screens (*tsuitate*), two sides of which depict flowers and birds of the four seasons, their reverses portraying Chinese historical figures (pls. 48–49). Rose mallow plants dominate the scene, towering above the rocks from which they grow. Above the water plantains at the river bank a swallow cavorts, and distant snowy mountains appear through the golden clouds. The lichen-covered rocks of the gold-leaf screen are painted in a semicursive (*gyōtai*) brushstroke that at times borders on the coarse. Although the screen is listed on the temple records as by Eitoku, the finely striated rocks that seem to flow from the bottom of the screen indicate Shōei's style, and it is consequently the current concensus that he, not Eitoku, produced the work. (See also pls. 48–50.)

52. *Monkeys*, by Kanō Shōei. Detail. Four *fusuma* panels in the west room (*nishi no ma*). Ink on paper. H. 175.5 cm., w. 93.5 cm. (each panel). Jukō-in, Daitoku-ji, Kyoto.

This family of long-armed monkeys has been depicted by Shōei with a gentle line that befits the calm atmosphere of the scene. Posed in nearly human attitudes, the monkeys rest on a rock next to a smooth-flowing stream. Quite different in tone from the painting of monkeys by Mu Ch'i, which was often emulated at this time, they exemplify the easy assurance that characterizes Shōei's mature style. (See also pl. 36.)

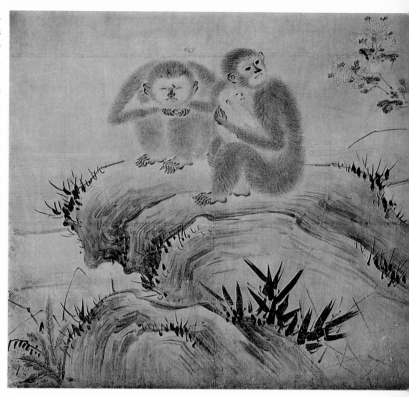

53. *Flowers and Birds of the Four Seasons*; attributed to Kanō Shōei. Detail. Pair of six-fold screens. Ink and light colors on paper. Saikoku-ji, Hiroshima Prefecture.

A brace of pheasants are rendered beneath an ancient pine at the bank of a briskly flowing stream. The style in which the tree and the rocks are painted indicates Shōei's hand, as do the tiny birds on the tree limbs and stream bank. The overall composition is based on Motonobu's principles, but these screens are neither quite as compact nor as intricate as those of Motonobu. Though these characteristics indicate Shōei's style, the manner in which the constituent parts have been blended into a single statement differs somewhat from other Shōei paintings, implying that the work may have been painted not by Shōei himself, but by an artist of his atelier. (See also pl. 39.)

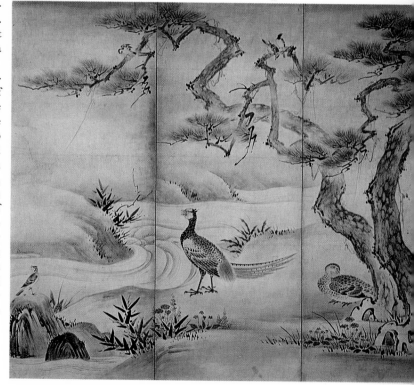

KANŌ SŌSHŪ

Sōshū (alternately, Munehide) was the second son of Shōei, and the younger brother of Eitoku. There is disagreement over his dates, but the consensus of opinion places his birth in 1551 and death in 1601, eleven years after his brother. According to the *Honchō gashi*, Sōshū studied the Eitoku style and preserved it in his own work; thus he can be viewed as a faithful follower of Eitoku and a conservator of his style.

Sōshū's first position of major responsibility fell to him in 1576 when he was left in charge of the Kyoto workshop of the Kanō school while Eitoku undertook the massive Azuchi Castle commission. That this happened in 1576 is reported by Sōshū himself in his last will and testament, addressed to his nephew Mitsunobu. Furthermore, since he states that he was twenty-five years old at the time, it is fairly certain that his date of birth was 1551.

Six years after the beginning of the Azuchi project, Sōshū left for Harima, not far from Kyoto along the Inland Sea, to serve Hideyoshi. It is clear from a letter bearing Hideyoshi's signature and dated 1582, included in the *Nasuke monjo* (Records of the Nasu Family), that Hideyoshi granted a stipend of fifty *koku* of rice to Sōshū's family to sustain them in Sōshū's absence (a *koku* of rice, about 180 liters, was the amount theoretically needed to feed one person for one year). Since the letter bears Hideyoshi's own signature, it can be inferred that Sōshū was in personal service to the general, who was then in Harima warring against the Mōri clan.

One of the earliest surviving paintings by Sōshū is a memorial portrait of Oda Nobunaga (pl. 55) believed painted in 1583, the year after Nobunaga was killed at Honnō-ji by his erstwhile ally Akechi Mitsuhide. This work, in the collection of the Chōkō-ji temple, Aichi Prefecture, is discussed below. In the succeeding years Sōshū played an increasingly important role in the Kanō school, and by 1590 he was a central figure in the organization. He was particularly active in the imperial palace project in 1590, and when the Hasegawa school of painters began maneuvering for a portion of the new palace commission, Sōshū, in the company of Eitoku and Mitsunobu, appealed successfully to the Kajūji family for redress (see chap. 2).

The last decade of Sōshū's life saw no cessation in his production. In 1594 he painted the ten-scroll *Pictorial Biography of the Monk Ippen* (pl. 61), now housed in the Kōmyō-ji temple. According to the inscription at the end of each of the ten scrolls, the project was commissioned by the Mogami family, daimyo of Dewa, as an offering to their temple. A second extant Sōshū painting of a religious subject, *Portrait of the Monk Nisshin* (pl. 54), dates from 1596, two years after the *Pictorial Biography of the Monk Ippen*. It was in this year that Nisshin retired from service after eighteen years as the sixteenth abbot of Honkoku-ji. The inscription at the lower left corner of the work is apparently in Nisshin's own hand. It reads, "Sixteenth day of early winter, 1596, at the age of thirty-six years. Painted by the aged Kanō Sōshū of the *hōgen* rank." The inscription indicates that the painting was made soon after Nisshin's retirement and that Sōshū had been invested with the honorary title of *hōgen* by 1596.

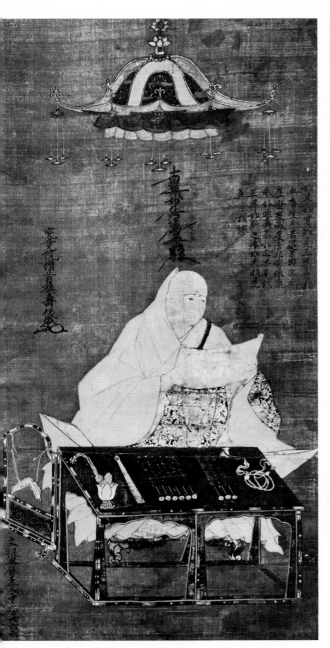

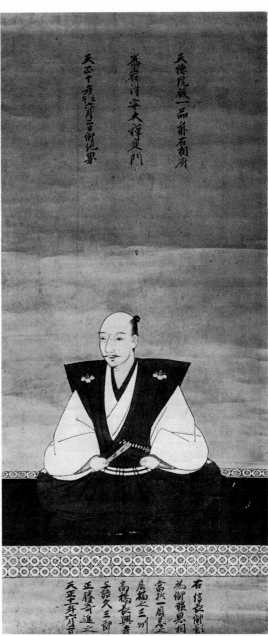

54. *Portrait of the Monk Nisshin*, by Kanō Sōshū. Hanging scroll. Ink and colors on paper. H. 89.5 cm., w. 47.3 cm. Kyoto National Museum.

55. *Portrait of Oda Nobunaga*. Hanging scroll. Ink and colors on paper. H. 70 cm., w. 31.2 cm. Chōkō-ji, Aichi Prefecture.

56. *Minamoto no Shitagō*, bearing the "Genshū" seal. One of the pictures of the Thirty-six Poets. Ink, colors, and gold on wood. H. 80.5 cm., w. 50 cm. Hōkoku Shrine, Kyoto.

Minamoto no Shitagō (911–83) was a famous Heian-period poet and one of the compilers of the *Gosenshū* (Later Poetry Collection). His portrait was hung originally in the worship hall of the Hōkoku-byō, the mausoleum of Toyotomi Hideyoshi. It is painted in traditional *yamato-e* style and thus bound by a stylistic canon not of Sōshū's creation, yet his particular style is seen in the facial expression of the poet, especially in the eyes and nose. The poet's features are of course based on earlier representations. The poem above the figure recalls the traditional practice of writing poetry on elegant colored and patterned paper. The characters are ascribed to the hand of Emperor Goyōzei (r. 1586–1611).

57. *Flowers and Birds of the Four Seasons*, bearing the "Genshū" seal. Detail. Pair of six-fold screens. Ink and colors with gold-leaf ground. H. 162.5 cm., w. 361 cm. (each screen). Private collection, Japan.

Two cranes promenade before a brushwood hedge and two cherry trees in full blossom. Peonies grow by the pond beyond. The composition, brilliantly colored and richly deco-

rated, successfully evokes the fullness of spring. Sōshū is credited with the work because of the "Genshū" seal and the large-scale composition in the Eitoku manner. *Flowers and Birds of the Four Seasons* is a good example of painting at the pinnacle of the Momoyama period, showing more excitement and splendor than the works of Eitoku's successor Mitsunobu. (See also pls. 58–59.)

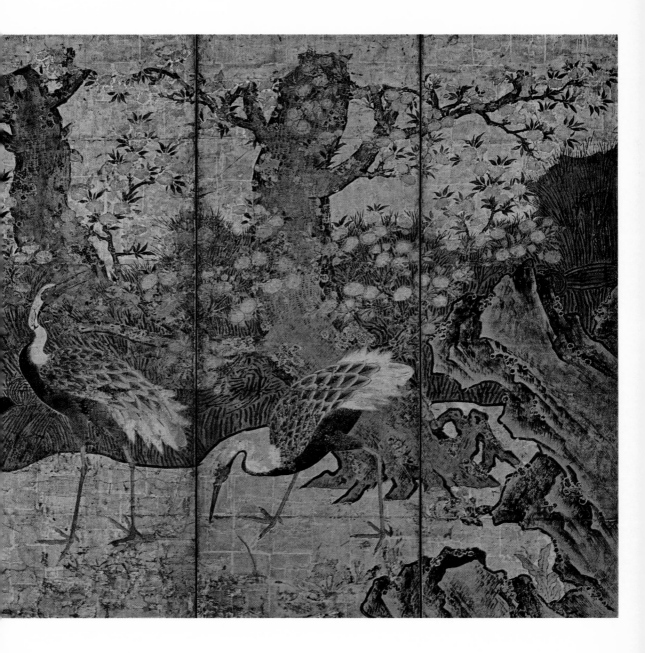

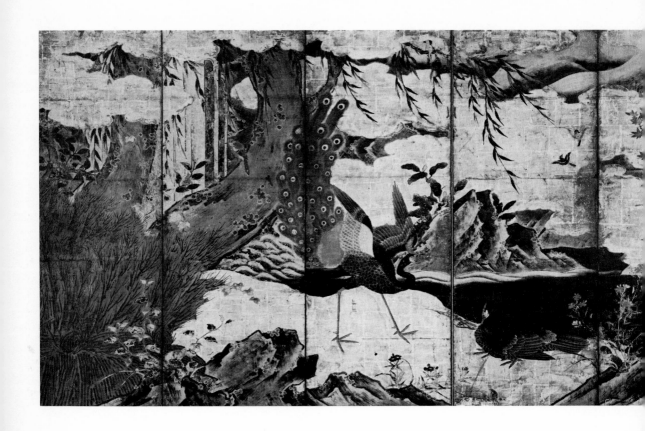

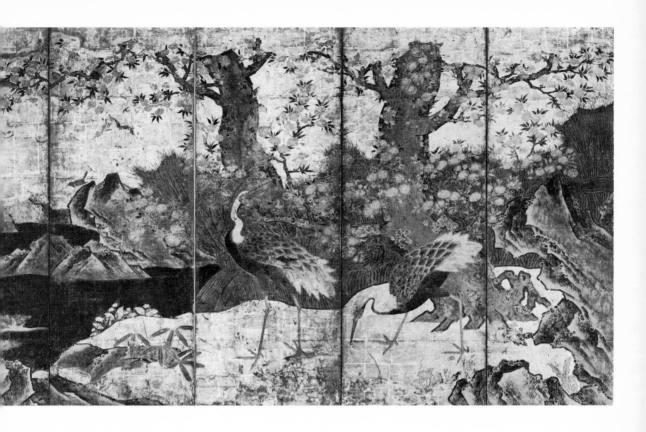

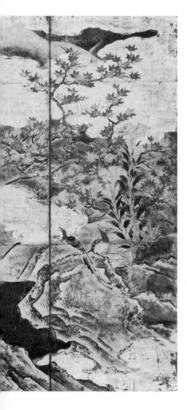

58–59. *Flowers and Birds of the Four Seasons*, bearing the "Genshū" seal. Pair of six-fold screens. Ink and colors with gold-leaf ground. H. 162.5 cm., w. 361 cm. (each screen). Private collection, Japan. (See also pl. 57.)

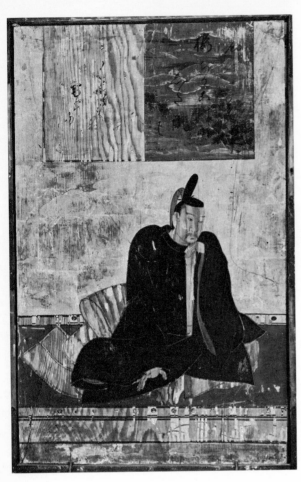

61. *Pictorial Biography of the Monk Ippen*, by Kanō Sōshū. Detail. Ten scrolls. Ink and colors on paper. H. 33.6 cm. (each scroll). Kōmyō-ji, Yamagata Prefecture.

60. *Ki no Tsurayuki*, by Kanō Sōshū. One of the pictures of the Thirty-six Poets. Ink, colors, and gold on wood. H. 80.5 cm., w. 50 cm. Hōkoku Shrine, Kyoto.

In 1598 Sōshū's patron, Hideyoshi, died, and the following year Hideyoshi's mausoleum, the Hōkoku-byō, was constructed. It is thought that Sōshū painted the *Thirty-six Poets* (pls. 56, 60) that originally hung in this worship hall, as his pseudonym Genshū is impressed on each of the paintings. Sōshū is reputed to have done votive pictures of horses, called *ema,* for the shrine as well, but they have been lost. *Ema* ("horse paintings") are painted representations of sacred horses, and often of other subjects as well, dedicated by a private patron to a shrine or temple. According to the records of Hōkoku Shrine, Sōshū's *ema* were the equal of those of Kanō Sanraku, a renowned master in this genre.

Sōshū's final years were devoted to the new Katsura mansion project. According to the diary of Prince Hachijō-no-miya Toshihito *(Toshihito shinnō nikki),* who commissioned this project, Sōshū began work on the mansion's screens in the spring of 1599 and finished them in the early summer of the following year. Late in 1601 the fifty-one-year-old Sōshū sent to Mitsunobu his last will and testament, in which he asked Mitsunobu to take care of his son Jinkichi (later known as Jinnojō) and see that he succeeded to the headship of his branch of the Kanō school. Sōshū's death in 1601 coincides with the end of the apogee of Momoyama painting.

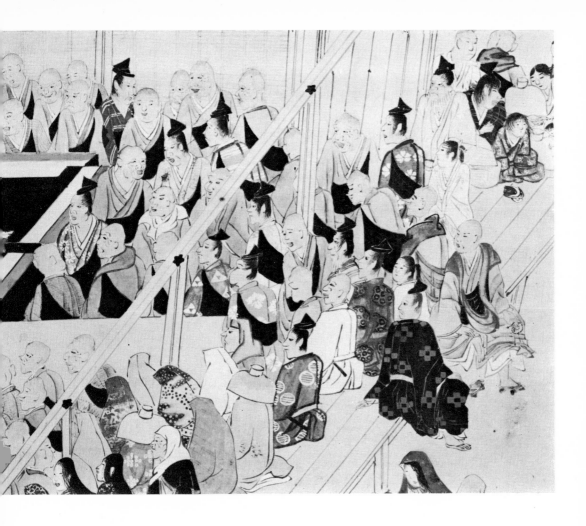

Yamato-e Subjects

Sōshū's paintings in general reflect the style of his elder brother Eitoku and do not demonstrate remarkable freshness or originality. It is only when he paints in the *yamato-e* manner that his own individuality appears. A fine example of his *yamato-e* work is his *Pictorial Biography of the Monk Ippen* (pl. 61), now in the possession of Kōmyō-ji temple. Ippen (1239–89) was a Buddhist monk who traveled throughout Japan preaching the doctrine of the Ji sect, which he founded. The inscriptions on the endpapers of each of the ten scrolls state that they were commissioned in 1594 by the Mogami family. On the decorative box containing the scrolls is a second inscription dated 1631, stating that the artist was Kanō *hōgen* and bearing the seal "Genshū," a pseudonym of Sōshū's.

The Kōmyō-ji scrolls are copies of a set once in the Fujisawa seminary of the Shōjōkō-ji temple in Kanagawa Prefecture. They are of great historical importance, as the originals were destroyed by fire. Thus, though the composition of the paintings was not originally conceived by Sōshū, his personal touch is seen in the precise, lively delineation of the facial expressions in the crowds of people. It seems that it is this figure-painting style that differentiates Sōshū's work from that of his son, Jinnojō, 111

62. *Returning Sails*, bearing the "Genshū" seal. Hanging scroll. Ink and light colors on paper. H. 55.2 cm., w. 40 cm. Private collection, Japan.

who also used the same "Genshū" seal. The illustrated section (pl. 61) depicts the monk Taa (1237–1319), who studied under Ippen, celebrating a memorial invocation of the Buddha's name at Taima in Sagami Province.

The theme of the thirty-six poets originated in a selection by the poet and anthologist Fujiwara no Kintō, at the beginning of the eleventh century, of the greatest practitioners of Japanese poetry to that date. The poets illustrated here are Ki no Tsurayuki (872?– 945; pl. 60), who wrote the classic *Tosa nikki* (Tosa Diary) and helped compile the *Kokinshū* (Collection of Ancient and Modern Poems), and Minamoto no Shitagō (911– 83; pl. 56), who was one of the compilers of the *Gosenshū* (Later Poetry Collection). The poems written above the portraits are in the hand of the emperor Goyōzei (r. 1586–1611).

While these depictions of the poets derive from *yamato-e* models, it is again the vivid facial expressiveness of the figures that marks Sōshū's personal style. Evident in the *Thirty-six Poets* is the type of firm mouth and penetrating eyes characteristic of fan paintings bearing the "Genshū" seal. The images of the poets are novel in that they are painted on gold grounds, and though in slightly weathered condition, on the whole they reflect their original appearance.

Portraits of Contemporaries

The talent Sōshū showed for capturing facial expression in his *yamato-e*-style painting also made him an accomplished portraitist. The portrait of Oda Nobunaga attributed to him is one of the best-known examples of the highly formalized mode of Momoyama portraiture (pl. 55). The general is portrayed in ceremonial *kamishimo* dress. Inscribed above are his posthumous name and the date of his death. Below is an inscription to the effect that the painting was commissioned for a memorial service on the second day of the sixth month, 1583, by Nobunaga's retainer Yogo Masakatsu, the temple petitioner. On the back of the paper mounting, "Kanō" is written and the "Genshū" seal affixed. Due to the absence of any donor inscriptions or other corroboration, however, it is impossible to attribute the work to Sōshū with certainty. It is nevertheless traditionally attributed to him and occupies a prominent position in his oeuvre.

Sōshū is also responsible for the portrait of the monk Nisshin (pl. 54). Nisshin (1561–1617) was the sixteenth abbot of the Honkoku-ji temple in Kyoto and played a major role in its rebuilding. He retired in 1596 for unknown reasons, however, and secluded himself in the Jōjakkō-ji in Saga, west of the capital. In the portrait he is seated under a canopy and wears a scarlet surplice *(kesa)*. Before him is a lectern on which sutras and a rosary are arranged. On the upper right is an inscription from the *Juryōbon* (The Tathagata's Eternal Life), the sixteenth book of the *Lotus Sutra*. Above Nisshin is the invocation "Hail the Lotus of the True Law Sutra" *(Namu myōhōrengekyō)*. "A portrait from life of the high priest Kyūkyōin Nisshin" appears at the left. As pointed out earlier, Nisshin himself wrote the date, 1596, in the lower left corner of the scroll, as well as the fact that it was painted by the artist Kanō *hōgen* Sōshū.

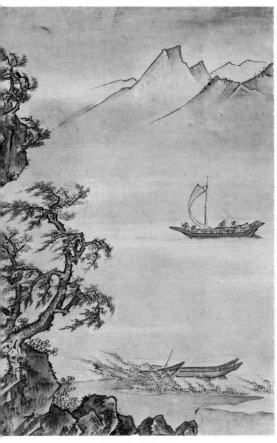
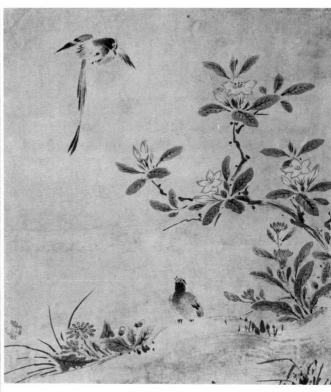

63. *Sankō Birds in Azaleas*, bearing the "Gen-shū" seal. Hanging scroll. Ink on paper. H. 51.5 cm., w. 47.5 cm. Private collection, Japan.

Screens and Hanging Scrolls

The *Honchō gashi* states that Sōshū's brushstrokes were coarse like Eitoku's. This is well illustrated in the pair of six-fold screens entitled *Flowers and Birds of the Four Seasons* (pls. 57–59). The screens are judged to be by Sōshū because of the "Genshū" ar-shaped seals appearing on both members. Due to the locations of the seals, however, it is unclear whether the screens were originally a pair or not.

The right-hand screen, depicting spring and summer, has as its central focus two cranes posed before a pair of cherry trees in full bloom, with a brushwood hedge wind-ing between the trees and with peonies growing on the bank of the pond beyond. The left-hand screen depicts autumn and winter: a peacock and peahen cavort under swaying willow trees; camellias, maples, and autumn bell flowers surround the pond; and snow shrouds the distant peaks.

The bold ink contours, harmonizing beautifully with the magnificent colors, are reminiscent of Eitoku's work. The composition recalls those of Eitoku, but in com-parison to Eitoku's *Pine and Hawk* screens in the Tokyo University of Fine Arts (pls. 20, 22), Sōshū's work seems a bit complicated and lacking in unity. He did not use empty space as creatively as Eitoku did; thus, his painting appears comparatively cluttered and lacking in depth. Sōshū's *Flowers and Birds of the Four Seasons* is, all told, a good example of the Momoyama style of the final years of the sixteenth century. It

is filled with excitement and splendor, in contrast to the subdued screens of the next Kanō master, Mitsunobu.

The same weaknesses that mar Sōshū's *Flowers and Birds of the Four Seasons* are seen in his hanging scrolls. *Returning Sails* (pl. 62) is painted in light colors in the formal *(shintai)* style. Because the reeds and boats in the foreground, the sailboat in the background, and the mountains in the distance are depicted with the same crispness and definition, the picture becomes flat and monotonous. This is also true of *Sankō Birds and Azaleas* (pl. 63). A monochrome ink painting in the fluid *(gyōtai)* style, it is almost completely two dimensional: the birds, azaleas, dandelions, and violets are arranged in vertical-horizontal relationships. Background is completely eliminated, further accentuating its spatial flatness.

Fan Paintings

While there are few fan paintings securely linked with Eitoku, both Shōei and Sōshū are known to have been prolific in this genre. The precise extent of Sōshū's work in this format is difficult to determine since his son Jinnojō also used the "Genshū" seal on fan paintings. It is Sōshū, however, who was responsible for many, if not all, of the fans in the *Famous Places in the Capital* series. Though once a set of approximately sixty fans collected in an album, only twenty remain and are now divided among various collections. Many of the scenes depicted, such as the Kinkata mansion of the Saionji family and the Hosokawa mansion, are also seen in Eitoku's *Scenes in and around Kyoto* (pls. 5–7, 15–16). The construction of the various mansions and temples depicted in the *Famous Places in the Capital* fans date prior to the revision of Kyoto temples in 1591, making it nearly certain that it was Sōshū, not Jinnojō, who was responsible for their execution. The fan painting entitled *Kitano Shrine* (pl. 65) is one of this series. The buildings, plum trees, and shrine visitors are depicted with close attention to detail and, as with Shōei's monochrome ink miniature of the same subject (pl. 47), it is because of the absence of the Sankōmon gate that the fan can be dated prior to 1607.

The "Genshū" seal also appears on fans mounted on screens in the collection of the Nanzen-ji temple (pl. 66). These screens, discussed previously, also contain fans with the seals used by Motonobu and Shōei. Most of the fans bearing the "Genshū" seal are highly colored paintings with gold backgrounds and depict Chinese historical figures. As the style is similar throughout to Sōshū's figure-painting style, it seems that he, and not his son Jinnojō, is responsible for them.

Though not a figure painting, the fan painting entitled *Waves and Cliffs* from the Nanzen-ji collection is historically interesting (pl. 64). It is a monochrome ink painting in the cursive *(sōtai)* style, and all detail has been eliminated save for the wave crests to the left and the reed-covered cliffs to the right. The "boneless" *(mokkotsu)* technique is used in which an area of ink describes the subject and not a black defining outline. The painting seems to have been modeled after a pair of hanging

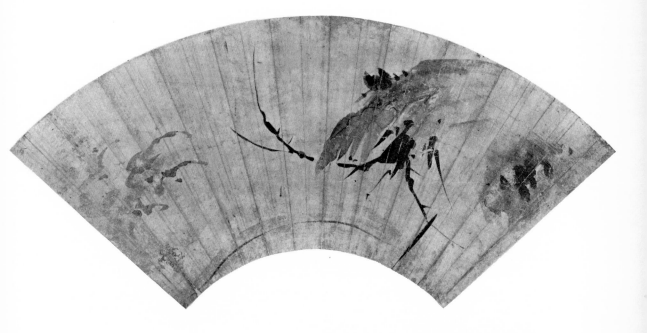

64. *Waves and Cliffs*, bearing the "Genshū"
seal. Folding fan painting mounted on a screen.
Ink on paper. W. 50 cm. Nanzen-ji, Kyoto.

scrolls entitled *Waves and Cliffs* by the mid-thirteenth century Chinese master Yü Chien.
Sōshū's fan painting corresponds with the description of Yü Chien's paintings found
in the *Tōhaku gasetsu,* a painting commentary written by the artist Hasegawa Tōhaku
(1539–1610), which states that "the waves strike the cliff and recede." Sōshū's fan
painting corresponds exactly to this description.

Though his compositions are often overcomplicated and lack dynamism, Sōshū was
a faithful follower of the Eitoku style and effectively adopted Eitoku's vivid brush
handling in his own paintings. In contrast, the style of his father, Shōei, was founded
on that of Motonobu, who lived a generation earlier. Shōei's paintings were behind
the times, though he was familiar with the new fashion of polychrome painting with
gold-leaf background popularized by Eitoku. Thus Shōei's paintings appear modest
and conservative in relation to the monumentality achieved in his son Eitoku's work.
Both Shōei and Sōshū were competent Kanō-school artists during the Momoyama
period, but their artistic achievements were overshadowed by their brilliant kinsman
Eitoku.

115

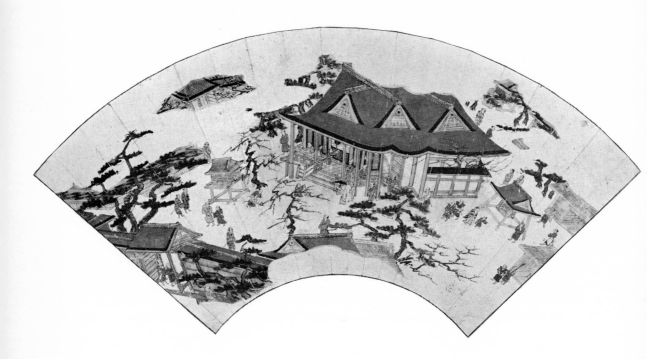

65. *Kitano Shrine*, bearing the "Genshū" seal. Folding fan painting mounted on an album leaf. Ink and colors on paper with gold-leaf ground. W. 50 cm. Private collection.

66. *A Tartar Hunt*, bearing the "Genshū" seal. Folding fan painting mounted on a screen. Ink and colors on paper with gold background. W. 50.8 cm. Nanzen-ji, Kyoto.

A Central Asian hunt is the subject of this folding fan, with Tartar horsemen deftly pursuing wild hare and deer. The vigorous action of the scene is heightened by brilliant coloration and gold ground. At the upper left is impressed the "Genshū" seal. Although both Sōshū and his son Jinnojō used this seal, the figures here are quite different from those of the younger artist. The simply rendered expressions on the round faces of these figures match those of the other four "Genshū" fans in the Nanzen-ji collection. This fan and the other four as well must thus be tentatively attributed to Sōshū.

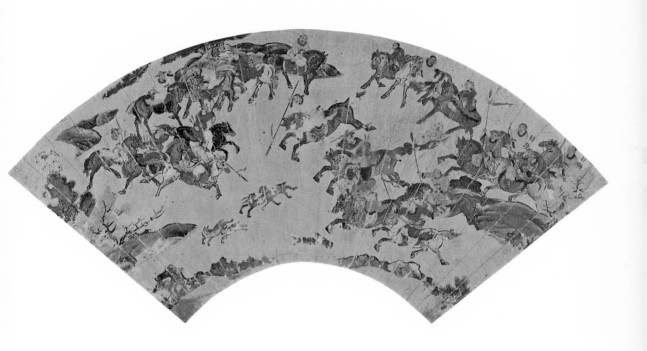

5

KANŌ MITSUNOBU

The leadership of the Kanō school was passed on to Mitsunobu (1561–1608), the eldest son of Eitoku, following the death of his father in 1590. The data available on Mitsunobu's life is meager in comparison with that on Eitoku; in general, his painting career spans the Tenshō (1573–92), Bunroku (1592–96), and Keichō (1596–1615) eras. The largest body of data on Mitsunobu concerns the last two periods, when Mitsunobu supervised the main branch of the Kanō academy. As holder of this position, Mitsunobu stood at the pinnacle of the Kanō family hierarchy. However, in following his career, it becomes evident that Mitsunobu lacked the ambition and talent that had secured for Eitoku, a generation earlier, the limelight of contemporary art circles. Under Mitsunobu's direction, the main or Motonobu branch of the Kanō school no longer reigned supreme in the art world, and Mitsunobu's success as an artist was checked by adroit competitors like Kanō Sanraku (1559–1635) and Hasegawa Tōhaku (1539–1610). Consequently, Mitsunobu has been rather neglected by art historians. In recent years, however, there has been considerable interest in studying Mitsunobu's painting style, partly in the interest of reclassifying many paintings traditionally attributed to Eitoku, partly in the interest of reevaluating Mitsunobu's own merit as an artist.

THE EARLY YEARS

When Mitsunobu was about ten years old, he was designated the direct successor of Eitoku. If one follows the account in the *Honchō gashi,* it seems that Mitsunobu had not been satisfactorily trained in the traditional Kanō school methods during his younger years, and in order to carry on the family heritage after Eitoku's death, he devoted himself to learning the doctrines and techniques of the school from relatives and Kanō pupils. There are other names that Mitsunobu used during his lifetime, chiefly Shirōjirō and Ukyōnoshin. Later Mitsunobu came to be called Ko Ukyō (Old Ukyō) to distinguish him from Kanō Yasunobu (1613–85), who also used the name Ukyō.

The earliest mention of Mitsunobu's painting activities is in connection with the

screen and wall paintings done for Azuchi Castle. According to a 1581 entry in the *Shinchō-kō ki* (The Biography of Nobunaga), Mitsunobu was one of the painters who received *kosode* from Nobunaga after the completion of the massive painting project for the seven-story central tower of the castle. There seems to have been haggling over the apportionment of the work at Azuchi Castle, but it is known that Mitsunobu worked under Eitoku's direction and was given the position of chief painter of the leading craftsmen.

According to the *Kachō yōryaku* (Records of the Shōren-in Temple), Mitsunobu painted an *ema* titled *Benkei on the Bridge,* inscribed in 1588 by Sonchō, the famous calligrapher-priest of the Shōren-in, Kyoto. We also know that Mitsunobu participated in such exclusive building enterprises as the imperial palace, Jurakudai, and Osaka Castle in the latter half of the Tenshō era (1573–92), during the lifetime of Eitoku. In the imperial palace undertaking it will be recalled that, in 1590, members of the Hasegawa school were maneuvering to take charge of the work in the *tainoya,* but their attempts were frustrated by the intervention of Eitoku and Sōshū. According to Kajūji Haretoyo's diary, one week after Eitoku died Mitsunobu took command of the imperial palace project and executed the paintings for the new buildings. As Eitoku's successor Mitsunobu fell heir to many Toyotomi-family painting projects; the *Kanō gokafu* (History of the Five Kanō Families) records the fact that Mitsunobu was awarded the vermilion seal inscribed *chigyō hyakkoku* (a feudal rank entitled to 100 *koku* of rice) by Toyotomi Hideyoshi after the death of Eitoku.

Nevertheless, many of the prize commissions of the Toyotomi family were awarded to the Hasegawa school while Mitsunobu was director of the Kanō workshop. A foremost example is the commission to paint at the Shōun-ji, the chapel founded in Osaka by the Toyotomi family to insure happiness in the next world for Hideyoshi's eldest son, Sutemaru, upon his early death at the end of the Tenshō era (1573–92). The resplendent flower and tree paintings made for this memorial chapel are now enshrined at the Chishaku-in, Kyoto. It was Mitsunobu, however, who was beckoned by Hideyoshi to Nagoya in Hizen Province, Kyushu, to decorate the rooms of the castle that had been hastily erected as an advance base for Hideyoshi's Korean expedition of 1592. According to the *Matsura-ki shūsei* (Collected Records of Matsura City [Northern Kyushu]), Mitsunobu depicted a landscape with flowers and birds for the *shoin* room, *The Queen Mother of the West* (in Chinese *Hsi-wang-mu*) for the formal reception room *(goza no ma),* a scene of cultivation for the next room, paintings of flowers and birds for the succeeding room and each of the rooms in the detached palace. Even in this project Mitsunobu was not free from artistic rivalry, for it seems that the Hasegawa school was apportioned paintings in the main residential quarter, in the *omote goza no ma* (front, formal reception room), and in the room next to it.

It is thought that the Nagoya castle project engaged Mitsunobu through the next year. Not only did he continue work on the wall paintings of Hideyoshi's lodgings at this time, but he also rendered a painting on a free-standing folding screen *(byōbu)*

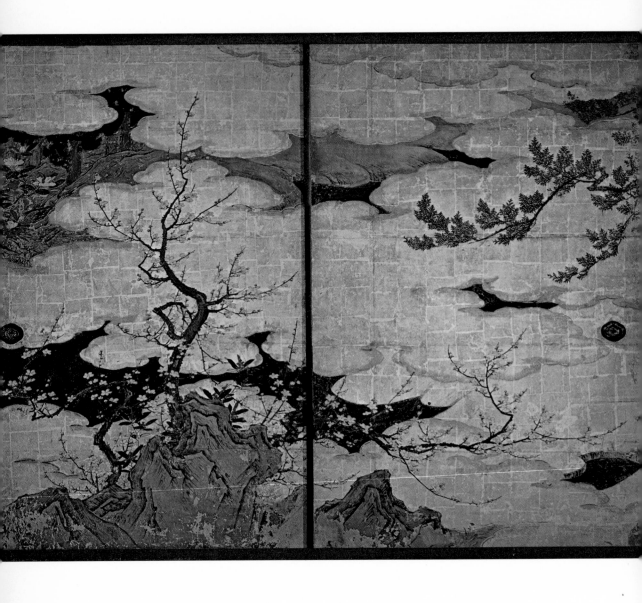

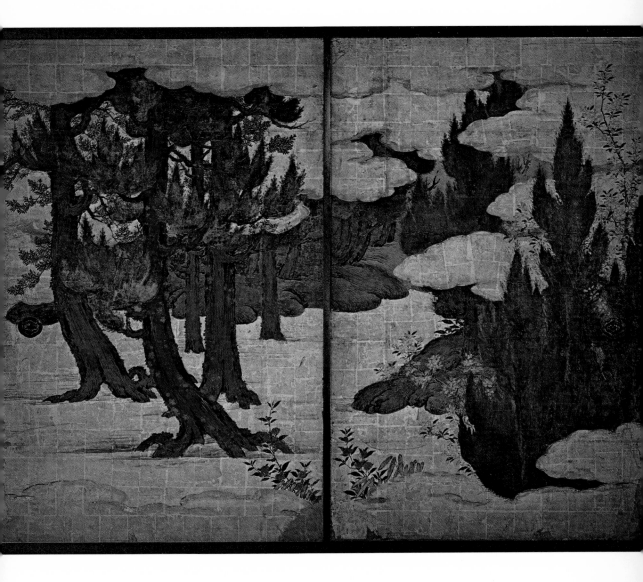

67. *Flowers and Trees of the Four Seasons*, by Kanō
Mitsunobu. Detail. Twelve *fusuma* panels in the
jōdan no ma. Ink and colors with gold-leaf ground.
H. 179 cm., w. 116.5 cm. (each panel). Kangaku-
in, Onjō-ji, Shiga Prefecture.

The cycle of *fusuma* paintings in the main guest
room of the Kangaku-in begins in the northwest
corner with a scene of plum blossoms and pro-
ceeds in an easterly direction to a grove of
evergreens and cypresses wreathed by blossoming
cherry trees (reproduced here). The seasonal
progression continues on the south wall where

hydrangeas and irises (representing summer)
metamorphize into the red foliage of fall.
Mitsunobu reserved the large *tokonoma* area of
the west wall for his triumphant finale to the
assemblage: a cascading waterfall amid snow-
laden alpine scenery (pl. 76). This work is
characteristic of Mitsunobu in its use of a com-
plex gold cloud to organize objects at various
planes in depth. Also representative of his style
are the rhythmical poses of natural forms and
the delicate brush texturing used to delineate
the tree limbs and rocks. (See also pl. 74.)

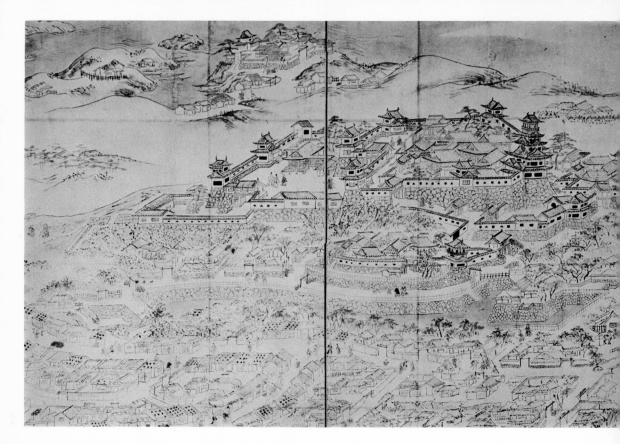

68. *Hizen Nagoya Castle.* Detail. Preliminary drawing now mounted as a six-fold screen. Ink on paper. H. 157 cm., w. 350.5 cm. Saga Prefectural Museum, Kyushu.

depicting the Nagoya castle site. According to a 1688 entry in the *Jōken-in gojikki,* a biographical history of the fifth Tokugawa shogun, Tsunayoshi (r. 1680–1709), it was presented to the Tokugawa family by the police commissioner Itakura Shigetsune upon his resignation in 1688. Further, in the *Kansei chōshū shokafu* (Records of Samurai Families Compiled in the Kansei Era, 1789–1801), Mitsunobu's work is described as a pair of screens, one of which featured the Nagoya castle while the other illustrated the famous island shrine at Itsukushima on the Inland Sea. Although it does not bear Mitsunobu's signature, there is an extant drawing (pl. 68) believed to be the one on which Mitsunobu based his screen painting of the Nagoya castle or, as another theory has it, a copy of the finished work. This drawing is now mounted as a six-fold screen, though it was not originally meant for mounting. Featured in this drawing are Hideyoshi's main compound *(hommaru)* and the surrounding auxiliary compounds that contained the residences of his family and other household members, the administrative buildings, and the official reception halls. Numerous daimyo residences are portrayed as well as the homes and activities of hundreds of city dwellers.

Aside from the mention in the *Oyudono no ue no nikki* of a screen done for the imperial court at the end of 1598, there are no records that illuminate Mitsunobu's activity after the Nagoya castle commission in 1592 until around the time of the Battle of Sekigahara in 1600. However, one can posit that Mitsunobu maintained strong ties with the

122

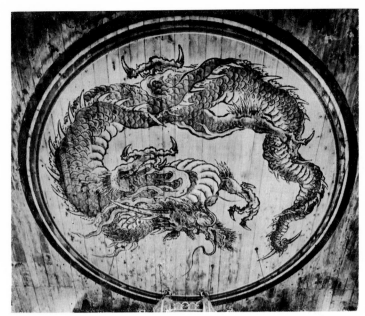

69. *Dragon*; attributed to Kanō Mitsunobu. Ceiling painting in the *hattō*. Ink and colors on wood. Shōkoku-ji, Kyoto.

Toyotomi family during this period, and it is extremely likely that he executed a portrait painting of his leading patron, Hideyoshi.

Mitsunobu's part in the decoration of the guest rooms of the Kangaku-in, in the temple compound of the Onjō-ji at Ōtsu, is documented in an inscription made at the time this chapel was repaired in the Kansei era (1789–1801). According to the repair slip, the Kangaku-in was built in 1600, and Toyotomi Hideyori appointed Mōri Terumoto (1553–1625) to be the shogunate administrator *(bugyō)* in charge of the project, with Mitsunobu commissioned to do the paintings. After this, because of the existence of the formidable Kanō-school artists Sanraku (1559–1635) and Naizen (1570–1616), who also painted for the Toyotomi family, the Kanō school as a whole maintained its prestigious position in contemporary painting circles.

Late in 1601 Mitsunobu's uncle Sōshū became seriously ill and drew up a will that he entrusted to Mitsunobu. In this document Sōshū outlined his desires for the succession of his branch of the Kanō school: it was Sōshū's express wish that his son Jinkichi (later known as Jinnojō) succeed him, but in the event of some catastrophe Mitsunobu was to choose an appropriate heir. Sōshū died the next year, and Mitsunobu placed one of his pupils, Kanō Kozaemon, in charge of Jinnojō's painting instruction. Sōshū's reliance on Mitsunobu to carry out the dictates of his will underscores Mitsunobu's position of authority in the Kanō family hierarchy.

123

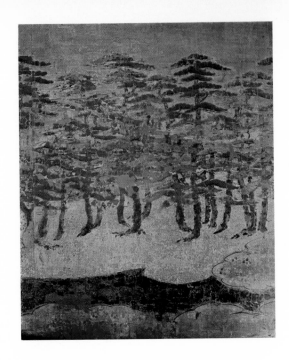

72. *Beach Pines*; attributed to Kanō Mitsunobu. Detail. Wall paintings in the inner sanctuary. Ink and colors on gold-leaf ground. Kōdai-ji, Kyoto. (See also pls. 70–71.)

70–71. *Beach Pines*; attributed to Kanō Mitsunobu. Detail. Wall paintings in the inner sanctuary. Ink and colors with gold-leaf ground. Kōdai-ji, Kyoto.

The Kōdai-ji was constructed in 1605–6 by Kita no Mandokoro as a mortuary sanctuary for her husband Toyotomi Hideyoshi. The *Beach Pines* wall paintings (*kabe haritsuke*) were carried out on the north, east, and west walls of the inner sanctuary as well as on the dais. The paintings are in the detailed *saiga* manner with gold backgrounds; the strident polychromy suggests *yamato-e* influence. One is struck by the decorative appeal of this work, with plum blossom patterns on the gold clouds and granular texturing of the green foliage. (See also pl. 72.)

Some of Mitsunobu's artistic endeavors during the year 1603 can be gleaned from a passage in Yamashina Tokitsugu's diary: it is reported in an entry of that year that Mitsunobu executed a painting, depicting scenes of the imperial palace and its surroundings, for the mansion of Tokugawa Hidetada (1579–1632), the second of the Edo shoguns. Tokitsugu's diary notation is particularly important since it is one of the records that documents a liaison between the main branch of the Kanō school and the Tokugawa family.

The Commissions at Shōkoku-ji and Kōdai-ji

In 1605 Mitsunobu painted a dragon for the ceiling of the *hattō* of the Shōkoku-ji (pl. 69). This eminent temple had been established in the late fourteenth century as a family mortuary temple by the Ashikaga shogun Yoshimitsu (r. 1368–94). Perhaps it is equally well known as the place where such illustrious priest-painters as Josetsu and Shūbun (both active first half fifteenth century) and Sesshū (1420–1506) gathered to receive instruction in Zen and to study painting. Despite its distinguished origins, the Shōkoku-ji's history had been marred by numerous fires and other disasters ruinous to temple structures. In 1596 Hideyoshi initiated a massive restoration campaign at the Shōkoku-ji, and late in 1605 the dedication ceremonies marking the completion of the *hattō* were held. Although the dragon painting on the ceiling of the *hattō* is not signed, the *Honchō gashi* attributes it to Mitsunobu. The dragon is deftly rendered in colors and ink and circumscribed by concentric circles; extending beyond this to the four corners of the ceiling are a network of undulating clouds.

Dating also from about this time are the screen and wall paintings done at the Kōdai-ji. The Kōdai-ji is famed as the Zen temple constructed by Hideyoshi's wife, Kita no Mandokoro, as a memorial chapel to her husband in 1605–6. Kita no Mandokoro took religious vows as the nun Kōdai-in, and resided at the temple until her death in 1624. In the sanctuary, flanking the main altar, are the statues of Toyotomi Hideyoshi (on the right) and Kita no Mandokoro (on the left; pl. 72). The walls and dais of the inner sanctuary are adorned with scenes of beach pines (pls. 70–72). These paintings are listed among Mitsunobu's oeuvre by such Edo-period records as the *Sanshū meisekishi* (Famous Historic Places in Yamashiro), but the temple records of the Kōdai-ji do not document them. The records do state, however, that Mitsunobu worked together with Kanō Kōi (d. 1636) and Watanabe Ryōkei (d. 1645) on the paintings designed for the guest rooms in the temple.

125

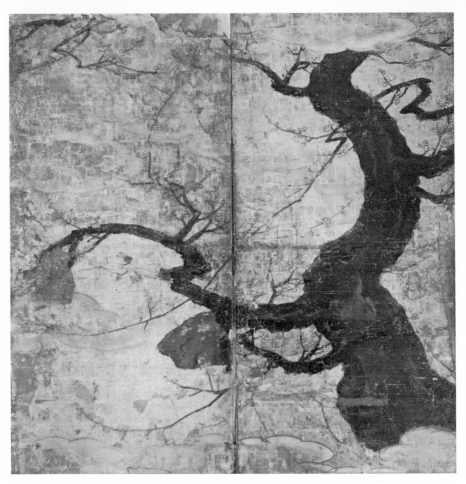

73. *White Plum.* Two-fold screen. Ink and colors on gold-leaf ground. H. 174 cm., w. 180 cm. Kōdai-ji, Kyoto.

Besides the *Beach Pines* of the inner sanctuary, it is thought that Mitsunobu also composed the paintings *Pine and Cryptomeria* for the Buddhist altar room *(butsudan no ma)* at the Kōdai-ji. Only a portion of these paintings has survived. It is the opinion of the Japanese art historian Doi Tsugiyoshi that the painting entitled *Autumn Cryptomeria,* now remodeled into a single two-fold screen, was originally part of Mitsunobu's scheme for the Buddhist altar room. This seems likewise to have been the lineage of *White Plum* (pl. 73), which is now also structured into a two-fold screen and retains the marks of handholds *(hikite)* as evidence of its original function as a sliding screen. Although the *White Plum* painting is not referred to in the temple's records or signed, chronologically and stylistically it is in harmony with the paintings done by Mitsunobu for the interior chambers of Kōdai-ji. It exhibits Mitsunobu's predilection for elegant compositions rather than bold ones in the Eitoku vein. The thin, exquisite plum branches, extending in graceful sinuous forms from the thick core of the trunk, recall Mitsunobu's characteristic fragility of design and execution. Adding an overall sense of delicacy, together with the modeling and the emphasis on forms, are the gold dust *(kindei)* sprinkled over the surface of the trunk and the *gofun* used to mold the plum blossoms in relief.

126

Mitsunobu's Legacy

For about twenty years after the death of Eitoku, Mitsunobu was the center of Japanese painting circles and, independently of Sanraku, exerted a tremendous influence on the Kanō school. Among those who inherited the Mitsunobu style were his son Sadanobu (1597–1623), his brother Takanobu (1571–1618), his younger cousin Jinnojō, and his best students, Kanō Kōi (d. 1636) and Watanabe Ryōkei (d. 1645). It is known that Kōi taught painting to the three sons of Takanobu—Tan'yū (1602–74), Naonobu (1607–50), and Yasunobu (1616–85)—and it cannot be overlooked that Kōi contributed, though secretly, to the establishment of the Edo Kanō branch, with Tan'yū as its head.

Mitsunobu's works, unlike those of Sanraku, did not take the direction of elaborating upon the monumental style of Eitoku and making it more ornamental in the spirit of the age. Rather Mitsunobu turned to the detailed *yamato-e*-style, from which he evolved a new aesthetic. Mitsunobu's paintings are said to be "in the *yamato-e* mode," and there are points of comparison that tie his elegant, restrained style to the Tosa *yamato-e* school. Tosa school influence on Mitsunobu's work may have ensued directly through marriage, for there are those who contend that he married the daughter of the artist Tosa Shōgen.

Unlike the energetic reception with which critics invariably greeted the frank, extroverted style of Eitoku, the later assessment of the artistic talent of Mitsunobu and that of his brother Takanobu was sometimes less than flattering. In the *Sangyōan danwa,* a compilation of discourses by Kimura Tangen (1679–1767), both Mitsunobu and Takanobu are given a cold reception and belittled as incompetent artists compared with their father. However, the *Honchō gashi,* the history of Japanese painting written by Kanō Einō, offers a more favorable opinion. This record states, in effect, that while Mitsunobu did not surpass the standard set by Eitoku, he was not a mediocre artist. Perhaps Mitsunobu should be thought of as an artist who, possessing a fine poetic sentiment, aimed at a graceful style. His merit might be more accurately determined if we were to view him as a painter who tried to respond in an individual way to the aesthetic sensibilities of the age.

During the early part of his career, Mitsunobu's most illustrious patrons were Toyotomi Hideyoshi and his son Hideyori. Even after supreme political rule passed from their hands to Tokugawa Ieyasu, the Toyotomi family were granted asylum at Osaka Castle and Mitsunobu continued to paint for them. Many of Mitsunobu's commissions after 1603, however, were executed for the new Tokugawa rulers, at first Ieyasu (r. 1603–5) and later his son Hidetada (r. 1605–23). To carry out these commissions, Mitsunobu began commuting to the new capital located at Edo (modern Tokyo), and in 1608, while returning home to Kyoto from one of these journeys, he died in the town of Kuwana in Ise Province (modern Mie Prefecture).

127

THE LARGE-SCALE WORKS

Nearly all of Mitsunobu's extant works are screen paintings, there being few hanging scrolls or fan paintings associated with his name. Consequently, in assessing his art one must concentrate on large-scale works, the most important of which date from his later years in the Keichō era (1596–1615). Among Mitsunobu's most representative large-scale works are the screen paintings done for the guest rooms of the Kangaku-in, a subtemple of the Onjō-ji in Shiga Prefecture. These paintings are particularly significant among Mitsunobu's oeuvre since they bear written documentation. In modern times a repair slip dated 1799 was discovered behind one of the wall paintings in the Kangaku-in, stating that the guest halls were constructed in 1600 by Toyotomi Hideyori and that the artist was Mitsunobu. The rooms associated with Mitsunobu's name today are the *jōdan no ma* and the next room *(ni no ma),* and include the gold-leaf *Flowers and Trees of the Four Seasons* as well as *Flowers and Birds,* also in polychrome but without a gold background.

For the *Flowers and Trees of the Four Seasons* (pls. 67, 74) in the *jōdan no ma,* or main room, Mitsunobu simply used varied types of trees and flowers to evoke the nuance of each season, entirely excluding birds from the composition. Squares of gold leaf establish a complex array of gold clouds over large areas of the painting, with occasional openings that offer glimpses of recessed areas of the landscape. In Mitsunobu's composition the gold background and gold clouds are arranged into various planes, segregating the scene into left and right halves and foreground and background areas. Although Motonobu was the first member of the Kanō family to experiment with gold as a background for paintings, it was under Mitsunobu that the gold-background composition reached its ultimate in technical perfection. Moreover, the use of gold is so lavish that the landscape element, generally used to form the nucleus of a scene, is de-emphasized.

One of the focal points of the cycle of flower and tree paintings that line the perimeter of the main room is the large painting of a waterfall (pl. 76) pasted on the wall of the recessed alcove *(tokonoma).* Due to moisture from the wall the alcove painting is considerably more deteriorated than the *fusuma* paintings in the room, but one can clearly discern a gushing waterfall in a snow-capped alpine environment. In contrast to the laterally expansive movement of the natural forms seen in the other large-scale works in this room (pls. 67, 74), the composition of *Waterfall* is quite intimate and self-contained.

The other room assigned to Mitsunobu in the Kangaku-in is the *ni no ma* (located next to the *jōdan no ma),* which contains twenty-four *fusuma* paintings on the theme of flowers and birds (pl. 75). In contrast to the paintings in the *jōdan no ma,* Mitsunobu not only relinquished the domineering gold background but peppered these scenes with many birds, as well as plants, to represent the seasons: sparrows and bamboo, cranes and rushes, pheasants and pines, and wagtails and rocks. In terms of composition, also, these paintings seem at variance with those in the *jōdan no ma.* For example,

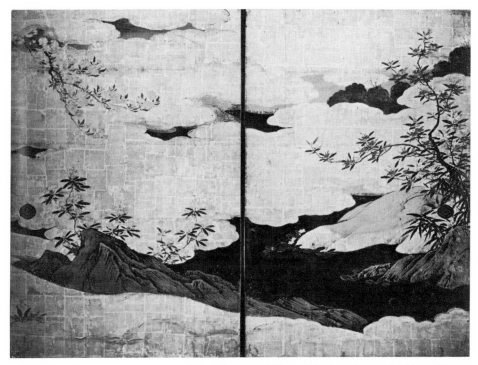

74. *Flowers and Trees of the Four Seasons*, by Kanō Mitsu-
nobu. Detail. Twelve *fusuma* panels in the *jōdan no ma*.
Ink and colors with gold-leaf ground. H. 179 cm., w.
116.5 cm. (each panel). Kangaku-in, Onjō-ji, Shiga Pre-
fecture. (See also pl. 67.)

the two massive pines in the northwest corner span eleven *fusuma* panels and recall
Eitoku's monumental style in their boldness and breadth. However, in spite of Mitsu-
nobu's employment of this Eitoku-like device, his composition is weak rather than
striking: his unification of the diverse flowers and birds is based on a schematic arrange-
ment of static natural forms rather than compositional alacrity. Whether or not this
room is the product of Mitsunobu's brush is open to speculation, but stylistically it
relates well to the *jōdan no ma* in the texturing strokes used in the rocks and land masses
and in the depiction of the huge pine trees. While there is little activity in the com-
position, there is a pleasing rhythmical apportionment of geese, pheasants, and other
birds.

An even greater elegance in design and delicacy in draftsmanship was achieved in
the screen and wall paintings that Mitsunobu executed for the main shrine *(honden)* of
Tsukubusuma Shrine, on a picturesque island in Lake Biwa. Practically no interior
surface was left vacant, and the overall scheme, flavorful in color and variety, resulted
in a room of sumptuous magnificence. It is not only the sliding screens *(fusuma)* that
bear pictorial compositions, but also, as seen in plates 86–89, the small panels above
the lintels *(nageshi)* where there are hanging clusters of wisteria, and the ceiling coffers
(gōma), which are painted with various flowering plants and boughs. In the *Flowers*

129

75. *Flowers and Birds*, by Kanō Mitsunobu. Detail. *Fusuma* panels in the *ni no ma*. Ink and colors with gold-leaf ground. H. 179 cm., w. 116.5 cm. Kangaku-in, Onjō-ji, Shiga Prefecture.

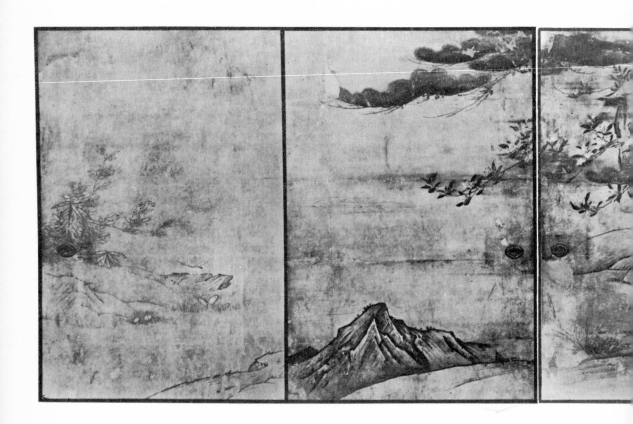

76. *Waterfall*, by Kanō Mitsunobu. Recessed alcove painting in the *jōdan no ma* guest room. Ink and colors with gold-leaf ground. H. 256 cm., w. 478.5 cm. Kangaku-in, Onjō-ji, Shiga Prefecture.

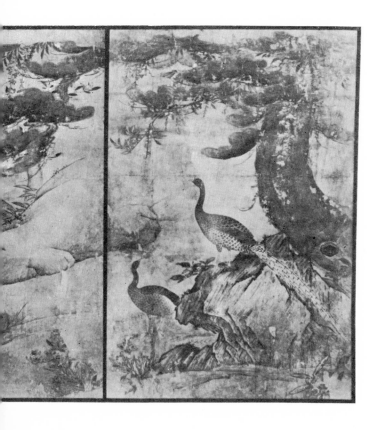

131

and Trees panels (pls. 87, 89) Mitsunobu used only flora to evoke the four seasons, a type of composition that he had experimented with earlier in the *Flowers and Trees of the Four Seasons* at the Kangaku-in (pls. 67, 74). Stylistically, the paintings in Tsuku-busuma Shrine are in complete accord with the elegant, gentle appearance of Mitsu-nobu's paintings described in the *Honchō gashi*. These paintings can be regarded as providing excellent examples of the slender flowers and plants and the gracefully proportioned tree branches that are characteristic of Mitsunobu's style.

Among the flower and bird paintings on gold backgrounds that set off the interior of the *shoin* at the Hōnen-in are included scenes of paulownias, pines, and young bamboo. Of these, two definitely form serial compositions: *Snowy Pine* (pls. 90, 92), now mounted as a pair of folding screens, and the *Young Bamboo* sliding-screen painting (pl. 91). Moreover, this group seems to be related to the *Paulownia* painting depicting a miraculous tortoise on a cliff. *Snowy Pine* has been attributed to Mitsunobu due to its close relationship with the type of pine tree present in the *ni no ma* guest room of the Kangaku-in (pl. 75). One can see striking similarities in the form of the pines, the arrangement of clumps of leaves, the placement of the lower branches, and the texturing of the bark. Likewise, it seems logical to attribute all the above-mentioned paintings in the Hōnen-in to Mitsunobu in spite of slight differences of detail, brush handling, gold squares *(kimpaku)*, overlapping of the paper foundation *(kamitsugi)*, and so on. Final judgement must await further scholarship.

The flower and bird paintings at Tsukubusuma Shrine and the Hōnen-in impart a feeling of delicacy as well as a sense of artful naturalism through the rhythmical distribution into depth of the scenes from nature. The *Flowers and Birds of the Four Seasons* screens (pl. 77), although bearing the "Shūshin" seal of Eitoku, should be considered in connection with Mitsunobu's style of flower and bird painting. General-ly, in depictions of flowers and birds of the four seasons a background landscape forms the foundation for the pictorial composition, but in these screens a gentle di-agonal orientation of the composition from right to left is used to develop perspective. No dominant, centralized motifs are employed; the pine trees at the beginning of the right screen and the cypresses at the upper level of the left screen bind together the composition of the whole. Although the different types of flowering trees and plants are grouped according to the four seasons, and rocks and land masses are divided by a complicated arrangement of clouds, an overall compositional unity is maintained. This pair of screens resembles the paintings in the guest rooms of the Kangaku-in not only in the construction of the gold ground but also in the detailed *(saiga)* style of execution. Characteristic of Mitsunobu is the stability of the scene, achieved in *Flowers and Birds of the Four Seasons* by anchoring the composition with jagged rocks in the foreground. The detailed painting style is used to advantage here in the treatment of the numerous birds, from the peacocks and wild geese that pose prettily in the foreground to the small birds engaged in aerial acrobatics in the dis-

tance. That Mitsunobu was proficient in flower and bird depiction is also confirmed in the *Tansei jakuboku shū*.

THE MITSUNOBU PINE

Mitsunobu's manner of depicting pine trees can be discovered through an analysis of the screen and wall paintings in the *honden* of Tsukubusuma Shrine (pl. 89), the *ni no ma* guest room of the Kangaku-in (pl. 75), such paintings as *Snowy Pine* in Hōnen-in (pl. 90), and various flower and bird paintings (pl. 77). None of these pines are mammoth; rather they are diminutive and graceful in form. The Mitsunobu style of pine served as a model for other paintings of pine trees, such as the group now in the three rooms that comprise the great entrance hall *(ōgenkan)* of the Myōhō-in in Kyoto (pls. 78, 84). Although the majestic pines extending laterally across the Myōhō-in entry rooms display the opulent Momoyama taste for monumental compositions after Eitoku, only some of the panels may be categorized as being in the Eitoku style, while others, upon inspection, indicate that of Mitsunobu. Expansive in conception and bold in technique, one group, of which plate 10 is a prime example, is closely akin to Eitoku's large-scale pine compositions. The other group exhibits a monumentality more attuned to Mitsunobu's elegant, studied forms and flat surface values (pl. 78). Thus, in contrast to the lively, large-scale style of Eitoku, Mitsunobu preferred a more intimate, detailed style.

To further elucidate Mitsunobu's manner of depicting pine trees we can examine his *Beach Pines* at the Kōdai-ji ancestral shrine (pls. 70–72, 85). Characteristic of Mitsunobu are such stylistic attributes as the flat clusters of leaves and the lighthearted profiles of the branches. Other stylistic peculiarities such as the structure of the gold clouds, the land embankments, and the roots of the pine tree are essential criteria in attributing works to Mitsunobu. While the theme of beach pines was a subject traditionally associated with *yamato-e,* Mitsunobu was adept at adjusting the *yamato-e* style to suit his needs in the Kōdai-ji *Beach Pines*. The appearance of *yamato-e* elements in Mitsunobu's paintings of flowering plants, birds, and insects is related in the *Honchō gashi,* and the resulting subdued veneer of his works has a warm endearing quality.

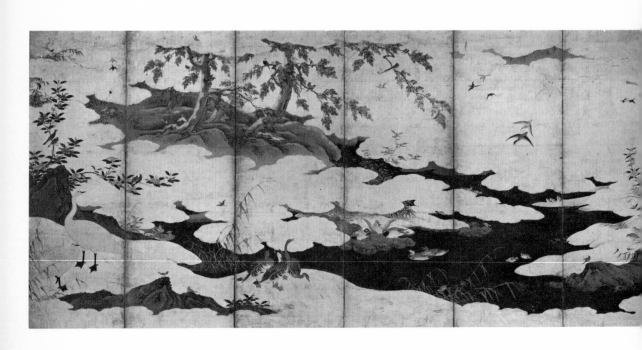

77. *Flowers and Birds of the Four Seasons,* bearing the
"Shūshin" seal. Pair of six-fold screens. Ink and colors
with gold-leaf ground. H. 164.5 cm., w. 353.4 cm. (each
134 screen). Private collection, Japan.

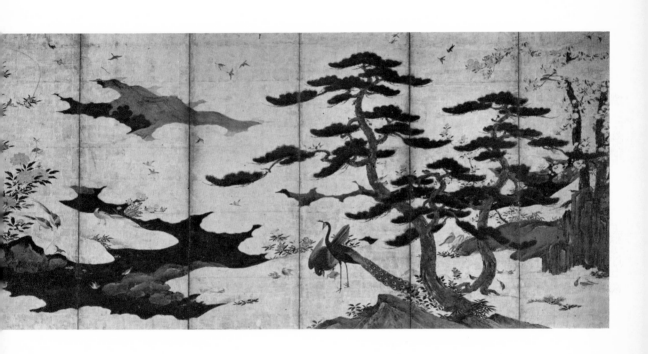

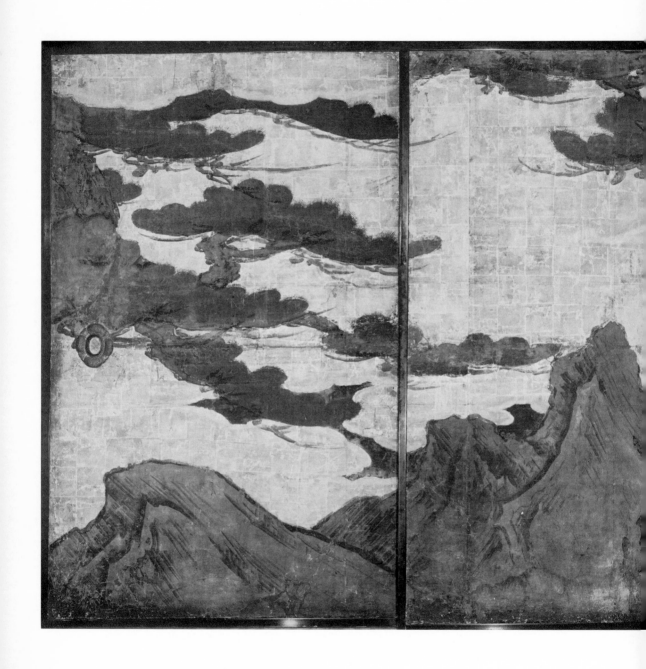

78. *Pines*. Detail. *Fusuma* panels in the entrance hall.
(Unillustrated half of rightmost screen is a later addition.) Ink and colors with gold-leaf ground. Myōhō-in,
Kyoto.

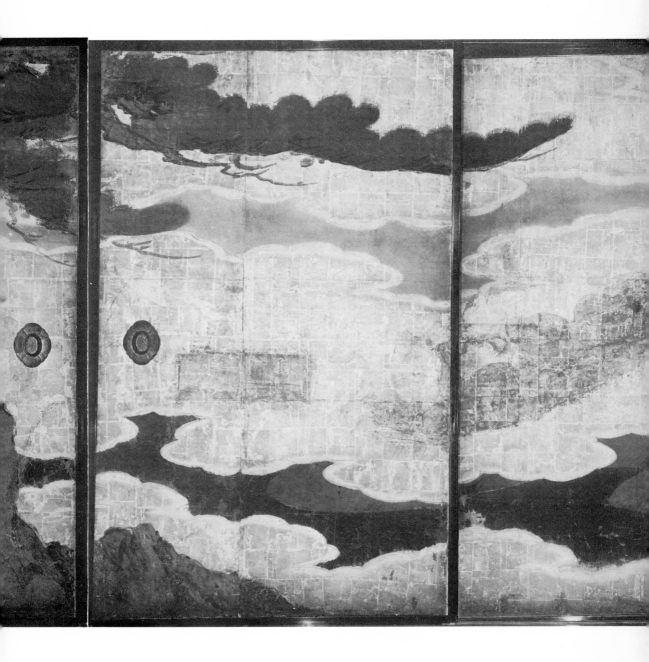

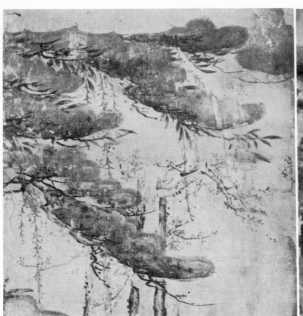

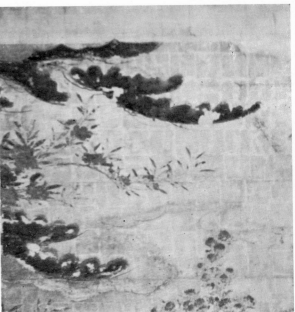

79. Pine branches. Detail from *Pine and Waterfowl* by Kanō Mitsunobu. *Fusuma* panels. Ink and colors with gold-leaf ground. Kangaku-in, Onjō-ji, Shiga Prefecture.

80. Pine branches. Detail from *Autumn Grasses* (pls. 87–88), two *fusuma* panels. Ink and colors with gold-leaf ground. Tsukubusuma Shrine, Shiga Prefecture.

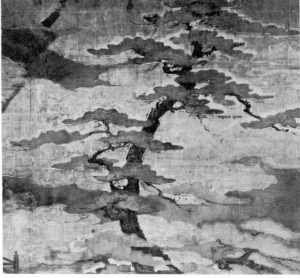

82. Pine branches. Detail from *Hermits* (pl. 96), an alcove painting. Ink and colors with gold-leaf ground. Myōhō-in, Kyoto.

81. Pine branches. Detail from *Snowy Pine* (pls. 90, 92), a pair of two-fold screens. Ink and colors with gold-leaf ground. Hōnen-in, Kyoto.

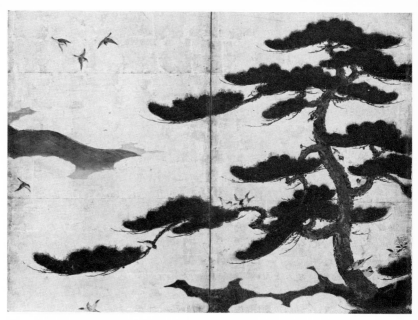

83. Pine branches. Detail from the right screen
of *Flowers and Birds of the Four Seasons* (pl. 77). Ink
and colors with gold-leaf ground. Private collec-
tion, Japan.

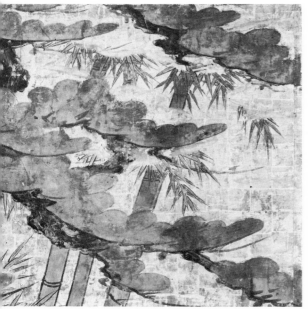

84. Pine branches. Detail from *Pines* by Kanō Mitsu-
nobu. Wall paintings. Ink and colors with gold-leaf
ground. Myōhō-in, Kyoto.

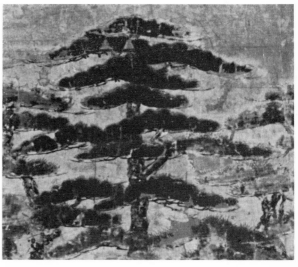

85. Pine branches. Detail from *Beach Pines* (pls. 70–72),
wall paintings. Ink and colors with gold-leaf ground. Kō-
dai-ji, Kyoto.

86. *Flowering Plants*; attributed to Kanō Mitsunobu.
Detail of the ceiling paintings. Ink and colors on gold-
leaf ground. Tsukubusuma Shrine, Shiga Prefecture.
(See also pls. 87, 89.)

87. *Flowers and Trees*; attributed to Kanō Mitsunobu. Detail. Screen and wall paintings in the *honden*. Ink and colors on gold-leaf ground. H. 170.5 cm., w. 116 cm. (each panel). Tsukubusuma Shrine, Shiga Prefecture. (See also pls. 86, 88, 89.)

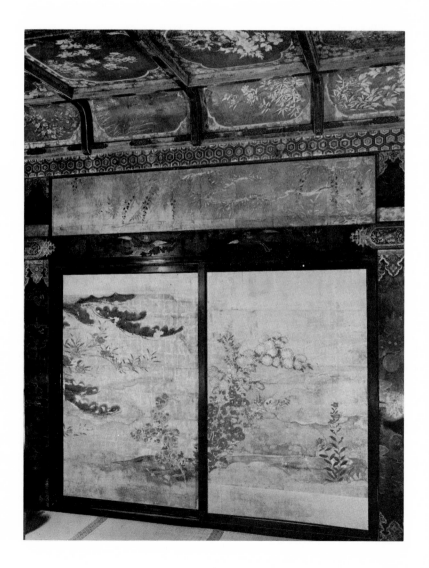

88. *Autumn Grasses*; attributed to Kanō Mitsu-nobu. Two panels from the set of *fusuma* paintings in the *honden*. Ink and colors with gold-leaf ground. H. 170.5 cm., w. 116 cm. (each panel). Tsukubusuma Shrine, Shiga prefecture.

The Tsukubusuma main shrine (*honden*) was built in 1602. The interior decoration was conceived with such dazzling showmanship in design that it came to be called the twilight hall (*higure goten*). In the decorative scheme, both exquisite lacquer-painted designs and openwork carvings were used to frame the bright screen and wall paintings on flickering gold surfaces. The *fusuma* painting illustrated here, to the right of the altar, depicts a pine, chrysanthemums, and begonias. Small areas of damage and chipping to the painting surface suggest that it was originally a wider composition. In the small panels above the lintels (*nageshi*) are elegantly wrought hang-ing wisteria (pl. 87). Over the black lacquered surfaces of the pillars and lintels are gold lac-quer paintings of birds and flowers interspersed with fifty-seven paulownia crests.

89. *Flowers and Trees*; attributed to Kanō Mitsunobu. Detail. Sliding screen, wall, and ceiling paintings in the *honden*. Ink and colors on gold-leaf ground. H. 170.5 cm., w. 116 cm. (each *fusuma* panel). Tsukubusuma Shrine, Shiga Prefecture.

Monumentally portrayed on the *fusuma* panels to the left of the altar is a plum tree in full bloom; offering a contrast at the upper left is a branch of delicately rendered bamboo leaves. The technique of suspending the tree branches in graceful arcs seen in this plum, as well as in the pine composition on the other side of the room, is one amply demonstrated in Mitsunobu's other works. The use of subdued colors seen here is also characteristic of the Mitsunobu style. Certain elements in the composition, such as the plum blossoms, have been modeled in relief, and the inconspicuous arrangement of gold clouds give this scene an elegant air. In all, this work is a representative example of flower and tree painting of the late Momoyama period (See also pls. 86, 87, 88.)

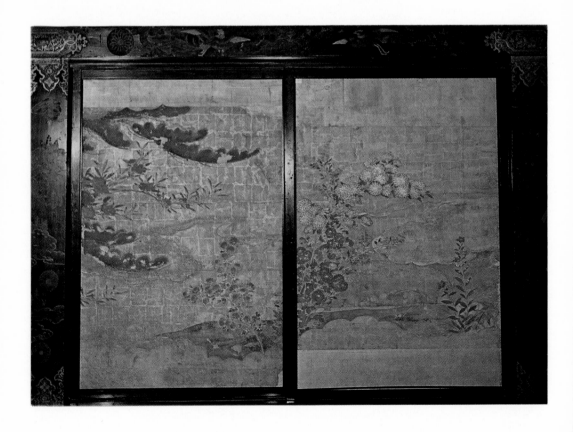

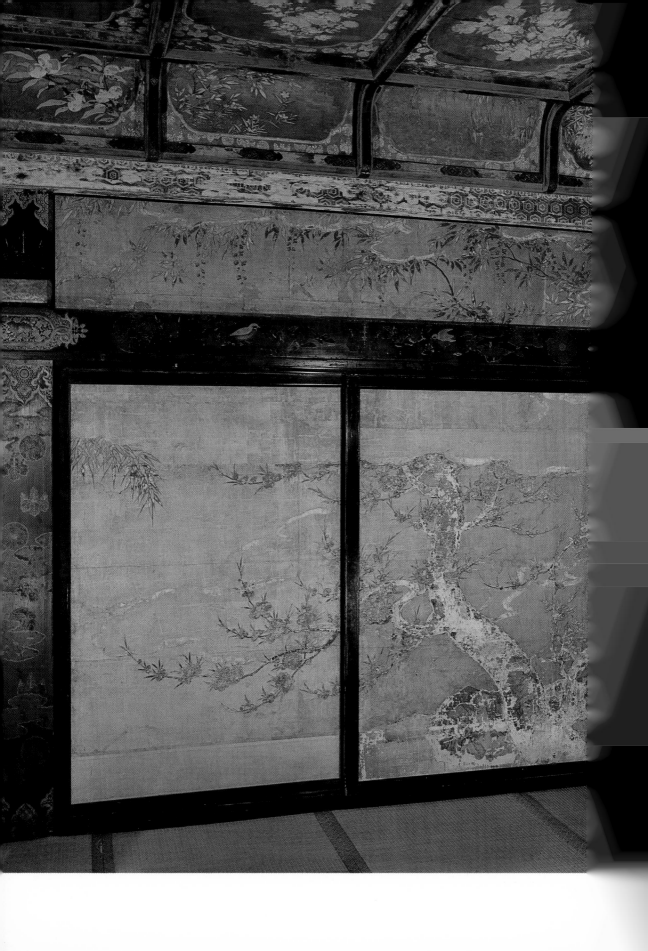

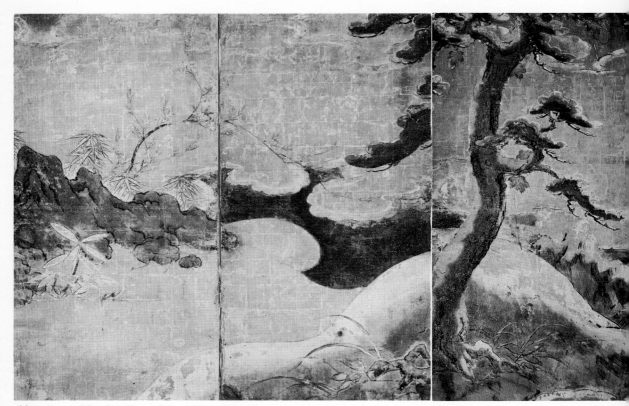

90. *Snowy Pine*, by Kanō Mitsunobu. Pair of
two-fold screens. Ink and colors on gold-leaf
ground. H. 154 cm., w. 171 cm. (each screen).
Hōnen-in, Kyoto. (See also pl. 92.)

144

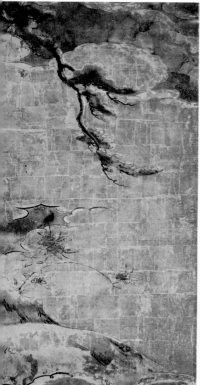

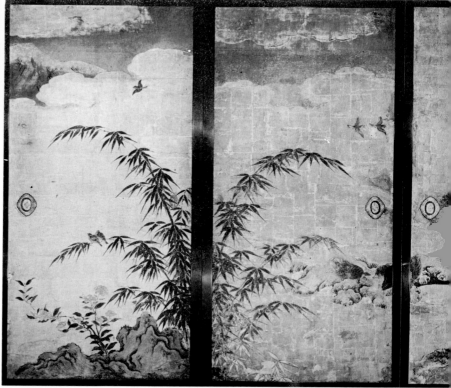

91. *Young Bamboo*, by Kanō Mitsunobu. *Fusuma* paint-
ing. Ink and colors with gold-leaf ground. Hōnen-in,
Kyoto. 145

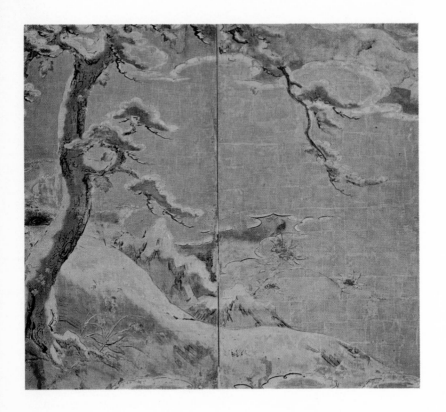

92. *Snowy Pine*, by Kanō Mitsunobu. Detail.
Pair of two-fold screens. Ink and colors with
gold-leaf ground. H. 154 cm., w. 171 cm. (each
screen). Hōnen-in, Kyoto.

This snow-brimmed landscape pivots around a
modestly attenuated pine, whose branches sag
under the burden of piled snow. This two-fold
screen is the mate of another which, differing
slightly in technique, completes the landscape
with a scene of middle-ground rocks and snowy
shrubs at the left (pl. 90). The remains of
handholds indicate that these folding screens
were originally *fusuma* panels, but their prove-
nance remains problematical. *Snowy Pine* cer-
tainly predates the building of the Hōnen-in in
1680 and was undoubtedly moved to this site
from another location. It is due to the stylistic
qualities of the pine branches that this paint-
ing has been associated with Kanō Mitsunobu,
but definitive attribution of this and the other
screens in the *shoin* of Hōnen-in still awaits
further research.

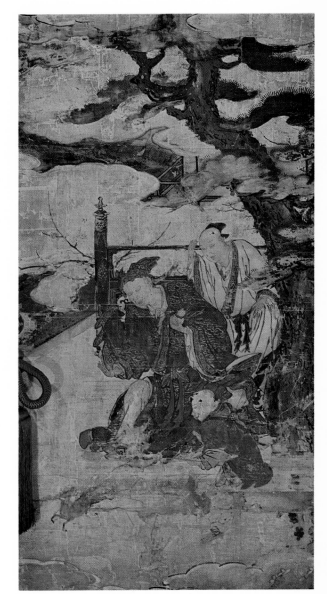

93. *Hermits*, by Kanō Mitsunobu. Detail. Four *chōdaigamae* paintings in the southeast room of the great *shoin*. Ink and colors with gold-leaf ground. Outer panels: h. 122.5 cm., w. 59.2 cm. each. Inner panels: h. 133 cm., w. 72 cm. each. Myōhō-in Kyoto.

The date of construction of the great *shoin* of Myōhō-in is uncertain and there is no unity among the thirty-eight paintings in its rooms. From their mixed appearance it is clear that the paintings are not in their original setting. The southeast room is done in representations of T'ang dynasty figures; the paintings of recluses affixed to the *tokonoma* (recessed alcove) and *chigaidana* (ornamental shelves) areas of the south wall, and the *chōdaigamae* (decorated doors) on the north side of this room, seem to comprise a series. While the paintings of the four sections of the *chōdaigamae* are of one style, each section illustrates an autonomous subject. The paintings depict T'ang dynasty hermits practicing mountain arts, and due to considerable damage to the surfaces, one can grasp the facial expressions only from the underdrawings. The tree branches in particular exhibit Mitsunobu's style. (See also pls. 94–95.)

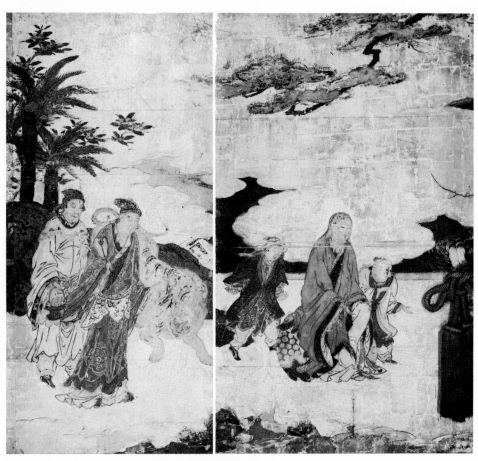

94–95. *Hermits*, by Kanō Mitsunobu. Detail.
Four *chōdaigamae* panels in the southeast room of
the great *shoin*. Ink and colors with gold-leaf
ground. H. 122.5, w. 59.2 cm. (panel on
left); 133, 72 cm. (panel on right). Myōhō-in,
Kyoto. (See also pl. 93.)

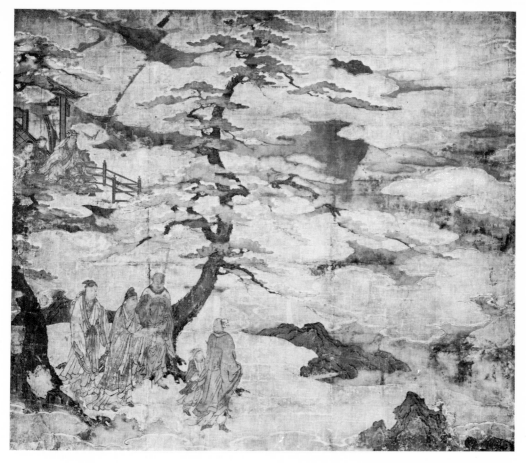

96. *Hermits*, by Kanō Mitsunobu. Detail of the alcove painting in the great *shoin*. Ink and colors with gold-leaf ground. Myōhō-in, Kyoto.

FIGURE PAINTING

Compared with his style of depicting flowers and birds, Mitsunobu's figure painting style is harder to codify. First of all, figure paintings by Mitsunobu are relatively scarce or lack documentation. Second, many are in poor condition, making assessment difficult. A good source for studying his figure painting style is the group of screen and wall paintings in the great *shoin* of the Myōhō-in in Kyoto. Stylistic similarities can be seen between the *Hermits* painting (pl. 96) located in the *tokonoma* and a painting of the same theme (pls. 93–95) affixed to the *chōdaigamae* (decorated doors). Moreover, the texture strokes used to shape the rocks and the conformation of the gold leaf are in accord with Mitsunobu's accepted oeuvre. The *tokonoma* painting is particularly important for determining Mitsunobu's figure style, seen in the staccato rhythms of his drapery folds and the facial expressiveness of the figures. One can point out such facial qualities as the firm mouth, the lengthening of the corner of the eyes, and the distinctive shape of the nose that distinguish these figures. The surface of these paintings, moreover, has abraded somewhat, making it possible to grasp the underpainting.

149

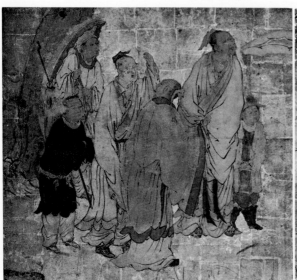 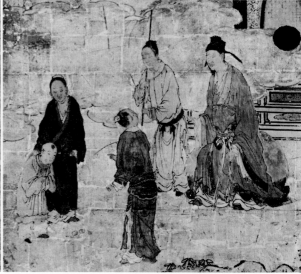

97. "Wang Tzu-ch'iao"; attributed to Kanō Eitoku. Detail from *Hermits*, *fusuma* panels in the *ohiru no ma* of the chief abbot's quarters. Ink and colors on gold-leaf ground. Nanzen-ji, Kyoto. (See also pl. 100).

98. "Lu Chi"; attributed to Kanō Eitoku. Detail from *The Twenty-four Paragons of Filial Piety*, a set of *fusuma* panels in the *ohiru no ma* of the chief abbot's quarters. Ink and colors on gold-leaf ground. Nanzen-ji, Kyoto. (See also pl. 99.)

In addition, the figure style of the Myōhō-in *Hermits* agrees with the description of Mitsunobu's figures as having small hands and feet, which is supplied in the *Tansei jakuboku shū*. However, since the Myōhō-in screen and wall paintings are not in their original arrangement, the period of production of *Hermits* is not clear even if examined from the viewpoint of the architectural history of the Myōhō-in *shoin*.

Similar to the *Hermits* of the great *shoin* in Myōhō-in are the *fusuma* paintings *Hermits* (pls. 97, 100) and *The Twenty-four Paragons of Filial Piety* (pls. 98–99) in the *ohiru no ma* of the chief abbot's quarters at Nanzen-ji. A *fusuma* painting of hermits of the same series can also be seen in the *jakō no ma*. Despite the existence of different stylistic nuances in this large group of paintings, in general one can see a Mitsunobu lineage. Their solidarity is not simply limited to figural portrayal: homogeneity extends to the complex gold background with its segmented composition as well as to the tree forms and texture strokes. While it is known that the *fusuma* paintings in the Nanzen-ji were transferred there from another structure, opinion is divided over the identity of the preceding structure. Some scholars support the view that these paintings came from the Sentō palace of the ex-emperor Ōgimachi (r. 1560–86), which was decorated in

150

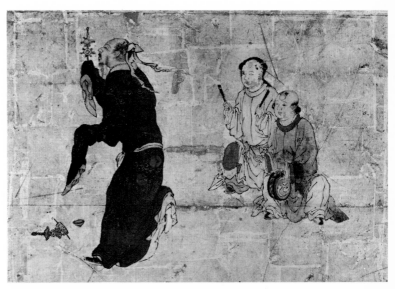

99. "Lao Lai-tzu"; attributed to Kanō Eitoku. Detail from *The Twenty-four Paragons of Filial Piety*, a set of *fusuma* panels in the *ohiru no ma* of the chief abbot's quarters. Ink and colors on gold-leaf ground. Nanzen-ji, Kyoto. (See also pl. 98.)

1586 by Eitoku and his disciples. Others have adopted the theory that the Nanzen-ji paintings came from the Seiryōden hall of the imperial palace, the decoration of which was completed in 1591. Moreover, the question as to whether or not the screens painted by Eitoku were included in this transfer is still unresolved. It has been traditional to attribute *Hermits* and *The Twenty-four Paragons of Filial Piety* to Eitoku, but they seem, upon inspection, to bear a closer relationship to the style of Mitsunobu. This proposal must be qualified as a tentative judgment and the question of the artist left as problematical.

In general, the fact cannot be overlooked that the works attributed to Eitoku include many paintings by later Kanō artists that incorporate the Mitsunobu style. Since the Eitoku style exercised a profound influence on the gamut of Momoyama art, it is not surprising that this phenomenon should have arisen. Through pursuing genuine Eitoku works and at the same time methodically arranging and categorizing the works of his circle of students and followers, we can gradually learn the true nature of Eitoku's oeuvre and that of his disciples. Towards accomplishing this task, needless to say, much difficult work still remains to be done.

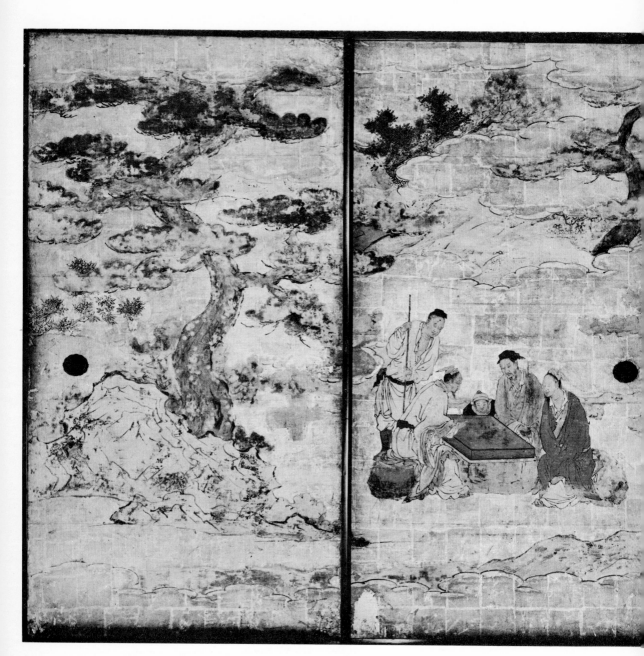

100. *Hermits*; attributed to Kanō Eitoku. Detail.
Fusuma panels in the *ohiru no ma* of the chief abbot's
quarters. Ink and colors with gold-leaf ground. Nanzen-
ji, Kyoto. (See also pl. 97.)

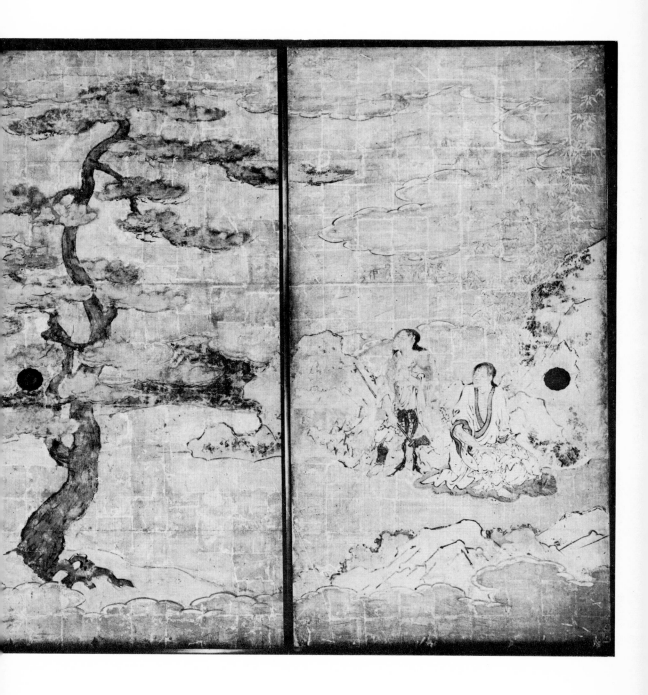

SEALS AND CERTIFICATES

The number of paintings impressed with the "Shūshin" jar-in-a-circle seal is fairly large. As the standard seal, one can accept the seal found on the *Scenes in and around Kyoto* screens (pl. 101), whose lineage as an Eitoku work has been established. There is also the seal reproduced together with Eitoku's signature in the *Honchō gain* (pl. 111), whose shape closely resembles the seal on the *Scenes in and around Kyoto* screens. Also very similar in conformation is the seal on the *Landscape of the Four Seasons* screens (pls. 102, 118). However, there is a problem in that these landscape screens do not conform to the so-called Eitoku style.*

While these aforementioned seals are comparatively large in size, there are also some small "Shūshin" seals, which are found on folding screens, hanging scrolls, and fans. However, there are a number of stylistic discrepancies among the smaller seals, making it difficult to ascertain a standard type. For example, the seals (pls. 107, 108) appearing respectively on the two fan paintings in plates 116 and 117 are quite similar and their condition is good. In contrast, the seals on the *Hsü-yu and Ch'ao-fu* hanging scrolls (pl. 105) and the *Pai-i and Shu-ch'i* painting (pl. 106) are quite crude, though the paintings themselves are excellent examples of the Eitoku style. Most likely the seals were affixed at a later date as marks of authenticity. The seal (pl. 103) on the *Twenty-four Paragons of Filial Piety* screens (pl. 119) was at one time considered a standard seal, but it is now thought to be an example of a seal applied at a later date *(ato-in).†*

In addition to seals, certificates of authenticity *(kiwamegaki)* cannot be overlooked as evidence that a later age judged certain paintings to be by Eitoku. These authentications were issued in the Edo period by the various heads of the Kyō Kanō (the Kyoto-based Kanō school) and the Edo Kanō (the Kanō school based in Edo, modern Tokyo). As such, they were judgments made by the highest authorities of the time. Even though they cannot be viewed as conclusive evidence in attributing a particular work to Eitoku today, these seals and certificates of authenticity have become important reference materials.

* See 辻 惟雄「伝狩野永徳筆 四季山水図屏風」(『美術研究』249) 昭和 41 年 [Tsuji Nobuo, "The *Landscape of the Four Seasons* Folding Screens attributed to Kanō Eitoku," *Bijutsu Kenkyū*, no. 249, 1966].

† See 土田杏村「狩野永徳襖絵論」(『東洋美術』13) 昭和 6 年 [Tsuchida Kyōson, "Discussion of Kanō Eitoku's Sliding-Screen Paintings." *Tōyō bijutsu*, no. 13, 1931].

101. 102. 103. 104. 105.

106. 107. 108. 109. 110.

101. "Shūshin" seal from *Scenes in and around Kyoto* (pls. 15–16).

102. "Shūshin" seal from *Landscape of the Four Seasons* (pl. 118).

103. "Shūshin" seal from *The Twenty-four Paragons of Filial Piety* (pl. 119).

104. "Shūshin" seal from *Flowers and Birds of the Four Seasons* (pl. 77).

105. "Shūshin" seal from *Hsü-yu and Ch'ao-fu* (pls. 26–27).

106. "Shūshin" seal from *Pai-i and Shu-ch'i* (pl. 28).

107. "Shūshin" seal from *Pair of Doves in a Pine Tree* (pl. 116).

108. "Shūshin" seal from *Pomegranate* (pl. 117).

109. "Shūshin" seal from *Bird of Prey* (pl. 120).

110. "Shūshin" seal from *The Tale of Genji* (pl. 30).

111. "Shūshin" seal and Eitoku's signature (*kao*) reproduced in Kanō Einō's *Honchō gain* (Japanese Painting Seals; published in 1693).

112. "Painted by Kanō Eitoku of the *hōin* rank"; seal of Kanō Tan'yū. From *Chinese Lions* (pl. 9).

113. "Genuine work of my grandfather, Eitoku, of the *hōin* rank—certified by Yasunobu." From *Cranes under a Pine Tree—Wild Geese in Rushes* (pl. 25).

114. "Eitoku's own brush—certified by Einō." From *Pine and Hawk* (pls. 20, 22).

111.

112.

113.

114.

157

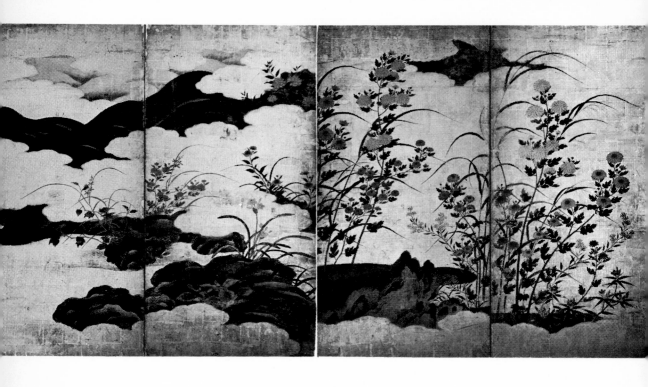

116. *Pair of Doves in a Pine Tree*; attributed to
Kanō Eitoku. Folding fan painting mounted on
a screen. Ink on paper.

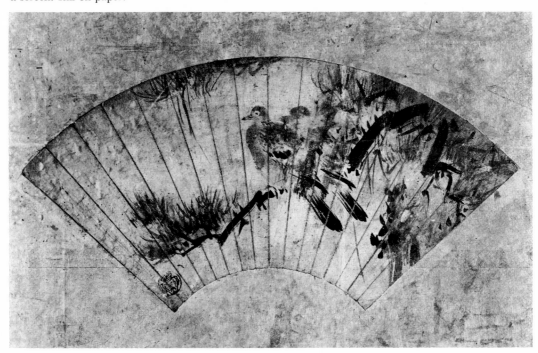

115. *Autumn Grasses*; attributed to Kanō Eitoku. Pair of two-fold screens. Ink and colors with gold-leaf ground. Imperial Household Collection.

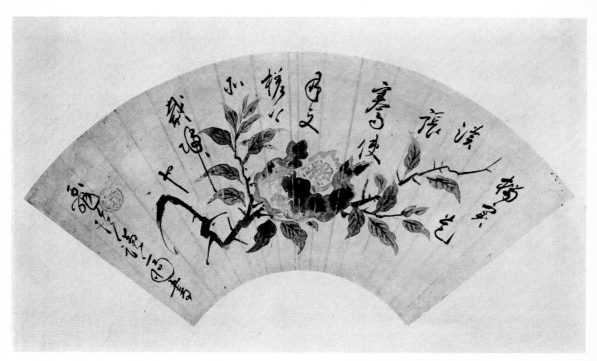

117. *Pomegranate*; attributed to Kanō Eitoku. Folding fan painting mounted on an album leaf.

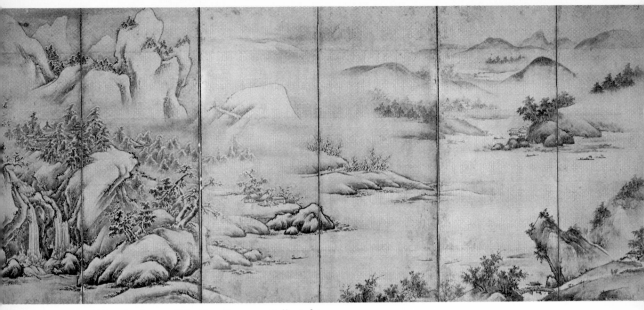

118. *Landscape of the Four Seasons*; attributed to Kanō Eitoku. Pair of six-fold screens. Ink on paper. H. 152.7 cm., w. 354.6 cm. (each screen).

119. *The Twenty-four Paragons of Filial Piety*; attributed to Kanō Eitoku. Detail. Pair of four-fold screens. Ink on paper. Hōnen-in, Kyoto.

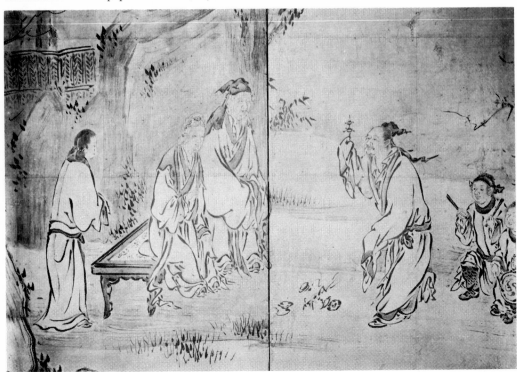

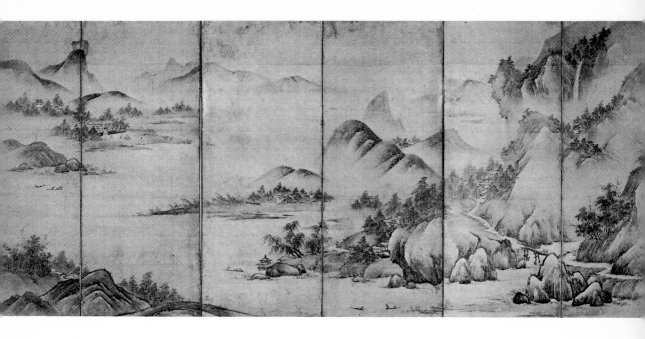

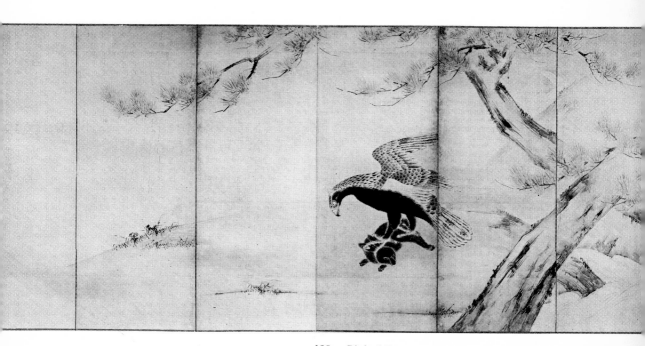

120. *Bird of Prey*; attributed to Kanō Eitoku. Six-fold screen. Ink on paper. H. 142.5 cm., w. 321 cm.

NOTES TO TEXT

Page 40
1. Eitoku is called Kanō *nyūdō* in this record. The term *nyūdō* designates someone who has taken priestly vows. Although there has been some debate among scholars over whether Eitoku became a priest or not, this record seems to indicate that he did, in fact, enter the priesthood.

Page 83
2. *Kobu* is the Japanese reading for the Chinese name of the Ministry of Public Affairs, commonly known as *mimbu* in Japan. Shōei held the formal title of *mimbu no jō*, which designates an assistant in the ministry.

Page 84
3. There is a tradition that the Kanō family was a branch of the great Fujiwara family, which dominated the imperial court and government administration in the Heian period and persisted thereafter as an influential family. In addition to the family name of Fujiwara, Shōei uses his official title of *mimbu no jō* in his signature (see preceding note).

Page 84
4. In the *Oyudono no ue no nikki*, these screens are referred to as the *kisanshi* screens; the meaning of this word, however, has not been adequately explained by scholars.

GENEALOGY OF THE KANŌ SCHOOL

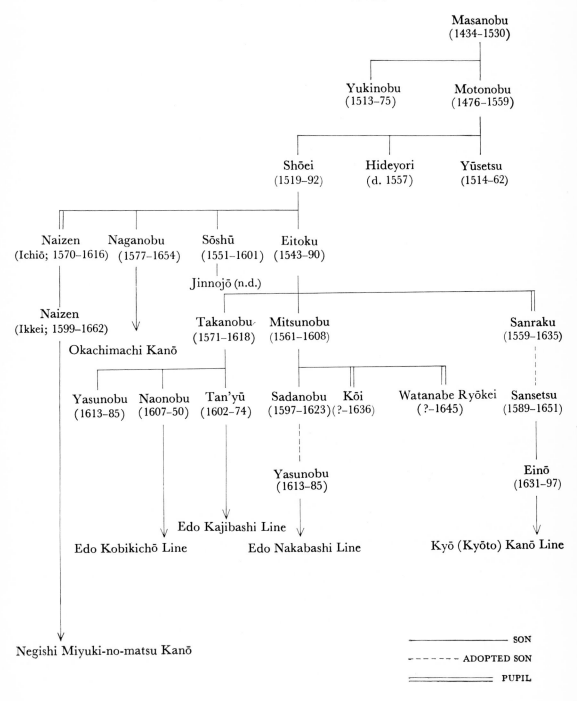

Masanobu
(1434–1530)

Yukinobu
(1513–75)

Motonobu
(1476–1559)

Shōei
(1519–92)

Hideyori
(d. 1557)

Yūsetsu
(1514–62)

Naizen
(Ichiō; 1570–1616)

Naganobu
(1577–1654)

Sōshū
(1551–1601)

Eitoku
(1543–90)

Jinnojō (n.d.)

Naizen
(Ikkei; 1599–1662)

Okachimachi Kanō

Takanobu
(1571–1618)

Mitsunobu
(1561–1608)

Sanraku
(1559–1635)

Yasunobu
(1613–85)

Naonobu
(1607–50)

Tan'yū
(1602–74)

Sadanobu
(1597–1623)

Kōi
(?–1636)

Watanabe Ryōkei
(?–1645)

Sansetsu
(1589–1651)

Yasunobu
(1613–85)

Einō
(1631–97)

Edo Kajibashi Line

Edo Nakabashi Line

Kyō (Kyōto) Kanō Line

Edo Kobikichō Line

Negishi Miyuki-no-matsu Kanō

——————————— SON

– – – – – – ADOPTED SON

══════════════ PUPIL

GLOSSARY

Buddhist altar room: in Japanese, *butsudan no ma;* located in the *hōjō.*

byōbu: a folding screen made of two, four, six, or eight panels. Folding screens were generally made in pairs and decorated with paintings or calligraphy. While the height of folding screens may vary considerably, the majority are around 155–170 cm. (cf. pls. 15–16), although *Chinese Lions* (pl. 9) is an enormous 225 cm. *Byōbu* has been translated as "folding screen" in the text.

chigaidana: ornamental shelves used for displaying treasured objects; located next to the *tokonoma* in a *shoin*-style room.

chōdaigamae: decorated doors that characteristically open on to a sleeping alcove in a *shoin*-style room.

daimyō: a feudal lord owing allegiance to the *shōgun,* who was the supreme military ruler. The *daimyō* possessed great domains of land and had a large number of retainers.

dairi: the extended imperial palace compound. The inner imperial residence is the *daidairi.*

ebusshi: a painter employed by a Buddhist temple.

Edo period (1600–1867): The period of rule of the Tokugawa shogunate, or military government, in Edo (modern Tokyo). In its early phases Edo society was strictly feudal in organization and Confucian in its philosophy and ethics. This conservative spirit is reflected in the Kanō style: the former boldness and colorful grandeur of the preceding Momoyama age was transformed into a style more restrained and harmonious. Many Kanō artists were given residences in Edo and served as official artists to the Tokugawa regime.

edokoro: official bureau of painters of the Japanese imperial court, large Buddhist temples, and Shintō shrines. The officially appointed artists who served the Ashikaga and Tokugawa shoguns are sometimes said to belong to the *bakufu edokoro,* but they are more commonly referred to as *goyō eshi.*

edokoro azukari: director of the *edokoro.* It is not clear whether this person originally was a painter himself or not, but later a master artist was customarily appointed to the directorship of the *edokoro* and was considered its chief painter.

eight views of the Hsiao and Hsiang rivers *(Shōshōhakkei-zu):* a Chinese painting theme that depicts the marshy country and poetic sights near the confluence of these two rivers in south China.

ema: literally, "horse picture." Originally a painted representation on a wooden plaque of the sacred horses *(jimme)* dedicated to a shrine, *ema* later came to depict other auspicious subjects as well, such as historical figures.

flower and bird painting *(kachō-zu):* This is a broad category of painting on the theme of flowers and birds, generally referring to close-up studies of birds in flowering trees or amid flowers.

flowers and birds of the four seasons *(shiki-kachō-zu):* a painting thematically based on flowers and birds representative of each of the four seasons of the year.

folding screen. See *byōbu.*

four elegant pastimes *(kinkishoga-zu):* a painting depicting the four traditional pastimes of cultivated Chinese gentlemen—zithern *(kin)* music, chess *(ki),* calligraphy *(sho),* and painting *(ga).*

fusuma: paper-covered sliding-door panels that form movable wall partitions in a room. Each panel is made with a wooden frame covered by several layers of paper.

While the height of *fusuma* panels will vary from structure to structure, the majority range from 165–190 cm. *Fusuma* has been translated "sliding screen" in the text.

fusuma-e: paintings on *fusuma* panels. Translated as "sliding screen painting" in the text.

Genji monogatari. See *The Tale of Genji.*

gofun: shell lime mixed with glue, used to provide a lustrous coating on paper, for relief modeling of flower petals and the like, and as an adhesive for sprinkled gold dust.

gold leaf. See *kimpaku*.

gōma: ceiling coffers, often brightly decorated with paintings; seen at top of plate 89 and in plate 86.

goyō eshi: a master painter employed by the court or military government.

gyōtai: one of the three basic brushwork styles, characterized by "running" *(gyō)* or semicursive brushstrokes. The *gyōtai* style represents the median between the precise, angular character of the *shintai* style and the brevity and imprecise character of the *sōtai* style. These terms, of Chinese origin, were originally used to describe modes of calligraphy. A representative example of the *gyōtai* style is the *fusuma* painting series *Landscape with Flowers and Birds* in the Jukō-in by Kanō Eitoku (pls. 2–4, 11–13, 18).

hattō: main hall in a Zen temple.

hikime kagihana: loosely, "straight-line eyes and hooked-line nose"; a traditional way of depicting facial features, particularly those of the nobility, in the *yamato-e* painting style.

hikite: indented handholds for opening and closing sliding screens. Due to damage suffered by sliding screens through wear or subsequent remodeling projects, sliding screens were often remounted as folding screens in order to preserve them. The telltale marks left by the handholds indicate the painting's original format.

hōgen: literally, "Eye of the Law"; an honorary Buddhist title conferred on eminent Buddhist and secular artists. See also *hōin*.

hōin: literally, "Seal of the Law"; a Buddhist title that came to be conferred on eminent Buddhist and secular artists. Of the three traditional rankings, *hōin* was the highest in status, followed in importance by *hōgen* and then *hokkyō*. The *hōin* title was awarded to artists, generally late in their careers, in recognition of extreme excellence in their field.

hōjō: the abbot's or chief priest's quarters in a Zen temple or subtemple. A typical *hōjō* consists of six rooms: the *shitchū* or central room (also *naka no ma*), the *rei no ma*, the patron's room, the *shoin no ma*, the *ihatsu no ma*, and the Buddhist altar room.

hokkyō: literally, "Bridge of the Law"; an honorary Buddhist title conferred on eminent Buddhist and secular artists. See also *hōin*.

Honchō gashi (History of Japanese Painting): an invaluable early art-historical document that gathers together the biographies of many important Japanese painters; written by Kanō Einō, and published in 1693. One must bear in mind that it was written by a member of the Kanō school of painters, whose bias towards his own school has influenced his account of the history of Japanese painting.

hondō: main hall of a temple.

ihatsu no ma: Zen abbot's private room in the *hōjō*, originally used for the succession rites from master to pupil.

jōdan no ma: formal reception room.

kachō-zu. See flower and bird painting.

kakemono: a vertical hanging scroll on which is executed a painting, calligraphy, or the like.

kimpaku: squares of gold leaf applied to a paper surface as a background for a painting or used to form pictorial elements of the compositions.

kimpeki: refers to highly colored paintings having a gold background. The combination of color and gold was admired for its strong contrast and dynamic beauty. The term is used especially in conjunction with the Momoyama screen painting style.

kindei: gold dust sprinkled selectively on a painting for pictorial or decorative effect. Also refers to the gold pigment made from gold dust mixed with affixative. See plates 4, 21.

kinji: literally, "gold ground"; a generic term used for paintings having a gold background regardless of whether it is gold leaf, gold paint, or gold dust.

kinkishoga-zu. *See* four elegant pastimes.

kiwamegaki: translated "certificates of authenticity"; short tabs of paper kept in the storage boxes of paintings that record the judgment of an art critic on the authenticity or authorship of the work. Occasionally the *kiwame* is written on the box or even on the painting itself *(shichūkiwame)*.

koku: about 180 liters of rice; theoretically the amount needed to feed one person for one year.

landscape with flowers and birds *(sansuikachō-zu)*: a painting thematically based on flowers and birds in a landscape setting. The prominent role given to the flowers and birds in the foreground of the composition differentiates this type from pure landscape painting *(sansui-zu)*, while the presence of a landscape setting distinguishes it from bird and flower painting proper.

mokkotsu: a painting technique in which the object is depicted by areas of ink and not by a black outline. *Mokkotsu* is often translated as "boneless technique."

Momoyama period (1573–99): A period of national reunification dominated successively by three military generals: Oda Nobunaga, Toyotomi Hideyoshi, and Tokugawa Ieyasu. The Momoyama period is no doubt most renowned for the birth of highly colored paintings with a gold background made on screens and walls *(kimpeki shōhekiga)*, although the development of genre painting on a large scale and Western-influenced paintings also characterized the age.

Muromachi period (1392–1572): The period of rule of the Ashikaga shogunate, or military government, in Kyoto. Artistically, the Muromachi period is known for the popularization of monochrome ink painting *(suibokuga)*. Although ink painting was still largely the avocation of Zen monks during the Muromachi period, secular artists such as Kanō Masanobu and Kanō Motonobu also turned to this new style of painting, transforming the highly spiritual and literary Zen ink-painting tradition into one more decorative and direct. During the fifteenth century the Kanō family provided the official artists to the Ashikaga shogunate.

nageshi: a lintel, often decorated with ornamental carving or painting. See plate 87.

naka no ma: central or main room.

ōhiroma: grand reception hall.

onari no ma: imperial reception chamber.

Oyudono no ue no nikki (Diary of the Imperial Servants): the name of this diary *(nikki)* derives from the name of a room in the imperial palace called the *oyudono no ue*. The diary was kept by various ladies of the court and imperial servants to record the everyday activity of the emperor, the events of the year, information about contemporary personages, court etiquette, literature, and so on. Extant portions survive from the mid-Muromachi through late Edo periods. Diaries like this are important research sources.

patron's room: in Japanese *danna no ma*; a type of reception room located in the *hōjō*.

rakuchū-rakugai zu. *See* scenes in and around Kyoto.

rei no ma: a type of reception room.

saiga: literally, "detailed painting"; characterized by precise brushstrokes and attention to detail in the depiction of the pictorial elements. The *saiga* style is best suited to a small format such as a fan or an album but it was sometimes adopted for a large format. According to tradition, Kanō Eitoku first painted in the *saiga* style, including such surviving works as *Scenes in and around Kyoto* (pls. 5–7, 15–16), before developing the *taiga* manner.

sansuikachō-zu. *See* landscape with flowers and birds.

scenes in and around Kyoto *(rakuchū-rakugai zu):* a type of "famous views" genre painting illustrating the scenic spots and important monuments of the capital itself *(rakuchū)* and environs *(rakugai)* peppered with seasonal festivals, entertainments, and scenes of workaday life.

screen and wall painting. See *shōhekiga.*

shikikachō-zu. *See* flowers and birds of the four seasons.

shintai: one of the three brushwork styles, adopted by Kanō Motonobu to give stylistic unity to the work of his atelier; characterized by "formal" *(shin)* or angular strokes. Of the three styles (see also *gyōtai* and *sōtai*), this is the most lucid and precise in character. A representative example of this style is Eitoku's *Four Elegant Pastimes* in the Jukō-in (pls. 14, 19).

shōgun: supreme military ruler of Japan and the head of the military government.

shōhekiga: paintings on such interior architectural components as sliding doors *(fusuma),* paper pasted on walls *(kabe haritsuke),* doors *(sugido),* ceilings, and *tsuitate,* which form an allover decorative scheme. *Shōhekiga* has been translated as "screen and wall painting" in the text.

Shōshōhakkei-zu. *See* eight views of the Hsiao and Hsiang rivers.

shoin: a distinctive style of domestic architecture developing in the Muromachi period and characterized by a writing room *(shoin)* with a *tokonoma, chigaidana,* and a *tsukeshoin,* a shallow bay with a low built-in writing surface.

sliding screen painting. See *fusuma-e.*

sōtai: one of the three brushwork styles adopted by Kanō Motonobu to give stylistic unity to the work of his atelier; characterized by "grass" *(sō)* or cursive strokes. This is the most relaxed and brief of the three brushwork styles. See also *shintai* and *gyōtai.*

suibokuga: literally, "water and ink painting"; paintings in black ink sometimes with the addition of light washes of color, which became the dominant painting technique in the Muromachi period.

taiga: literally, "large painting." This term refers to paintings with compositions and pictorial depictions that are monumental in conception and executed with broad, vigorous handling of the brush. The origin of the *taiga* style is credited to Kanō Eitoku, who, according to tradition, became so popular as an artist that he had to abandon time-consuming, detailed-style paintings in lieu of the more quickly realized, broadly conceived style of painting that has been termed *taiga. Chinese Lions* (pl. 9) is a foremost example of the *taiga* style.

tainoya: auxiliary living quarters in the *shinden-zukuri* style of architecture.

Tansei jakuboku shū: a compilation of biographies of Japanese painters written by Kanō Ikkei and published in 1662. Ikkei traces the rise of painting from the Muromachi period through the early Edo period.

tenshukaku: the central towerlike structure or donjon of a castle.

The Tale of Genji (Genji monogatari): early eleventh-century novel written by Lady Murasaki dealing with the romantic intrigues and aesthetic preoccupations of Heian aristocratic society. Scenarios from the novel became popular painting themes.

tokonoma: recessed alcove in a *shoin*-style room. In an all-encompassing scheme of interior decoration, this area was decorated with paintings on paper pasted directly to the wall. In other cases, the *tokonoma* wall itself was left unadorned, but hung in this space were one or more hanging scrolls *(kakemono).*

tsuitate: a single-panel nonfolding standing screen. *Tsuitate* vary considerably in height from very low, oblong screens to ones slightly taller than a human being.

uchiwa: an oval-shaped nonfolding fan with handle. These oval- or round-shaped fans were usually mounted on a bamboo frame.

warafude: coarse straw brushes used to paint rough and sweeping strokes; said to have

167

been adopted by Eitoku in his *taiga* paintings.

yamato-e: paintings in the Yamato, or Japanese, tradition. Generally, they are highly colored and depict native literary or narrative subjects. *Yamato-e* was a name used to distinguish indigenous painting from Chinese-style painting, and came to refer to paintings of Japanese themes in the native painting style, quite removed from the Chinese painting tradition. This term is most often used for the picture scroll *(emakimono)* painting of the medieval period. The painting of Minamoto no Shitagō (pl. 56) is a good example of a Kanō portrait painting in the *yamato-e* style.

zashiki: a reception room.

BIBLIOGRAPHY

JAPANESE SOURCES
(selected by the author; annotated by Catherine Kaputa)

秋山光夫「桃山時代障屏画論」(『日本美術論攷』) 東京 第一書房 昭和4年 [Akiyama, Teruo. "Discussion of Screen Paintings of the Momoyama Period." In *Studies in Japanese Art*. Tokyo: Daiichi Shobō, 1929].

Deals with the flowering of Momoyama screen painting *(shōheiga)*—paintings on screen formats such as *fusuma, byōbu, tsuitate,* and *shōji* (latticed sliding panels).

———「四季花鳥図屏風と筆者元秀に就いて」(『画説』57) 昭和16年 [———. "The *Flowers and Birds of the Four Seasons* Folding Screens and the Painter Genshū [Sōshū]." *Gasetsu*, no. 57, 1941].

An analysis of Sōshū's *Flowers and Birds of the Four Seasons* folding screens.

土居次義「狩野永徳伝の一節」(『史迹と美術』106) 昭和14年 [Doi, Tsugiyoshi. "A Segment of the Life of Kanō Eitoku." *Shiseki to bijutsu*, no. 106, 1939].

In this short study Mr. Doi examines the life and achievements of Eitoku's early years up until his work at the Jukō-in during his early twenties, as gleaned from such documents as the *Tansei jakuboku shū* and *Honchō gashi*.

———「松栄画に関する研究」(『宝雲』28) 昭和16年 [———. "Research on Shōei's Paintings." *Hōun*, no. 28, 1941].

An examination of the major works of Shōei including the Rajōmon *ema* painting, *The Death of the Buddha, Flowers and Birds of the Four Seasons* in the Nagasaki Collection, the Jukō-in paintings, and others.

———「狩野松栄の一画蹟」(『史迹と美術』148) 昭和18年 [———. "One Painting by Kanō Shōei." *Shiseki to bijutsu*, no. 148, 1943].

An in-depth study of the pair of hanging scrolls *Mynah Birds and Gardenias—Small Birds and Plum Tree* in the Tokyo National Museum.

———「相国寺法堂の天井画と狩野光信」(『日本近世絵画攷』) 京都 桑名文星堂 昭和19年 [Kanō Mitsunobu and the Ceiling Painting in the Shōkoku-ji *hattō*." In *Studies in Recent Japanese Painting*. Kyoto: Kuwanabunseidō, 1944].

A study of the dragon painting on the ceiling of the *hattō* of the Shōkoku-ji temple and related documents that help secure a Mitsunobu attribution for this work.

———「無款の永徳筆人物図屏風」(『日本美術工芸』133) 昭和24年 [———. "The Unsigned *Hermits* Folding Screens by Eitoku." *Nihon bijutsu kōgei*, no. 133, 1949].

In this article Mr. Doi introduces a pair of unsigned monochrome ink folding screens of Chinese figures that had recently come to light. By comparing the brush styles of the figures, pines, and other elements with those of ink paintings accepted as authentic

Eitoku works, Mr. Doi establishes a basis for attributing these screens to Eitoku.

——「豊国神社の歌仙扁額について——狩野宗秀研究資料」(『大和文華』 4) 昭和26年 [——. "Concerning the Pictures of the Thirty-six Poets in the Hōkoku Shrine: Kanō Sōshū Research Data." *Yamato Bunka*, no. 4, 1951].

An examination of the paintings of the Thirty-six Poets by Kanō Sōshū, on wooden tablets in the Hōkoku Shrine, and related documents.

——「高台寺と狩野光信」(『史迹と美術』 620) 昭和41年 [——. "Kanō Mitsunobu and the Kōdai-ji Temple." *Shiseki to bijutsu*, no. 620, 1966].

An analysis of the screen and wall paintings in the Kōdai-ji and the roles of Mitsunobu and his two students Watanabe Ryōkei and Kanō Kōi.

——「狩野光信の唐人物図」(『茶道雑誌』30-8) 昭和41年 [——. "The Chinese Figure Paintings of Kanō Mitsunobu." *Chadō zasshi*, vol. 30, no. 8, 1966].

Prior to this study of Mitsunobu's figure painting style, scholars had concentrated chiefly on his flower and bird paintings. In this short article Mr. Doi focuses his attention on the *Ming-huang—Yang Kuei-fei* screens in the Freer Gallery of Art, Washington, D.C.

——『桃山の障壁画』(日本の美術 14) 東京 平凡社 昭和39年 [——. *Momoyama Screen and Wall Paintings.* Japanese Art, vol. 14. Tokyo: Heibonsha, 1967].

Excellent introduction to the development and florescence of screen and wall painting in the Momoyama period. Good illustrations.

——「狩野宗秀に関する考察——日禛上人像を中心として」(『国華』 914) 昭和43年 [——. "An Inquiry into Kanō Sōshū centering on the Portrait of Nisshin Shōnin." *Kokka*, no. 914, 1968].

An in-depth study of Sōshū's portraits of Nisshin and related figure paintings. In this article Mr. Doi also examines a number of documents that shed light on Sōshū's painting career.

——『永徳と山楽』(人と歴史シリーズ) 東京 清水書院 昭和47年 [——. *Eitoku and Sanraku. Man and History Series.* Tokyo: Shimizu Shoin, 1972].

Readable introduction to the life and paintings of these two Kanō school artists.

源 豊宗「狩野光信の遺作」(『仏教美術』14) 昭和4年 [Minamoto, Toyomune. "Kanō Mitsunobu's Surviving Works." *Bukkyō bijutsu*, no. 14, 1928].

Discussion of Mitsunobu's important surviving paintings.

水尾比呂志「上杉家蔵洛中洛外図屏風と狩野永徳」(『国華』 862) 昭和39年 [Mizuo, Hiroshi. "Kanō Eitoku and the *Scenes in and around Kyoto* Folding Screens in the Uesugi Collection." *Kokka*, no. 862, 1964].

In this in-depth report Mr. Mizuo presents the earlier scholarship done on Eitoku's *Scenes in and around Kyoto*, and systematically analyzes the style of these screens as well as the date and circumstances surrounding their execution.

持丸一夫「狩野宗秀に就いて」(『美術研究』147) 昭和23年 [Mochimaru, Kazuo. "Concerning Kanō Sōshū." *Bijutsu kenkyū*, no. 147, 1948].

An early study of the life and career of Sōshū. Special attention is given to the works bearing the "Genshū" seal.

中村渓男『永徳』(日本の名画) 東京 平凡社 昭和32年 [Nakamura, Tanio. *Eitoku.* Famous Japanese Paintings Series. Tokyo: Heibonsha, 1957].

Good survey of the life and art of Eitoku.

楢崎宗重「松栄直信について」(『国華』785) 昭和32年 [Narazaki, Muneshige. "Concerning Shōei Naonobu." *Kokka*, no. 785, 1957].

Analysis of the life and painting career of Kanō Shōei.

——「肥前名護屋城図と狩野光信」(『国華』915) 昭和43年 [———. "Kanō Mitsunobu's Painting of Hizen Nagoya Castle." *Kokka*, no. 915, 1968].

In this article Mr. Narazaki examines the ink sketch of Hizen Nagoya castle mounted on a six-fold screen that was discovered in 1968. He concludes that the sketch stylistically agrees with Mitsunobu's works and was probably a preliminary study for a full-scale work made while he was engaged in the decoration of Hizen Nagoya castle in 1592.

谷 信一「狩野宗秀に関する一小事歴」(『美術研究』147) 昭和23年 [Tani, Shin'ichi. "A Short Factual History of Kanō Sōshū." *Bijutsu kenkyū*, no. 147, 1948].

A brief study of the life and career of Kanō Sōshū.

土田杏村「聚光院の松栄襖絵」(『東洋美術』8) 昭和6年 [Tsuchida, Kyōson. "Shōei's Sliding Screen Paintings in the Jukō-in." *Tōyō bijutsu*, no. 10, 1931].

A scholarly study of Shōei's part in the Jukō-in painting commission, with particular attention given to a stylistic analysis of Shōei's works.

——「狩野永徳襖絵論」(『東洋美術』13) 昭和6年 [———. "Kanō Eitoku's Sliding Screen Paintings." *Tōyō bijutsu*, no. 13, 1931].

Particular attention is given to a study of the stylistic properties of Eitoku's major works.

辻 惟雄「狩野松栄筆廿四孝図屏風」(『美術研究』243) 昭和40年 [Tsuji, Nobuo. "The *Twenty-four Paragons of Filial Piety* Folding Screens by Kanō Shōei." *Bijutsu kenkyū*, no. 243, 1965].

This article examines the *Twenty-four Paragons* screens and other related works by Shōei. Mr. Tsuji concludes that the screens were probably commissioned by the Shintō priest Tanamori Fusaaki, who also commissioned the Rajōmon painting for the Itsukushima Shrine.

——「聚光院の障壁画と松栄・永徳」(『大徳寺真珠庵・聚光院』障壁画全集) 東京 美術出版社 昭和46年 [———. "The Screen and Wall Paintings in the Jukō-in: Shōei and Eitoku." In *The Shinju-an and Jukō-in Subtemples of the Daitoku-ji Temple*. Complete Collection of Screen and Wall Paintings. Tokyo: Bijutsu Shuppansha, 1971].

Excellent discussion of Eitoku's and Shōei's *fusuma* painting in the Jukō-in. Includes plan and complete cycle of the *fusuma* paintings.

山根有三「檜図屏風解説」(『国華』778) 昭和32年 [Yamane, Yūzō. "Explanation of the *Cypress Trees* Folding Screen." *Kokka*, no. 778, 1957].

According to tradition, *Cypress Trees* was originally a sliding screen painting executed by Eitoku for the Hachijō-no-miya mansion. Due to discrepancies with *Chinese Lions*, accepted as Eitoku's standard work, the former cannot be attributed to Eitoku with absolute certainty, although it may represent the style of his last years.

——『南禅寺本坊』(障壁画全集) 東京 美術出版社 昭和43年 [———. *Nanzen-ji Hombō*. Complete Collection of Screen and Wall Paintings. Tokyo: Bijutsu Shuppansha, 1968].

Excellent illustrations and discussion of the paintings in the *hombō* of the Nanzen-ji temple in Kyoto.

171

FURTHER READING
(selected and annotated by Catherine Kaputa)

Akiyama, Terukazu. *Japanese Painting*. Lausanne: Skira, 1961.
Excellent introduction to the development of painting in Japan.

Asahi Newspaper, ed. *Momoyama Culture*. Tokyo: Asahi Newspaper, 1976. In Japanese. [朝日新聞社編『桃山文化』 東京 朝日新聞社 昭和 51 年]
Exhibition catalogue of the art of the Momoyama period including many outstanding pieces.

Covell, Jon Carter. *Masterpieces of Japanese Screen Painting: The Momoyama Period*. New York: Crown, 1962.
Deals with key examples of Momoyama screen painting.

Doi, Tsugiyoshi. *Research on Recent Japanese Painting*. Tokyo: Bijutsu Shuppansha, 1970. In Japanese. [土居次義『近世日本絵画の研究』 東京 美術出版社 昭和 45 年]
Anthology of the major scholarly articles published by Doi on various phases of Momoyama and Edo period painting. Contains many articles on Kanō school artists.

————. *Motonobu and Eitoku*. An Outline of the Art of Ink Painting, vol. 8. Tokyo: Kōdansha, 1974. In Japanese. [———— 『元信・永徳』（水墨美術大系 8） 東京 講談社 昭和 49 年]
Excellent color plates and general art-historical background of the Kanō school from its inception in the Muromachi period to the early Edo period, emphasizing the painting careers of the two major Kanō artists, Motonobu and Eitoku. Captions and list of plates in English.

Doi, Tsugiyoshi; Takeda, Tsuneo; and Sugase, Tadashi. *Momoyama*. Japanese Paintings, vol. 6. Tokyo: Kōdansha, 1966. In Japanese. [土居次義 武田恒夫 菅瀬正『桃山』（日本絵画館 6） 講談社 昭和 41 年]
Good plates and introduction to the Momoyama era. List of plates in English.

Fujioka, Michio. *Castles and Shoin*. Book of Books (Japanese Art), vol. 16. Tokyo: Shogakkan, 1971. In Japanese. [藤岡通夫『城と書院』ブック・オブ・ブックス（日本の美術 15） 東京 小学館 昭和 46 年]
Readable introduction to the development and maturation of castle and *shoin*-style architecture.

Grilli, Elise. *The Art of the Japanese Screen*. New York and Tokyo: Weatherhill, 1970.
Detailed discussion of a small representative group of masterpieces of Japanese screen painting. Excellent plates.

Hirai, Kiyoshi. *Feudal Architecture of Japan*. Translated by Hiroaki Saito and Jeannine Ciliotta. Heibonsha Survey of Japanese Art, vol. 13. New York and Tokyo: Weatherhill and Heibonsha, 1973.
See for the development of various architectural styles during Japanese feudal era.

Kanō, Einō. *History of Japanese Painting*. 1693. Reprint. Tokyo: Kokusho Kankōkai, 1974. In Japanese. [狩野永納『本朝画史』（1693 公刊） 東京 国書刊行会 昭和 49 年]
Valuable as an early art-historical document that gathers together the biographies of many important Japanese painters. Also includes sections on the origins of painting, *edokoro*, painting subjects, and seals, which offer insights into early Japanese painting history, philosophy, and connoisseurship.

Kirby, John B., Jr. *From Castle to Teahouse: Japanese Architecture of the Momoyama Period.* Rutland, Vermont: Tuttle, 1962.
Survey of Momoyama period architecture.

Kyoto National Museum, ed. *Screen Painting of the Medieval Period.* Kyoto: Benridō, 1969. In Japanese. [京都国立博物館編『中世の障屏画』京都 便利堂 昭和44年]
Catalogue of significant folding screen and sliding screen paintings of the medieval period in Japan. List of plates in English.

Matsushita, Takaaki. *Ink Painting.* Translated by Martin Colcutt. Arts of Japan, vol. 7. New York and Tokyo: Weatherhill and Shibundo, 1974.
Contains a good discussion of the early Kanō painters Masanobu and Motonobu as well as the development of the various schools of ink painting that flourished in Japan.

Metropolitan Museum of Art. *Japanese Art in the Age of Grandeur.* New York: Metropolitan Museum of Art, 1975.
Exhibition catalogue of representative examples of Momoyama painting, ceramics, and applied arts from Japanese collections.

Noma, Seiroku. *The Arts of Japan: Late Medieval to Modern.* Translated by Glenn T. Webb. Tokyo and New York: Kodansha, 1967.
Excellent plates and survey of important art works from Momoyama through modern period.

Paine, Robert T., and Soper, Alexander C., *The Art and Architecture of Japan.* 2nd ed. New York: Penguin, 1975.
Basic text for students, covering major areas of Japanese art up to the modern period.

Saitō, Ken. *General Survey of the Kanō School.* 3 vols. Tokyo: Kanō-ha Taikan Hakkōjo, 1912–14. In Japanese. [斎藤 謙『狩野派大観』（三巻）東京 狩野派大観発行所 大正1-3年]
Early introduction to Kanō school painting. Text merely supplies short biographical sketches of Kanō artists. While the illustrations are generally poor in quality, some do not appear elsewhere.

Sansom, George. *A History of Japan, 1334–1615.* Stanford: Stanford University Press, 1961.
Provides a good historical and cultural analysis of Muromachi and Momoyama periods.

Takeda, Tsuneo. *Screen Painting.* Japanese Art in Color, vol. 13. Tokyo: Shogakkan, 1967. In Japanese. [武田恒夫『障屏画』（原色日本の美術 13）東京 小学館 昭和42年]
Comprehensive introduction to major Japanese paintings of the Momoyama and early Edo periods on sliding and folding screens. Excellent plates. List of plates in English.

———. *Screen Painting.* Book of Books (Japanese Art), vol. 17. Tokyo: Shogakkan, 1971. In Japanese. [———『障屏画』 ブック・オブ・ブックス （日本の美術 17）東京 小学館 昭和46年]
Good introductory text to screen painting of the Momoyama period. Many color illustrations.

Tanaka, Ichimatsu et al., eds. *Complete Collection of Screen and Wall Paintings.* 10 vols. Tokyo: Bijutsu Shuppansha, 1960–72. In Japanese. [田中一松他編『障壁画全集』（十巻）東京 美術出版社 昭和35-47年]
This series deals with a significant group of painting projects for the interior decoration

173

of major Japanese temples, castles, and other structures during the Momoyama and early Edo periods. Excellent text and plates.

Warner, Langdon. *The Enduring Art of Japan.* New York: Grove Press, 1958.
Sensitive introduction to Japanese art.

Webb, Glenn T. "Japanese Scholarship behind Momoyama Painting and Trends in Japanese Painting ca. 1500–1700 as Seen in the Light of Stylistic Re-examination of the Nature of Chinese Influence on Kanō Painters and some of their Contemporaries." Ph.D. dissertation, University of Chicago, 1970.
Interesting stylistic analysis of Japanese painting during this two-hundred-year period.

Yamane, Yuzo. *Momoyama Genre Painting.* Translated by John Shields. Heibonsha Survey of Japanese Art, vol. 17. New York and Tokyo: Weatherhill and Heibonsha, 1973.
See for discussion of Kanō paintings depicting genre subjects.

INDEX

Japanese
Arts
Library

In 1966 the Shibundo publishing company in Tokyo began an unprecedented series of monthly publications on Japanese art entitled *Nihon no bijutsu* (Arts of Japan). Prepared with the cooperation and editorial supervision of the Agency for Cultural Affairs and the three great national museums in Kyoto, Nara, and Tokyo, the series is written by leading Japanese scholars for a general audience, each issue devoted to a single aspect of Japanese art. Now totaling over 130 issues, this monumental series presents a comprehensive, detailed picture of Japanese art unequaled in Japanese publishing history—and now available to the English-reading public. Entitled the Japanese Arts Library, the English edition is being translated by scholars of Japanese art under the overall editorial direction of John Rosenfield of Harvard University. Abundantly illustrated and adapted for the Western reader, the Japanese Arts Library is an outstanding event in English-language publication.

Published titles

1. *Shino and Oribe Ceramics*
2. *Japanese Portrait Sculpture*
3. *Kanō Eitoku*
4. *Pure Land Buddhist Painting*

In preparation

Bugaku Masks
Nagasaki Prints and Early Copperplates
Early Ink Painting
Tempyō Sculpture
Hasegawa Tōhaku
Early Temple Architecture
Asuka-Hakuhō Sculpture
Shoin-style Architecture
Jōgan Sculpture
Shintō Architecture
Pictorial Biography of Ippen Shōnin
Portrait Painting
Avant-garde Art
Early Genre Painting
Tale of Genji Picture Scroll